MW00777962

Asen, Ancestors, and Vodun

Asen, Ancestors, and Vodun

Tracing Change in African Art

EDNA G. BAY

To Julia —
My pool pal,
former running buddy,
and best confidant —

Eddy

UNIVERSITY OF ILLINOIS PRESS
Urbana and Chicago

Library of Congress Cataloging-in-Publication Data
Bay, Edna G.
Asen, ancestors, and vodun : tracing change in African art / Edna Bay.
p. cm.
Includes bibliographical references and index.
ISBN-13 978-0-252-03255-4 (cloth : alk. paper)
ISBN-10 0-252-03255-1 (cloth : alk. paper)
1. Altars, Fon—Benin. 2. Ironwork, Fon—Benin. 3. Metal sculpture—
Benin. 4. Fon (African people)—Religion. 5. Ancestor worship—Benin.
I. Title.
NK8289.6.D3B388 2008
730.089'96337—dc22 2007019170

To the memory of

Grâce d'Almeida
and
Paulette d'Almeida Viakinnou

Loyal friends, dedicated professionals, devoted mothers
May this slim asen crafted of words hold your spirits close
and help preserve the memory of your intelligence,
kindness, and generosity.

Contents

Preface

This book has been long in the making. I initially became curious about ancestral asen during my first period of field research in Benin in 1971–73. I was researching a dissertation on women in the kingdom of Dahomey. As the months in Abomey passed and I developed a network of contacts and friends, I began to receive more and more invitations to ceremonies, and I was a participant in the "feeding" of ancestors in several families. Years later I moved to Atlanta and met William Arnett, who at the time had more than forty asen in his personal collection of African art. With the encouragement of then-director Clark Poling of the Emory Museum, I developed a plan for an exhibition of asen based on the Arnett holdings that would be documented through field research. The National Endowment for the Humanities funded six months of research in Benin, which led to an exhibition and catalog in 1985: *Asen: Iron Altars of the Fon People of Benin*. Following the show, I continued to work on the history of Dahomey and at regular intervals spent short periods in residence in Abomey or along the coast.

In the 1990s, I began to realize how much the traditions associated with asen manufacture and use were changing, along with major changes in funerary practices in Benin. As I looked at ancestral asen over time, I also began to recognize how different the patterns of asen creation and consumption were from what is generally understood about African art. Asen do not fit comfortably in either of the two categories currently used to classify African art: classical and contemporary. Their roots are in the precolonial period, but well within the phase of intense European contact and influence. They are made of materials imported from Europe, cast using a technology learned

from a European source, and decorated with figures modeled in a style indistinguishable from figures fashioned for a tourist trade. Nevertheless, asen are sacred objects made for ritual purposes. As art objects they have ties to similar sacred forms used in association with vodun, objects that clearly predate European contact and reflect deeply religious values in Fon culture.

I decided to write this story of ancestral asen when I realized that asen were beginning to disappear. Individuals of means order them less frequently these days. One hears stories of asen being discarded or stolen for sale to outsiders. Some people claim that progressive families are replacing them with photographs. In effect, the life cycle of this art form is nearing its end. I have undertaken in this book to trace the course of ancestral asen production from its birth in the nineteenth century through its development and flourishing in the twentieth. I end by exploring possible reasons for its imminent demise in the current century. At the same time, I want to stress that the story of asen's life cycle is not one to be greeted with mourning for the loss of "tradition." For me, asen art is a perfect reminder of the creative energy and cultural resilience of people in Benin, of the reality that all cultures all the time are constantly reinventing themselves and the material objects that reflect their beliefs. It is a lesson that outsiders to Africa too often forget.

The numbers of institutions and individuals who deserve thanks for assisting me in this project, carried out intermittently over so many years, is very large. Without financial support, none of this would have been possible. I gratefully acknowledge the Social Science Research Council (Foreign Area Fellowship Program), which funded my first work in Benin, and the National Endowment for the Humanities, which supported the bulk of the research for this study. Emory University has been centrally and crucially important in allowing leaves from teaching and supporting my travel and writing. The internationalization fund administered by the Institute for Comparative and International Study and travel allowances provided by my department, the Graduate Institute of the Liberal Arts, were of great help. Emory College and the Graduate School of Arts and Sciences provided support for the production of the many illustrations in this volume. I owe special thanks to Deans Robert A. Paul and Richard Rubinson for that support. I have also received important financial support from the organizers of several conferences held in Benin and sponsored by the Université d'Abomey-Calavi, the government of Benin, and UNESCO.

I hesitate to begin naming individuals who have helped me over the years, knowing that there are so many people, some now deceased, who have been of assistance that I will leave some out. In Benin, friends who have offered many

kinds of support include Angèle and Alexis Féliho, Léonard Loko, Camille Dosso-Yovo Loko, Honorine Loko, and Elisée and Maria Soumonni. Joseph Adande has been unfailingly supportive, offering his time, his knowledge of Beninese arts, and his good advice. Generations, literally, of guides and local historians have shared their knowledge of the culture and history of Benin: René Aho, M. Vincent, Protais Chaba, Bachirou Nondichao, Pierre Agessi Voyon, Martine de Souza, Gabin Djimassen, and Aloha Agbakodji. I thank the staffs of the Musée Historique d'Abomey, the Beninese national archives, the national library, and the École du Patrimoine Africaine. Museum personnel in the United States and Europe over the years have been wonderfully supportive: Claude Savary of the Musée d'Ethnographie de la Ville de Genève, Alisa LaGamma of the Metropolitan Museum of Art, Gérard Sagnol of the Société des Missions Africaines in Lyon, Jessica Stephenson of the Carlos Museum of Emory University, Amy Staples of the National Museum of African Art, and the director and professional staff of the Musée Albert-Kahn, including in particular Flore Hervé. Irène d'Almeida worked with me on Fongbe, and Yvan Bamps helped with photo permissions. Despite all this good help, I accept full responsibility for the errors and lapses that this text undoubtedly contains.

I save my final and most heartfelt thanks for two persons very dear to me. Grâce d'Almeida opened her home and heart to me during my 1984 field research and continued to welcome me throughout the years until her death in the summer of 2005. Seeing her at intervals in Benin, the United States, and Haiti, I marveled at her energy, her drive, and her genuine surprise at her own well-deserved successes. Grâce's older sister, Paulette, better known to the family as Dagan, was the first child and hence the person responsible for her siblings. Dagan found solace for the unexpected losses of a son and her dear husband in her magnificent garden. I'll long remember our conversations on her verandah when she would reminisce about her upbringing in Dakar.

A Note on Orthography

Fongbe is a tonal language that was not recorded systematically until the development of a scheme by R. P. Basilio Segurola in the 1950s. His Fon-French dictionary (1963) was substantially revised through the efforts of Father Jean Rassinoux with other priests and scholars (Segurola and Rassinoux 2000). Fongbe in the late twentieth century began to be studied by linguists as part of a dialect cluster now commonly referred to as Gbe that includes dialects known by the names Ewe, Fon, Adja, Aja, and other variants. It is now properly recorded in either the Africa Alphabet of the International African Institute or through the symbols of the International Phonetic Association (Capo 1991).

My own knowledge of Fongbe is rudimentary. As such, I am not competent to transpose material that I have received in spoken form into a strict orthography, nor do I feel competent to transform the attempts to represent Fongbe by earlier scholars into an orthographic system. I have therefore chosen to represent words and phrases in Fongbe in several ways. First, if an author has recorded text in a published work, I have retained the original spelling. Second, I have recorded contemporary place names according to current usage in Benin, which tends to correspond to common spellings in French. Hence I use Porto-Novo rather than Porto Novo and Ouidah in place of Whydah. Finally, I have deliberately altered some spellings commonly used by Beninese to allow them to correspond to English pronunciation. For example, I have chosen to record the name of the precolonial kingdom in southern Benin, Dahomey, using the spelling of the colony and independent state. Recent Beninese scholars spell the name Danxome, which follows the

Segurola system and alerts speakers of French to the fact that the "a" in the name is slightly nasalized and the "h" aspirated. However, English speakers would typically pronounce such a spelling as Dan-zome, the final syllable rhyming with "home," a pronunciation that seriously distorts the spoken name.

In short, readers with a good deal of linguistic expertise and knowledge of Fongbe are likely to find inconsistencies in my orthographic informalities. I apologize for these problems and look forward to their corrections.

Asen, Ancestors, and Vodun

INTRODUCTION

Les morts sont plus vivants que les vivants.

(The dead are more alive than the living.)
—Roger Brand

 This book tells the story of the rise and decline of a sculptural tradition in southern Benin, West Africa. It is a biography of ancestral *asen,*[1] an art form made to honor the dead. Like much of so-called classical African art, asen have religious functions in a social order, yet in their fabrication, circulation, and relatively recent invention, ancestral asen embody ironics and contradictions that confound much of our received wisdom about African art. Asen are also social documents that speak through an iconographic vocabulary tied to a range of highly inventive oral arts. In asen's visual-verbal expression we hear of changes in kinship, class, and culture, as southern Beninese society experienced dramatic political and economic changes through the nineteenth and twentieth centuries: rule by a slave-raiding monarchy, domination by French colonialism, and postcolonial political turnings in a modernizing state. This book follows ancestral asen from their invention to the present, explores the technologies and social structures behind their production, and outlines their changing iconographical messages against a backdrop of social change in southern Benin.
 Ancestral asen are metal sculptures that serve as sites of interaction between the visible world of contemporary life and the invisible realm of spirits. *Asen* is a generic term for a class of moveable metal objects of widely varying form and size that attract and temporarily fix or hold spiritual entities—spirits associated with the dead and those of the deities known as *vodun.* In that sense, the history of asen is intimately tied to the larger religious-philosophical system known variously as Vodun or Vodou and that today sustains believers in West Africa and the Western Hemisphere. The asen of

this book represent one portion of that vast, dynamic system of belief yet reflect central themes of the interaction between the seen and unseen in the religious thinking of Vodun: of the power of the spirit world, of the need to insure and protect, and of the efficacy of prayer and sacrifice.

Ancestral asen are created to honor the dead. When in use, they provide a place where ancestral spirits alight, and thus they momentarily fix the family dead in a sacred space where the living can focus on the presence of the invisible and communicate with the dead. The asen of this history are those dedicated to deceased members of families in southern Benin, and particularly in the region of the city of Abomey. There, funerary asen have been used at differing levels of society for at least 150 years. Virtually all such asen conform to a standard type with three distinctive parts: 1) a pointed iron stake varying in length from roughly 20 centimeters to 1.5 meters surmounted by 2) an inverted cone fashioned from sheet metal (*asen aladasen*) or formed of umbrella-like metal spokes (*asen gbadota*) that supports 3) a flat circular platform or plateau that may act as a base for one or more small metal sculptures (figures 1 and 2). Kept in a special building within the family compound, asen represent the collective presence of the family's ancestors, who are called with praises and feted with sacrifices, convened to hear news of family events, and consulted on matters of importance to the living descendants of the line.

The relatively brief lifetime of ancestral asen production has coincided with striking social and political changes in southern Benin. Ancestral asen came into use in the early to mid-nineteenth century in Abomey, then the capital of the kingdom of Dahomey.[2] A state that was born in the seventeenth century in response to the depredations of slave raiding in the hinterland of the Slave Coast, Dahomey was an expansionist kingdom founded by a band of migrants who claimed origins to the southwest of Abomey. Dahomey's founders settled at the center of what became known as the Abomey plateau, some one hundred kilometers from the sea (figure 3). From there, they expanded their territory through warfare and raiding, ultimately building a polity whose prosperity was directly linked to its participation in the overseas trade in slaves. Ethnically, Dahomey included a mix of peoples who came to be called Fon, most of whom spoke languages of the Gbe language family and all of whom shared certain cultural commonalities. Gbe-speaking peoples are found along the coast and in the near hinterland of an area stretching roughly from what is today the border area of Ghana and Togo in the west to the border between Benin and Nigeria in the east. In the course of its history, the kingdom of Dahomey incorporated peoples first from Gbe-speaking and

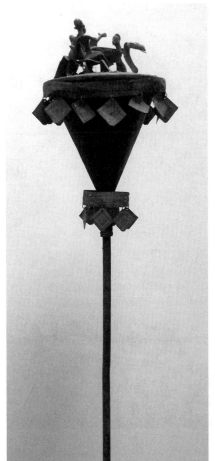 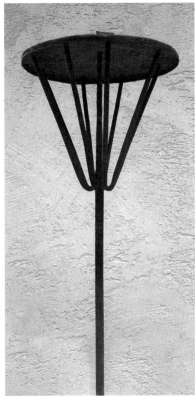

Figure 1. *Asen aladasen.* Said to be the original asen form, the top is popularly compared to the shape of a closed gourd. Photo: E. Bay.

Figure 2. *Asen gbadota.* Literally, asen like a hat, usually compared to an umbrella because of the supporting ribs. Photo: E. Bay.

later Yoruba-speaking groups to the east and northeast and enjoyed relative success, at least in the eighteenth century, in providing opportunities for newly arrived individuals of talent and ambition to amass wealth and power (Bay 1998).

The incorporation into Dahomey of peoples from an ethnically diverse population base points to the outstanding feature of Fon culture—its eclectic

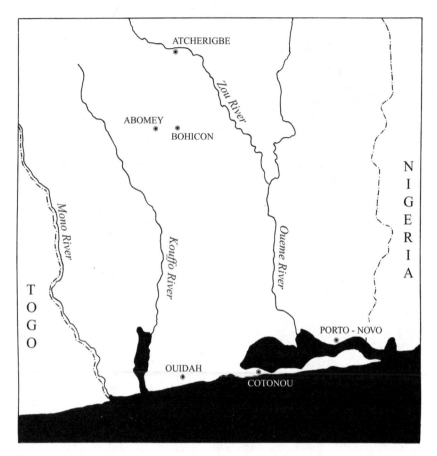

Figure 3. Southern Benin.

nature. From the earliest written accounts of the Dahomean kingdom, which date to the turn of the eighteenth century, observers have remarked upon the Fon propensity to embrace and adopt influences from many directions: Europe by way of the Atlantic coast, Akan areas to the west, Yoruba-speaking lands to the north and east, and to a far lesser extent, Islamic West Africa to the north. The nineteenth century saw the culture of Dahomey enriched by the forced immigration into the kingdom of thousands of Yoruba-speaking refugees and captives, victims of civil wars in their homelands. It was the period, too, of the arrival of a small but highly influential number of Africans returned from slavery in Brazil. These Aguda, or Afro-Brazilians, settled mainly in coastal ports like Ouidah, Dahomey's main outlet to the

sea, where they practiced and promoted a unique blend of lusophonic and West African culture. By century's end, active competition among the British, French, Portuguese, and Germans for authority over the area ended with the French destruction of the kingdom and the establishment of a colony named Dahomey. Whether invader or trader, missionary or African returnee, outsiders in the area throughout the period of the kingdom were the subject of curiosity and study as Fon culture, itself born of a mix of diverse peoples, adopted and adapted new influences. The sweep of documented Fon eclecticism is vast and includes items of material culture, technologies, deities, and principles of state organization. Nevertheless, the cultural influences from outside were without exception grafted onto a worldview that is associated with vodun.

Vodun posits a link, a mutual interdependence, between visible worlds of the living and invisible worlds of the spirits (figure 4). Communication between the two is through sacrifice, prayer, possession, and divination. Both vodun spirits and ancestral dead have access to *aché* (power), which can be used for good or ill, to aid or punish. To meet life's challenges, to protect oneself and one's family, to overcome obstacles and ensure prosperity, it is individuals' and indeed humankind's obligation to recognize and serve these spiritual entities, to propitiate and honor the vodun and the dead in order to solicit and be aided by the power that they are capable of wielding. Yet the relationship of the living to the spirit world is complex, for deceased ancestors and vodun are equally dependent for their strength upon the continued sustenance provided by those who serve them, upon the proffered sacrifices and prayers. Like humankind, spirits wither and die without food, without social contact, or without purpose for their existence.

Vodun spirits are literally without number, present in natural objects and events, installed in shrines, and sometimes existing unrecognized by servers unaware of their needs. They are capable of movement, of traveling with devotees, and of revealing themselves in dreams, possession, and other physical signs. Vodun from one region may be adopted and transported to another, where they can be set up with shrines virtually anywhere that the vodun deem appropriate. Images of deities, saints, and mythic figures may be recognized as already extant vodun. Over time, vodun servers have claimed and adopted vodun and imagery of various kinds from virtually every cultural tradition that Vodun has touched: other areas of Africa, Christianity, Islam, and even Hinduism. In the introduction to her doctoral dissertation, Dana Rush gives an inspired description of this eclectic sensibility associated with the culture of Vodun: "Vodun is a testament to the strength and flexibility

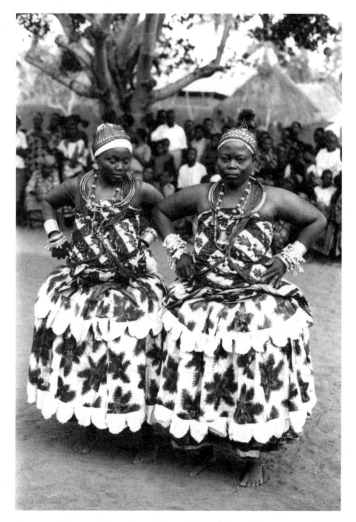

Figure 4. Adepts of the vodun Sakpata, deity of the earth, wait to perform. Near Abomey, 1972. Photo: E. Bay.

of a belief system that perpetually adapts, adjusts, invents, re-invents, and modifies itself. Within the religious system of Vodun, there exist endless options derived from endless sources which ultimately form, re-form, and transform Vodun arts and religious consciousnesses. As long as Vodun is on the move, its transformation is forever unfinished" (Rush 1997, 2).

Vodun are honored at shrines and in public performance, in the presence

of congregations of devotees and interested bystanders. In contrast, ancestors are approached at home, in the privacy and sanctity of a sacred courtyard that generally contains two structures. The first is a reception room, the *ajalala,* where the head of the lineage meets visitors, family disputes are resolved, and family enterprises are discussed. The second, at a right angle to the ajalala, is the *deho* or *dehoho* (literally, the small house, or room of prayers), where the lineage asen and a small number of similar shrine objects are arrayed (figure 5). The presence of asen adjacent to the site of crucial activities and decision making for the living means that the lineage dead are able to be present in the continuing life of the family. It is in this sacred space that the entire lineage is expected to gather from time to time for cycles of ceremonies in honor of the ancestors. Under the direction of elderly women of the lineage, the ancestors are called to be present in the deho and are offered a multitude of sacrificial drinks and foods: water, alcoholic and other beverages, the fresh blood and cooked meats of sacrificial animals, grains and vegetables, and prepared dishes including the ancestral favorite, cooked beans. Onlookers kneel, their shoes and sandals cast aside. Officiants who pour libations and set out food do so with heads respectfully bowed, backing away from the asen and kneeling as befits their rank as juniors and subordinates to the dead. After the ancestors invisibly have their fill, the family members share the leftovers, always in order of age (figure 6).

In intervals between these ancestral feasts, smaller groups of lineage members approach the deho for consultations with the ancestors on questions of importance: Is a proposed marriage in the interests of the line? Should a young family member travel to study in North America? How should family lands be allocated among competing claims? Which of the ancestors is reincarnated in a newborn child? Ancestral asen figuratively stand at the intersection between worlds, functioning as a site where the concerns, pleas, and praises of the living can be heard by the dead and where the responses of the long departed may be heard through the mystery of divination.

The Art of Asen

Against this background of ethnic diversity and cultural eclecticism, of a worldview characterized by close interaction between the seen and the unseen, this book traces the development of form, iconography, and meaning in ancestral asen. H. J. Drewal has noted the paucity of studies in the field of the arts of Africa that are concerned with the history of art or, more exactly, with art history, defined by him as "the tracing of constancy and change in

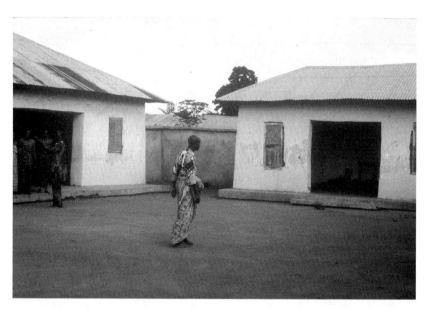

Figure 5. Royal family member approaches the *deho*, or house of prayers. To the left is the *ajalala*, the reception room for the compound head. Near Abomey, 1984. Photo: E. Bay.

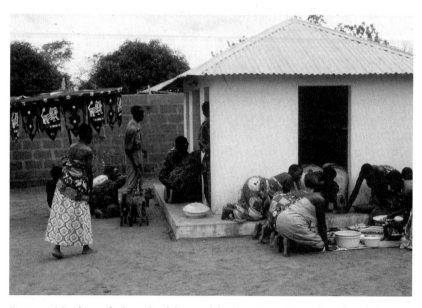

Figure 6. Members of a branch of the royal family wait outside while the family head offers prayers to the spirits of ancestors present in the deho. Near Abomey, 1984. Photo: E. Bay.

the form, style, and meaning of art objects" (Drewal 1990, 39). The art history of asen in Drewal's sense is a central focus of this study and provides intriguing evidence of the propensity of African cultures to adopt, adapt, and innovate. As objects whose iconography and meaning exhibit remarkable change over a compressed period of time, asen remind us that religious processes inspire creativity and innovation, but around principles of belief that remain central. They remind us, too, that the religious and political are inseparable, even in an art form that is ostensibly associated only with the devotion that the living demonstrate to their deceased kinsmen within the boundaries of their own private domestic space.

As a form of ritual sculpture, ancestral asen violate an array of stereotypes about African art. Objects that are made by African artists and used by African peoples for a religious purpose in an African culture, asen more than meet the standard definition of authenticity for the classical arts of Africa. None have been produced for sale to unsuspecting collectors as authentic objects, nor are asen made for a tourist trade.[3] However, unlike many other so-called traditional or classical arts of Africa, asen are not associated with some distant past far removed from European contact and influence. Rather, they appear to date to the late precolonial period, when regular interactions between Dahomey and Europe had been common for well over a century. Ancestral asen borrow their name, basic form, and a series of meanings from the neighboring Yoruba people but fulfill sacred functions in ways unique to the Fon of Benin. In the nineteenth century they were adopted as a court art designed to enhance the prestige of a living dynasty, their use as ancestral altars having been invented to celebrate the apotheosis of royal ancestors. Following the abolition of the monarchy and imposition of French colonial rule, the use of asen diffused outward and downward throughout Beninese culture, as people at all social levels adopted the use of ancestral asen, democratically employing the marks of royal prestige under colonial and postcolonial regimes. The finest twentieth-century asen, characterized by an excellence of smithing artistry and comparable artists' fees, became a form of conspicuous consumption made all the more ironic by the fact that an asen, after consecration, is enclosed in a building and seen only by family members on relatively rare occasions.

Perhaps most ironic of all are the traditions of asen fabrication that link their production directly to European materials and training. Throughout their existence, ancestral asen have without exception been created with metals imported through the overseas trade with Europe, usually for other purposes: coins, automotive bodies, bottle caps, faucets, and even cartridges,

to name a few sources. Moreover, many of the finest examples fashioned in Abomey include figures cast in the lost-wax process that was known for centuries in West Africa yet practiced in Benin only after its introduction by a European source at the end of the nineteenth century. The modeling style characteristic of the cast asen figures was learned by a single smith trained in Europe. He and his family adapted a casting style promoted for tourist consumption to the sacred tradition of asen manufacture in Abomey.

Ancestral asen, then, are an embodiment of contradiction: a sacred African art form created in the recent historic past using European materials and technologies, embellished with figures drawn from a tourist tradition and fully commoditized in the twentieth century. Unlike most classical African art forms, we can discern roughly when ancestral asen were invented; we can watch the form change and develop over time; we can identify the names and artistic styles of several of the premier makers of asen; we can trace the decline of asen in workmanship and use; and finally, we can predict the form's disappearance. In short, asen art defies categories, but its biography holds fascinating potential for exploring the creativity of African cultures.

Asen as Social Documents

The circular tops or plateaus of ancestral asen may or may not include representational figures of various kinds: animals, plants, humans, tools, and other man-made objects (figure 7). When present, those representational motifs can be read. Their messages have changed over the course of the lifetime of asen production, and their meanings have reflected in extraordinarily accurate and insightful ways the directions of social and cultural change in Dahomey/Benin.

From its beginnings, asen iconography was closely aligned with Fon verbal arts, using motifs that evoked proverbs and praise poetry. Asen in the period of the kingdom of Dahomey were made in honor of deified individuals, initially the kings and queen mothers, and later other prominent individuals. In what was effectively a form of symbolic portraiture, the plateaus of asen contained sculptures alluding to praise names, feats, and triumphs associated with the person they honored. Often, asen artists fashioned these portraits through the use of rebuses, motifs whose spoken names punned and pointed to phrases that in turn evoked the name of an individual monarch. Asen imagery throughout its history links Fon verbal and visual arts in a constantly changing rhythm of visual meanings that migrate across artistic media, linking poets to appliqué artists and praise singers to smiths.

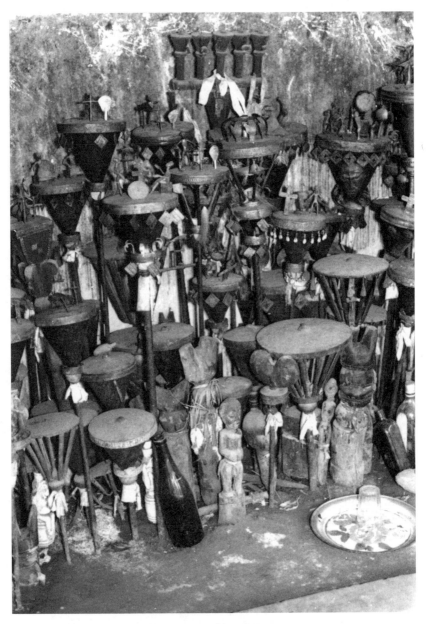

Figure 7. Interior of a deho. Abomey, 1999. Photo: E. Bay.

With the colonial period, the monopoly on asen use by political elites was broken, opening the way for the gradual diffusion of ancestral asen across all social classes of Benin. Asen iconography changed too, as French cultural colonization challenged African culture at many levels. By the 1920s, ancestral asen tableau messages celebrated the solidarity of the family, emphasizing the donor of the object, so that asen moved from being portraits of royalty to interactive representations of the dead and their loved ones. As the twentieth century wore on and modernizing trends challenged family cohesion, the representational motifs changed again, moving from the symbolic to the literal. The honored dead began to be portrayed by more direct representational means, shown at their occupations or literally labeled with small sheet-metal placards. Meanwhile, asen donors, with their pledges of faithfulness and lineage solidarity, began to disappear from asen iconography as pressures of modernity undermined expectations of kin sustenance.

By late in the twentieth century, asen had become a target in intense culture wars in a democratic state where politics and religion were inextricably intertwined, as they had been in precolonial Dahomey. Under assault by a movement sponsored by the Roman Catholic church, by the teachings of Protestant evangelicals, and even by the changing practices of practitioners of Vodun, asen use at the turn of the twenty-first century is succumbing to the slow, subtle decline of kinship solidarity in Beninese culture. Asen are beginning to disappear, rejected as inappropriate to a modernizing Christianity or replaced by the technology of photography.

Finally, the history of the manufacture of asen introduces us to the politics of courtly competition among artisans and to the economics of arts production in colonial and postcolonial states. The finest ancestral asen are associated with a single lineage of smiths, the Hountondji, who claim long alliance with and allegiance to the royal dynasty of Dahomey. Privileged by the nineteenth-century monarchs, yet challenged by competing metal artists, the Hountondji struggled to ingratiate themselves with the precolonial and colonial rulers. In the twentieth century, the Hountondji smiths seized economic and creative opportunities, building a sacred asen tradition with cast brass figures fostered by the French for a tourist trade. They succeeded in instituting and maintaining a monopoly on their cast figural style through the entire twentieth century, though at the price of a certain creative stagnation. Meanwhile, non-Hountondji smiths developed a parallel thriving industry in the production of asen with figures of cut sheet metal. Creators of an art of assemblage, asen smiths as a whole have been praised as masters of recycling.

* * *

This book traces these complex interweavings of social, political, aesthetic, and religious impulses that make up the history of ancestral asen in southern Benin. Chapter 1 begins with a consideration of Vodun in the area of Abomey, exploring the precolonial and twentieth-century histories of the gods and how their natures are subject to manipulation by human agency. The chapter then turns to the meaning of the term *asen* in Fon culture and discusses generally the use of ancestral asen in the twentieth century. Chapter 2 moves to the precolonial period and a close look at the court of King Gezo, the monarch who appears to have introduced the use of asen in ancestral rituals. We then look (in chapter 3) at the Hountondji family of smiths as they functioned under the kings and as they weathered the transition to the colonial period through the exploitation of new technologies and stylistic innovations. Social changes in the early twentieth century are the subject of chapter 4, which also traces the Hountondji experience with new technologies and their adaptation of French-promoted tourist castings to ancestral asen art. Chapter 5 moves to a consideration of verbal-visual interaction in the arts and analyzes the poetics of the iconography of asen made for the royal dead. Chapter 6 traces changes in the messages of asen tableaux through the twentieth century, while Chapter 7 focuses on the end of the twentieth century and modernity's challenges to the continuation of asen fabrication.

Vodun, Sacrifice, and the Sinuka

*Si l'art, au bas-Dahomey, s'est réfugié à un moment donné dans le
palais des princes, il a d'abord pris naissance dans les couvents et
bosquets vodû.*

(Even if the art of southern Dahomey found shelter at a particular
moment in the palace of princes, it was born first in the convents
and groves of the vodun.)

—Robert Sastre

Ancestral asen were ubiquitous in late twentieth-century southern
Benin. They were sold in markets or could be ordered from smiths, and the
compounds that served as ancestral homes for most Fon extended fami-
lies contained dozens of asen, either locked away in storage or arranged in
shrines. Asen were common objects, yet there was no unanimity in people's
understanding of their origins or of their ceremonial use. Local definitions
of asen were contradictory, and patterns associated with their use varied.
Adding to the confusion were common etymologies of the word *asen* that
reflected Fon verbal artistry rather than historical information about their
origins. Indeed, creative punning and wordplay are woven throughout the
fabric of asen history, affecting our understanding of their origins in heal-
ing ritual, their use in ceremonies, and their dialogue with other artistic
media.[1]

I argue in this chapter that ancestral asen are but one form of a class of
moveable metal objects considered to be capable of attracting and holding a
spirit. Asen were associated with vodun shrines and with burial practices in
Dahomey prior to the invention of ancestral asen. Ancestral asen developed
out of these older forms and their close association with understandings of
the spirit world and beliefs about the powers of the vodun. Indeed, the coni-
cal form characteristic of ancestral asen would have reminded the people of
Dahomey of the mysteries of the vodun and hence offered a figurative and

literal platform for the expression of ideological symbols by a ruling dynasty intent on enhancing its own prestige through the deification of its members. As we will see, the adaptation of asen to ancestral use by the ruling lineage was part of a long process of manipulation of the spirit world toward its own consolidation of worldly power. It is no coincidence that ancestral asen use became important against a backdrop of a regime fundamentally challenged by long-term losses of economic power. Ancestral asen at the level of the monarchy were designed to glorify a dynasty struggling against diminishing political control in two worlds—visible and invisible.

Following the destruction of the kingdom with the French conquest, ancestral asen use ultimately spread throughout Fon culture to people of all social classes and income levels. Ancestral asen, as they came to be used in the broader culture, provided prestige to the living yet did not replace certain other ritual items, most notably *sinuka,* the sacred bowl-shaped gourds that remained the central symbol of the continuing relationship of the living to the dead.[2] The contradictions of the overlapping terminology associated with the use of asen and sinuka underline the historically shallow period of ancestral asen use in twentieth-century southern Benin.

This chapter sets the stage for a consideration of the invention of ancestral asen by exploring the religious context of their roots. It begins with an overview of the vodun and their nature, including the association of asen with rituals in the honor of vodun. I then turn to the little-known origins of the word *asen* and its links to a Yoruba deity of healing. Finally sinuka, the gourds used to serve drink and food and the quintessential emblems of ideas about sacrifice in Fon culture, are considered in light of their use as a synonym for ancestral asen.

The Vodun and History

The vodun and their close relatives, the *orisha* of Yoruba-speaking areas, are described by servers in terms of mixed bundles of personality characteristics.[3] Like human beings, given vodun may alternately exhibit admirable, even heroic, qualities, yet they are capable of pettiness, jealousy, and other negative traits. Vodun exist as moral exemplars, humans writ divinely large in all their promise, beauty, and weakness. Descriptions of vodun often emphasize the powers of punishment and vengeance unleashed by vodun against those who have offended them by harming and threatening their servers. But above all, vodun offer their servers protection, security from the many hazards that confront humans as they go through life.

Some vodun, like Heviosso, are said to have once been human, but they were transformed into gods by exhibition of some extraordinary characteristic. Others appear always to have been associated with natural forces and reflect the power of such forces. Vodun associated with nature, too, may serve as metaphors for relationships: Dan Ayido Hwedo, the serpent vodun, links earth and sky as a rainbow, a mediator between realms (figure 8). Like the humans on whom the gods are modeled, the vodun provide an unending wealth of material for stories and folklore, offering entertainment and moral instruction that reflects social dilemmas and guides human decision making.

Several points about vodun are crucial for understanding their relationship to ancestors. The first is the recognition that the systems of Vodun among Gbe-speaking peoples and orisha among Yoruba-speakers share a spiritual tradition in which conceptual assumptions and ritual practices associated with an ever-shifting world of numberless spirits remain constant while specific deities—like people trading and warring—flow back and forth, are captured and resettled, take new names in different locations, and retain traditions of their places of origin. To oversimplify a complex history of humans and gods, we can distinguish two patterns of religious

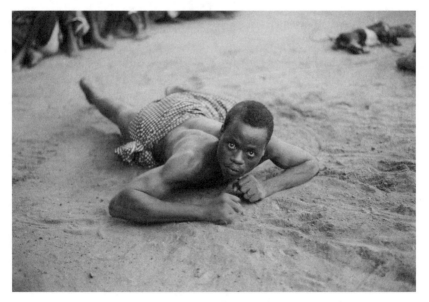

Figure 8. Initiate possessed by Dan, the serpent vodun. Near Abomey, 1972. Photo: E. Bay.

and cultural flow over the centuries since Europeans first appeared in West Africa and prompted a shifting of political economy toward the coast. The predominant flow carried goods and gods east and west through a coastal lagoon and river system stretching from the mouth of the Volta River to the delta of the Niger. It was supplemented by small streams of cultural influence running down to the coast with slaving caravans. The establishment of the kingdom of Dahomey sometime in the seventeenth century signaled a shift of these patterns in what became southern Benin, as a centralizing state drew peoples and cultures into a whirlpool of change and control whose center lay on the Abomey plateau, relatively far inland from the coast. Along with people, vodun in the Dahomean vortex were variously discovered, created, imported, exported, absorbed, nurtured, and limited by the hands of Dahomean political authorities. The swirling cultural energies of the Abomey plateau over time became linked along a north-south axis to Ouidah, the coastal entrepôt that represented Dahomey's direct contact with Europe and the Western Hemisphere. This north-south system of cultural flows would change yet again in the twentieth century, returning to an east-west pattern with results that will be discussed in chapter 7.

The comparability of vodun between Gbe and Yoruba speakers points to a second phenomenon of Vodun, the religious system's ability to support a fully localized community of spirits that paradoxically is part of a universe of deities recognizable throughout the far-flung realm of Vodun. Through this paradox of local variation, vodun active in a given location may vary in nature, and even by name, yet still be recognized by servers as part of a family that is known widely and that in turn is referred to by a single name. Sandra Barnes (1997) has theorized this phenomenon in the context of Ogun (Gu), a complex of spirits whose many manifestations are common in the region, to say nothing of the Western Hemisphere. In effect, the names of Gu—or Sakpata, Heviosso, and Legba, among the better-known Fon families—are a conceptual classification system of divine characteristics devised by the initiates who serve and honor vodun. Thus, to give another example, the family of thunder divinities known as Heviosso (figure 9) are linked conceptually because they all punish those who offend them through the violence of storms: Sagbo (Sobo), the androgynous head of the Heviosso line, strikes robbers, sorcerers, and other bad people with lightning; the female Aden appears when the sky is darkening and arrives with a fine rain; Accrombe (Aklombe) sends hail and kills while taking the lips of his victims; Jakata, whose name derives from the Yoruba for "thrower of stones," sends torrential rains and takes the eyes of his victims; Gbesu stays near her parent and

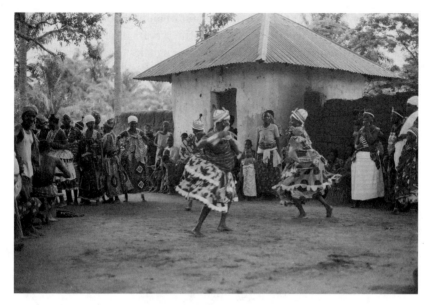

Figure 9. Initiates of the vodun family of Heviosso in performance. Near Abomey, 1972. Photo: E. Bay.

does not kill, but her voice can be heard rumbling at the far horizon; and the most violent of all, Bade (Gbade), comes with storms capable of tearing the bodies of his victims to shreds (Verger 1954, 174; Falcon 1970, 31). This paradox of local variation within a conceptual singularity applies to virtually all the spirits, thus providing the realm of Vodun with cohesion and a sense of spiritual unity while allowing for tremendous local variation and for the prominence of one or another vodun in any particular location.[4]

Because vodun were and are virtually constantly on the move, it is impossible to describe, as many have attempted to do, a stable hierarchy of the most prominent vodun that would be relevant to the broad expanse of West Africa where they are recognized. Rather, all descriptions of specific vodun are necessarily local, tied to a particular place and a specific historical period. Our focus here is on the Abomey plateau, where twentieth-century scholars have tended to group the vodun into two general categories: popular and royal.

The popular deities are those, like Heviosso, Sapata, Gu, Dan Ayido Hwedo, and others, who may draw initiates from virtually any sector of society. While in theory a vodun may call, or "kill," any individual to become an initiate, in fact the responsibility to serve a vodun in the Abomey area is directly linked

to kinship and is inherited by a descendant of an initiate or *vodunsi* (liter-
ally, a dependant or wife of the vodun). The servers of popular vodun are
organized into congregations, each headed by a male-female pair of *hungan*
(literally, chief for a vodun). As such, they constitute an organization crossing
kin and possibly class lines (figure 10). In addition, personal gods among the
popular vodun respond to the particularities of individual circumstances.
For example, Fa, the deity of divination, may be approached by virtually

Figure 10. Young novices devoted to the family of the vodun Heviosso.
Near Abomey, 1972. Photo: E. Bay.

anyone through a private one-on-one relationship with a diviner or *bokonon* of Fa. At a deeper level, Fa holds out the promise to all men in Fon culture to reveal and manage personal destiny. *Hoho* is the word for twin and the name of another personal vodun, one that protects twins. Mothers of twins and twins themselves often become involved with the cult of twins, which offers them protection and prosperity.

The royal vodun in contemporary Abomey are the Nesuhwe, a series of cults that honor deified members of the royal family, many of their closest associates, and the spirits of magical monsters born to the family and called Tohosu. Each branch of Nesuhwe is linked to the associates of a particular king and may include twenty to thirty deified princes and princesses (direct siblings of the king), plus ministers (male and female) and other high-ranking officials (figure 11). From a historian's point of view, Nesuhwe is a fascinating phenomenon because it memorializes the leaders of each king's reign. During annual ceremonies when the Nesuhwe vodun mount their servers, one can meet the spirits of people who were important in royal administrations as long ago as two hundred years. In contrast, Tohosu are vodun said to have

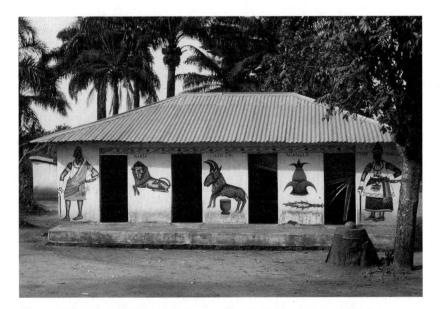

Figure 11. Nesuhwe shrine house in Abomey, 1972. Unlike most other vodun shrine structures, those of the Nesuhwe are large in size and placed in prominent sites. Cyprien Tokudagba, a self-taught artist who is internationally known, initially developed his reputation through paintings done on Nesuhwe shrines such as this. Photo: E. Bay.

been fathered by the kings but who take fantastical forms and are associated with the low-lying waters of marshes or swampy areas. The public performances for the Tohosu are joined with Nesuhwe, since both are children of the royal family.

Tohosu appear to have been honored before the creation of Nesuhwe. They are said to have made themselves known to Fon culture initially in the mid-eighteenth century as creatures born into the royal family with anomalous characteristics whose arrival demanded ritual attention. Tohosu in theory are recognized through birth abnormalities, with signs that range from hair and teeth at birth to extreme physical deformities.[5] It is claimed that Tohosu are returned to the fluid world from which they had come, for "Tohosu" means literally "king of the waters." Eldest among the Tohosu is Zumadunu, a child of King Akaba (who reigned in the early 1700s). Zumadunu was born with teeth, hair, a beard, and six eyes (two each on his forehead, the back of his head, and his chest). Able to walk and talk at birth, Zumadunu had a growth on his buttocks so enormous that it dragged after him when he moved. Within a day he had transformed himself into a ball, and then a bird, which remains his central visual symbol (Verger 1954, 189).

What accounts for the appearance of royal vodun in Dahomey, and why would a dynasty honor what appear to be its own birth defects? The potential of the vodun to assist humankind was not lost on the rulers of Dahomey. At the level of the kingdom, the monarchs needed the power of the vodun *and* their own ancestors to govern: to assure victory in warfare, to punish enemies, to make the earth fertile, and to safeguard the king's health. The successes of the kings were seen as signs of divine approval. In effect, spiritual and human powers were mutually reinforcing; earthly success meant that beings in the spirit world had helped Dahomey, and the gods and ancestors were treated to sumptuous sacrifices that in turn increased their power and ability to assist the monarchy even more. The monarchy approached the vodun in two ways. Some were embraced as allies, pampered and adored so that their power would develop in support of the kingdom. Other vodun were ignored or suppressed in the expectation that their strength would be diminished. Choices of which vodun to revere and which to restrain were made consciously as an attempt to alter power relationships among the gods for the benefit of the dynasty. But the kings were also wary of the potential political strength of the popular vodun and the earthly priests with networks of followers throughout the kingdom. The direction of manipulation by the kings therefore was toward favoring vodun that could be controlled, or at least those whose worship did not involve the regular assembling of large numbers of people.

Time and again, the kings would try to set up spirits that they could control over and above the cults headed by priests they feared. One of the most famous examples of the reordering of the invisible world happened in the middle of the eighteenth century. At that period, a very powerful woman, Hwanjile, ruled as queen mother, or *kpojito* (figure 12). A commoner and probably a slave originally from Aja country to the southwest, Hwanjile used her abilities as a priest of popular vodun to help solidify the strength of her

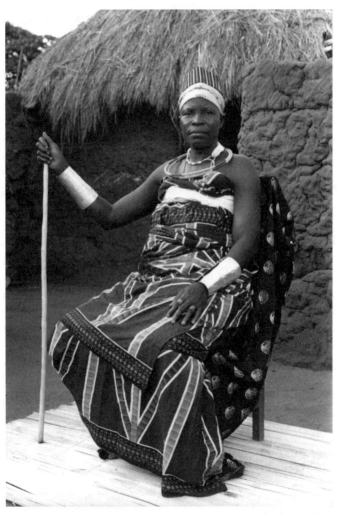

Figure 12. Daa Hwanjile, successor to the stool of the eighteenth-century Dahomean kpojito (queen mother). Abomey, 1972. Photo: E. Bay.

protégé and reign-mate, King Tegbesu. Hwanjile imported a number of vodun and set them up under her direction in the center of the city of Abomey. Among them was a pair of what generally are called "creator deities," Mawu and Lisa, who were made supreme over all the other vodun. Interestingly, the male-female pairing of Lisa (male) and Mawu (female) was not conceptually what westerners might expect of a "creator couple," for there was no sense that they were parents of any other deities. Rather, Mawu and Lisa were a governing pair that reinforced an ideological vision of power relationships at the center of the state of Dahomey. In effect, Mawu and Lisa were a couple that mirrored the rulers in the land of the visible, the powerful Kpojito Hwanjile and her reign-mate, King Tegbesu.

Mawu and Lisa reigned supreme in Dahomey in the eighteenth century, but times changed, and the rulers of the kingdom gradually saw their world in different ways. Economic depression at the end of the eighteenth century and drastic drops in revenue as the slave trade ended early in the nineteenth meant that there was much less largesse for the ruling elites to distribute. Commoners, who had played highly visible roles in eighteenth-century politics, began to be distrusted by the royal family, which increasingly monopolized material resources to its own ends. The royal family's concerns with its own well-being were reflected in turn in its promotion of vodun of royal origin. By the early nineteenth century, the Tohosu spirit Zumadunu had replaced Mawu and Lisa as head of all the vodun. King Gezo (1818–58) created a massive elaboration of royal ceremonies in honor of the deified kings and queen mothers that mimicked the possession rites of popular vodun and literally doubled the amount of time the court spent with ritual (Bay 1979).

By the mid- to late nineteenth century, ceremonies to honor common peoples' ancestors and the popular vodun, those rituals that provided the fundamental sustenance on which their strength depended, were permitted only after the completion of the long cycles of ceremonies in honor of the kings and the ceremonies of Nesuhwe (figure 13). And as the nineteenth century drew to an end, the royal family allowed common families in Abomey who aligned themselves with a branch of the royal family to begin ancestral rites with their royal Nesuhwe "kin," and rituals leading to the deification of commoners were beginning to be practiced (Bay 1998).

In short, the kings of Dahomey over the course of 150 years or so had tried to monopolize power in the visible world while they manipulated the realm of the vodun to ensure the primacy of the royal dynasty over all others, human and vodun. By making the apotheosis of the kings the central element of royal ceremonies and placing the cults of Nesuhwe into the premier position

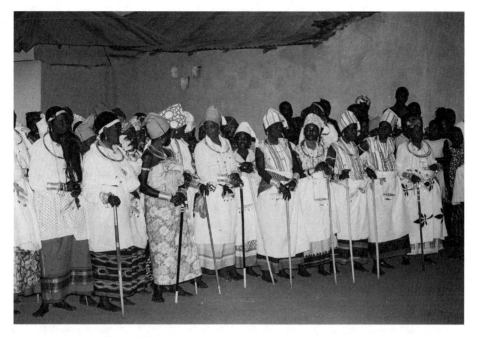

Figure 13. Members of the royal cult of the Nesuhwe before performance. Abomey, 1973. Photo: E Bay.

in the kingdom, they reached for overwhelming religious as well as secular power.[6] It is not surprising that the Tohosu, like the popular vodun who were associated with fearsome powers of nature, would have been described as monstrous beings. Indeed, the association of Tohosu with marshes and swamps, the border areas between earth and water, signaled their ability to cross between worlds, to mediate between the visible and the invisible and hence to command overwhelming power (*aché*). And elaborate ceremonies at the level of the monarchs reinforced the point that the dangerous monsters of the spirit realm were the offspring of the kings themselves and were directly related to royal power in the visible world.

Asen and the Vodun

By the late twentieth century, the word *asen* tended to be synonymous in popular thinking with the staked conical form of ancestral asen, their rounded platforms typically decorated with cut or cast metal figures. However, a variety of asen forms that include but are not limited to the standard ancestral

asen form are in fact associated with the vodun. Ancestral asen mimic the function of asen for vodun, which as a form clearly preceded them, by acting to attract and hold a spirit. Asen of all types are without exception made of metal and, as such, always contain the vodun Gu, who must be removed ritually from the metal implement before another spiritual entity can alight.

Asen for the vodun range in size from those small enough to be carried on the person of a devotee or planted on the tiniest shrine to asen of massive form, as in the case of certain examples from nineteenth-century court art. Asen associated with vodun and those linked historically to royal arts production take a variety of forms. For example, asen placed on altars for individual vodun take forms unique to that deity. An undulating iron serpent is an asen for Dan Ayido Hwedo, the serpent and rainbow vodun. The vodun's sex is always indicated by a presence of horns for the male and their absence for the female, for Dan Ayido Hwedo, like the rainbow itself, always appears as a male-female pair (figure 14).[7] Asen in the form of the familiar double-axe symbol of Heviosso (Shango in Yoruba culture) appear on shrines to that vodun. Small asen placed on the altars to twins take distinct forms associated with the circumstances of birth, while an asen whose end resembles the flat blade of the knife used for scarification is associated with Mawu (Savary 1970, 49).

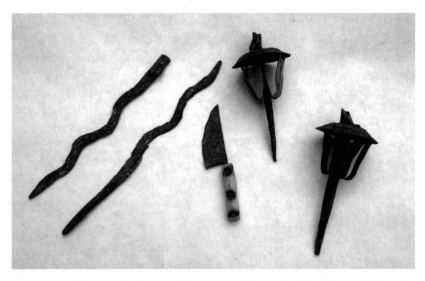

Figure 14. Small personal asen carried by servers of the vodun. The asen in the form of a knife is seven centimeters in length. Photo: E. Bay.

Perhaps most varied are the forms of asen for Gu, who by definition is present in all metals and hence can be honored through iron objects of virtually any form that can serve as asen. Gu is particularly associated with three different types of asen: the *gubasa,* or sword of Gu, a large iron weapon with a curved blade that may be decorated with symbolic engravings, patterns of cuts, or soldered iron tools; the *gudaglo,* a smaller curved blade whose handle is a bell; and the *gudjidjo,* a handheld bundle of iron implements that mimicks the conical asen form. For example, a shrine to Gu in a smithing family in Abomey presents a range of iron asen; these asen upon asen include metal parts salvaged from a car, a gubasa, nearly a dozen conical asen, and a long row of tiny hanging iron implements that bristle with power: hoes, swords, knives, files, hooks, spears, and other cutting blades (figure 15). Gu provides a link, too, to the court-art traditions of the nineteenth century, when he was honored as a central deity associated with the making of war. Numerous gubasa dating to the late nineteenth century are preserved in museum collections (figure 16). Perhaps the finest is a magnificent example created by a gifted Yoruba-speaking artist, Ekplekendo Zomabodo Glenegbe Akati. Now a prized possession of the Musée Historique d'Abomey, the gubasa is pictured in Pierre Verger's *Dieux d'Afrique* (1954, 182). With a blade studded with dozens of iron implements, the massive Asen Guma, the Asen of the Rage of Gu, was a centerpiece on which offerings were made before war and pledges sworn to vanquish the enemy.

One of the most extraordinary extant works of precolonial African art is the famous iron statue of Gu formerly preserved in the collection of the Musée de l'Homme in Paris and now in the Musée du quai Branly (figure 17). As recounted by Simon Gounon Akati, the grandson of Ekplekendo Zomabodo Glenegbe Akati, the figure was created by his grandfather as an asen to be used in the grand ceremonies that marked the final funeral of King Gezo in 1860. Following Gezo's death in 1858, his son Glele, like all Dahomean kings who preceded him, had to consolidate his control over the kingdom, eliminate at least one competing claim to the leadership of Dahomey, and demonstrate his command of visible and supernatural sources of power. Only then could he perform the final funeral ceremonies for his father and become formally acknowledged as king through the cycle of ceremonies called Ahosutanu, or Grand Customs. In effect, an incoming king had to be installed in the wake of major accomplishments, and typically there was a delay of two to four years between the time of the death of one monarch and the completion of Grand Customs. During that interim, at mid-nineteenth century, Glele launched his first war, against Anagodume, a Yoruba-speak-

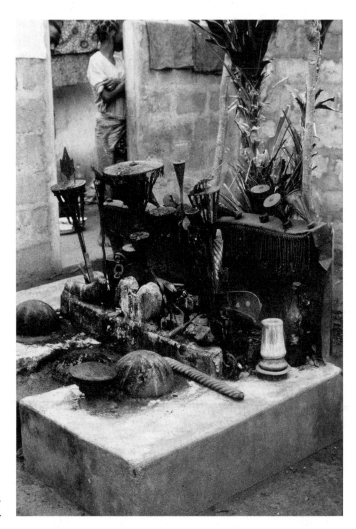

Figure 15. Altar to
Gu in the com-
pound of a lineage
of smiths. Abomey,
1984. Photo: E. Bay.

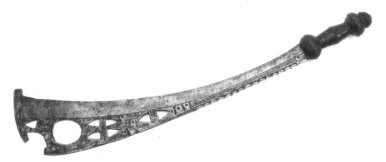

Figure 16. Gubasa, or sword of Gu. Forged iron. Length: 104 cm; width: 16 cm.
Acc. 020506. 1945. Musée d'Ethnographie de la Ville de Genève.

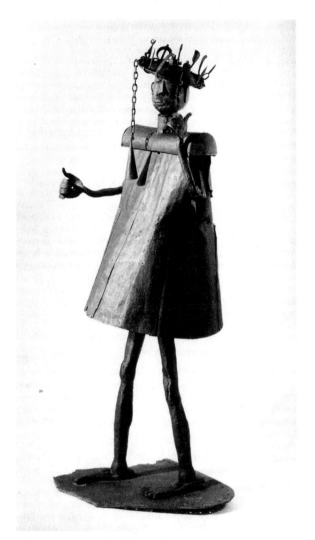

Figure 17. Statue of Gu. Mid-nineteenth century. Wrought iron and wood. Height: 165 cm. Inv. 71.1894.32.1, from the Musée de l'Homme. © Photo SCALA, Florence. Musée du quai Branly, 2006.

ing area to the east. Glele's success in warfare proved royal prowess and also yielded needed spoils of war: abundant captives to be sacrificed as part of the funeral ceremonies. But Akati adds that the Dahomean army arrived while the people of Anagodume were in the midst of ceremonies for the vodun. As a result, the Dahomeans brought back numerous leaders—priests, heads of

lineages, chiefs—and some of the vodun themselves, most notably an incar-
nation of Gu. At his triumphant return from war, Glele called Akati and told
him to create an asen that would commemorate the war and honor Gezo;
the result was the Gu figure. Pleased with his smith's success, Glele devised
a praise name for Gezo that was applied to the Gu figure: Basa glagla (liter-
ally, the arm or knife that is courageous, daring, audacious). In the words of
Akati's grandson, "With Gezo's help, Glele went off and conquered even Gu,
the god of war."[8]

The Name *Asen* and the Yoruba Connection

The name *asen* and the distinct conical form of Fon ancestral asen were
adopted from Yoruba culture, although I found no memory of the intro-
duction of asen into Dahomey. In Yoruba-speaking areas, the name and
form are associated with the orisha of medicine, Osanyin, whose knowledge
of the healing properties of leaves and herbs offers humankind relief from
physical suffering. Osanyin accompanied Yoruba-speaking peoples into the
overseas diaspora, where the deity is honored in Cuba and Brazil. Every-
where, Osanyin is associated with Opa Osanyin, iron staffs used by herbalists
(figure 18). An Opa Osanyin typically consists of an iron stake surmounted
by a circular form or an inverted cone that is topped with birds. Alternate
forms may include miniature representations of forged metal tools arranged
in conical form.

As a Yoruba deity, Osanyin has close associations with two other gods,
Ogun (Gu) and Ifa (Fa). Ogun is associated with iron, warring, hunting, and
all activities dependent upon metal tools, while Ifa presides over a complex
system of divination. Ogun's presence in iron is said to permit the herbalist
to cut his way through bush and forest to gather needed healing plants. Ifa
works with Osanyin by matching diagnoses of illnesses with appropriate
herbal remedies. Diviners of Ifa prepare medicines from plants, but the herbal
remedies are effective only when administered with particular incantations.
Those incantations, through puns and wordplay, verbally link the names of
the medicinal plants, the *odu* (or sign of Ifa) under which they are classified,
and the anticipated healing effect (Verger 1995).

In the Abomey area, a myth recorded in the 1930s by Bernard Maupoil,
whose study of Fa divination remains unsurpassed, links Osanyin under the
name *asen* directly to healing and divination:

> Quand Fa apparut pour la première fois sur terre, il demanda qu'on lui trouvât
> un esclave pour labourer son champ et versa une certaine somme à cet effet.

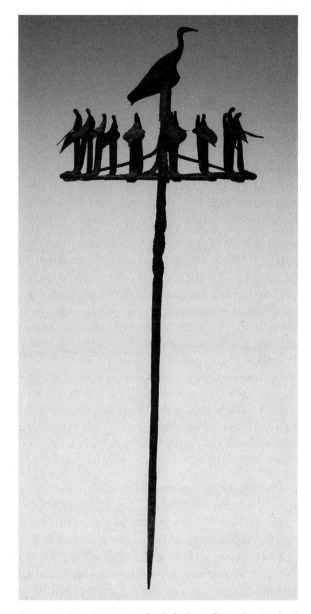

Figure 18. Opa Osanyin, or herbalist's staff. Yoruba. Michael
C. Carlos Museum. Lent by William C. Arnett.

On lui acheta au marché un esclave nommé *Asē-acrelele,* et on le lui amena. Fa l'envoya aussitôt dans son champ pour couper de l'herbe. *Asē,* au moment de commencer son travail, s'aperçut qu'il allait couper l'herbe qui guérit la fièvre. Il s'écria: "impossible de couper celle-ci! Elle est trop utile." La seconde herbe qu'il avisa guérissait les maux de tête. Il se refusa aussi à la détruire. La troisième supprimait les coliques. . . . "En vérité, dit-il, je ne puis arracher des herbes si nécessaires."

Aussitôt on alla rapporter à Fa que son esclave se refusait à couper des herbes qui avaient toutes une grande valeur et contribuaient à tenir le corps en bonne santé. Fa appela *Asē-acrelele* et le pria de lui montrer ces plantes précieuses. Et quand il eut tout entendu, il décida qu'*Asē* n'irait plus travailler au champ, mais demeurerait auprès de lui pour continuer à lui expliquer les vertus des plantes, des feuilles et des herbes.

(When Fa appeared for the first time on earth, he asked that people find him a slave to work his field, and he provided money to this effect. They bought him a slave named Asen-acrelele at the market and brought him to Fa. Fa immediately sent him into his field to cut the weeds. Asen, as he began his work, realized that he was going to cut the herb that cured fever. He cried out: "Can't cut this! It's too useful." The second plant that he noticed cured headaches. He refused to destroy that one too. The third got rid of diarrhea. . . . "In fact," he said, "I can't pull up such useful plants."

Soon people went and told Fa that his slave refused to cut the weeds, all of which had great value and contributed to good health. Fa called Asen-acrelele and asked him to show him these precious plants. And when he had heard all, he decided that Asen would no longer go to work in the field, but would live near him to continue to explain the virtues of plants, leaves and herbs.)
(Maupoil 1943, 176)

Each Fon diviner owns an iron staff (the *asen acrelele*), which is present when he consults Fa and is used to lead processions into the sacred forest, where individuals go to learn their sign of Fa (figure 19). The asen acrelele typically stands about one meter in height and is topped by a simple closed cone. Just beneath the cone, an L-shaped handle is attached, which provides a hand-hold for the asen acrelele when it is being used as a staff. The stake includes groups of small bells arranged at regular intervals along the shaft. A second, smaller asen, the *zun-sen* (literally, forest asen), is also used in forest rituals, where it symbolizes the search for medicinal leaves that is a major task of Fa and his priests. Significantly, deceased diviners may be honored and nourished by the pouring of sacrificial liquids on the asen acrelele. The living diviner "verse sur le chapeau de l'asē le liquide offert, qui coule jusqu'au

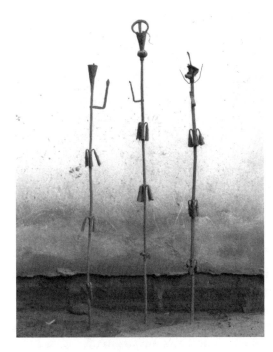

Figure 19. Asen acrelele
(diviner's asen). Private
collection, Abomey, 1999.
Photo: E. Bay.

sol" (pours the offered liquid on the hat of the asen, and it runs down to
the ground) (Maupoil 1943, 176). Upon a diviner's death, his asen acrelele is
desacralized and discarded.

Three key deities are present in both Yoruba and Fon traditions that link
the name *asen* with iron stakes and conical forms: Fa (Ifa), Asen (Osanyin),
and Gu (Ogun). For the Fon, Fa is the medium through which the healing
substances of Asen may be made efficacious, in turn through the technology
represented by Gu.

Sinuka, Sacrifice, and the Fon Cosmos

Despite this strong evidence of the origins of asen in the healing arts of the
Yoruba diviner, people in contemporary Benin do not link asen to a deity of
the same name. Rather, Fongbe speakers provide etymologies of the word that
typically suggest the manner of use of ancestral asen. Most commonly, the
word *asen* is said to derive from the phrase *a sen* (literally, you worship) or
wa sen (to come and worship) (Maupoil 1943, 174). Some add that the name

expresses the idea of offering in the form of service, since *sen* can mean to serve or to perform one's duties (Mercier 1952, 7). People typically add that asen are really *sinuka* (literally, gourds for drinking water), and occasionally someone will argue that the closed conical form of some asen is meant to represent a closed calabash.

This link in Fon thinking between ancestral asen and sinuka is one of some historical depth. J. A. Skertchly, whose account of his 1871 visit to Dahomey provides our first detailed descriptions of royal ancestral asen, appears to have been told that asen were comparable to calabashes, for he uses the terms interchangeably (1874, 381, 412, 419, 420, 429).[9] At the turn of the twentieth century, the colonial administrator and ethnographer Auguste le Hérissé similarly believed that the word *asen* should be translated "assiette des fétiches ou des morts" (plate of the spirits or of the dead) (1911, 363).

Paul Mercier, who studied royal asen preserved in the Musée Historique d'Abomey in the mid-twentieth century, claimed that the word *asen* refers to the object prior to consecration and that sinuka is associated with it once sanctifying ceremonies have been performed. Similarly, in the 1960s, Claude Savary was told that an asen is called a sinuka when in ceremonial use (1970, 49). However, I found the terms *asen* and *sinuka* used interchangeably for consecrated asen. Moreover, the technical terms given to Mercier for the two types of asen add to the murkiness of definitions. The closed cone, or *aladasen,* type, he reports, is so named because it is an older form brought with the founders of the Fon kingdom from Allada, the city from which they migrated to the Abomey plateau. He provides a second name for the closed-cone asen, *godokponon* (literally, asen like a gourd), which reinforces the popular notion that the conical form, with its flat round top, has some formal similarity to a closed calabash. In contrast, the spoked asen is called *asen gbadota* (literally, asen like a hat). On both types, Mercier claims that the flat circular top is called technically the sinuka, even though the term *sinuka* is applied also to the entire asen (1952, 7–9).[10] However, to argue a close similarity of form between the cone of an asen and the form of a closed calabash, or between the flat circular top of an asen and a gourd bowl, is to stretch the limits of imagination; a more plausible connection is through the meanings associated with gourds and the honoring of the dead.

What, then, does the word *sinuka* evoke for people in southern Benin? The sinuka is the fundamental vessel used in the sacrament of sacrifice, the bowl-like gourd on which all offerings to the ancestors and vodun are presented. As such, it symbolizes the interaction of the living with the spirits and points to a broad range of meanings that situate the living in relationship to

the spirit world, and that ultimately evoke the Fon conception of the cosmos. The closed calabash form in particular has appeared as a frequent image on asen throughout the history of the ancestral art form. Indeed, it is arguably the only image that has remained central as asen imagery has moved from honoring the deified ancestors of the royal dynasty in the nineteenth century to speaking of the relationship of the living to the dead in the twentieth.

At its commonest level, sinuka is associated with the fundamental act of welcome to a Fon home, the offering of a drink of fresh water from a small gourd. The bringing of a sinuka is a first act of greeting. The host sips from it, pours a small offering of water on the floor for the ancestral spirits, and offers the calabash to the guest, who sips in turn. The offer of fresh water is replete with significance on the streamless plateau that was the heart of Dahomey, where wells are sometimes dug to depths of fifty meters, and where contemporary houses are usually built with a cement cistern. Symbolically, the act signals the sharing of a scarce and precious substance, the trust between host and guest for their interaction, the anticipated positive communication in the cooling atmosphere of pure water, and the forthrightness promised by the witnessing presence of the host's ancestors. It is only after sharing the calabash of water that a guest states the purpose of his or her visit and a host offers further drink or food. In parallel fashion, in late twentieth-century Benin, the deho (or shrine) where the ancestral asen were kept in most common families always contained a pottery jar of water, and next to it a gourd. The first act of a family member who entered the room for any reason would be to dip the sinuka in the water, splashing it in offering on the asen (figure 20).

Living beings relate to the spirit world through the sacrament of sacrifice. Sacrifice is described through metaphors of feeding and through literal offerings of food and drink, always and only on gourd vessels.[11] Water is the essential initial offering, followed by alcohol, sacrificial blood, and a wide range of solid foods. The power to act is gained through nourishment, and feeding is a fundamental metaphor that describes the empowerment of beings in the world of the unseen and of the seen. Bernard Maupoil succinctly described the relationship of mutual interdependence between vodun and humanity in Fon areas:

> Par leurs prières et leurs sacrifices, les hommes "donnent de la force aux vodũ." Plus les offrandes sont nombreuses et magnifiques, plus les divintés ont de force, meilleures sont leurs intentions; si leur nombre décroît, les vodũ s'affaiblissent.

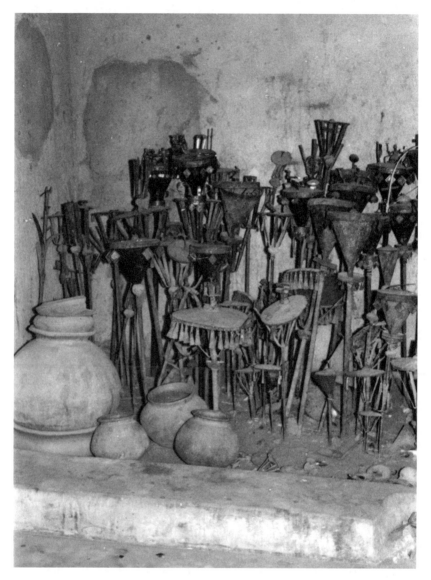

Figure 20. Deho with pottery jars for ritual water. Abomey, 1984. Photo: E. Bay.

(By their prayers and sacrifices, people "give strength to the vodun." The greater and more numerous the offerings, the more the deities have power, the better their intentions; if their number decreases, the vodun weaken.) (1943, 57)

Ancestors are of a different, lesser, order than the vodun. Yet, as Beninese point out, they are venerated because "ils intercèdent auprès des divinités

pour le bien des leurs, et parce que leurs conseils protègent contre les dangers" (they intercede with the gods for the good of their own family members and because their advice protects against dangers) (Falcon 1970, 150). Feeding, then, is a metaphor of reciprocity. As with living beings, sacrificial foods nourish and strengthen, allowing the unseen to reciprocate with blessings, so that the dead, having been fed, in turn can empower the living (figure 21). Sacrifice involves the principle of communion with the other world. People commonly point out that the dead, and the vodun, eat "invisibly" the essence of the sacrifice, and once they have dined, the living similarly consume the strength-giving substances, always in rank-order of age. In impact, "Le sacrifice est un acte social" (sacrifice is a social act) (Maupoil 1943, 58).[12]

Sacrificial foods are always offered on gourds. For example, the blood of sacrificed animals is collected in a small gourd, then poured on asen or other altars, or applied by fingers dipped and stroked onto surfaces by officiants. Calabash bowls of beans, a favorite food of many vodun, are left before shrines, and the annual offerings to the ancestral dead arrive in massive gourds. At the time of the annual feeding of the ancestors, the sacred courtyards in front of common families' deho are typically jammed with calabashes of beans, stews, loaves of bread, mounds of the maize- or yam-based staple commonly called *pâte,* and leaf-wrapped balls of cassava-based *akasú.*[13] The Dahomean kings continue to eat once during each four-day Fon week; the women who feed them walk to the royal tombs in the central palace at Abomey, carrying on their heads large closed calabashes of food wrapped in print cloth (figure 22). A modernized pair of sinuka are built into the cement floors of the tombs of recent kings. The tomb of King Behanzin, for example, is a circular house containing in its interior an iron single bed. Behind its head are molded two calabash-shaped depressions—called *sinuka*—where the *tassinon* (elder women) of the family offer sacrifices and pray.

Depictions of gourds on ancestral asen recall and reinforce the principle of sacrifice and offering. Kneeling female figures often hold large calabashes, either closed or open, before seated figures that represent the dead (figure 23). The kneeling stance, which may be assumed by women or men, is one in which the younger show respect for elders, in which individuals visibly demonstrate rank within families: children to parents, wives to husbands, adults to ancestors. Alternatively, one or more seated ancestors may be shown before a gourd, again signaling the offering of sacrifice to the dead.

An ambiguous asen representation of a closed calabash points to yet another level of sinuka meaning and to the cosmic dimensions of asen iconography. One of the asen preserved in the Abomey palace museum, nearly all of which date to late in the nineteenth century, shows a closed calabash

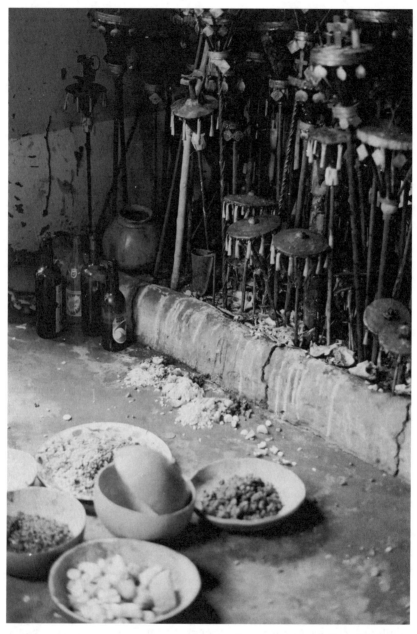

Figure 21. Food left on calabash vessels for the ancestors. Note soft-drink and beer bottles in background in front of the pottery vessel for water. Abomey, 1984. Photo: E. Bay.

Figure 22. Women of the royal family carry food for the deceased kings in massive cloth-covered closed calabashes. Simboji Square, in front of the main entrance to the central palace. Abomey, 1972. Photo: E. Bay.

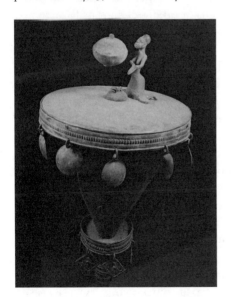

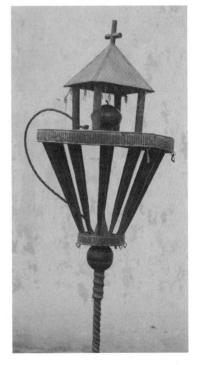

Figure 23. Asen tableau showing a kneeling female figure holding a closed calabash. William Arnett Collection.

Figure 24. Royal asen from the Musée Historique d'Abomey. Photo: E. Bay.

underneath a roof supported by four round pillars. A cross stands at the apex of the roof, while a braided cord links the base of the calabash to the bottom of the spoked conical asen form (figure 24). Like other royal asen, this one is made of precious metals: the roof is silver, and the columns are wood covered with a sheath of silver; the framework of the building is copper; and the braided rope is made of two threads of iron and one of silver. Paul Mercier in 1952 claimed that this asen was dedicated to all the kings. He commented that its exact interpretation is unclear, though "[l]a calebasse représent ici le monde" (the calabash here represents the world) (1952, 26). By the time of my fieldwork on asen in the mid-1980s, this same asen was on public display in the palace museum and was attributed to the reign of King Agaja (ca. 1716–40). Museum guides reported that the asen commemorated the establishment of a Catholic chapel during the reign of that king. When told that the cross symbolized the religion of the Europeans, the king is said to have ordered the addition of the gourd as a symbol of the religion of Dahomey.

Whatever the relative accuracy of these attributions or interpretations, the information gathered by Mercier and the interpretation given to me some thirty years later point to a vision of the cosmos that was articulated in the mid-1930s by Gedegbe, the aged Yoruba-speaking diviner of Fa who had been personal advisor to Kings Glele (1858–89) and Behanzin (1889–94). For Gedegbe, the cosmos was in form like a closed gourd, in the interior of which are earth, sky, waters, and the realms inhabited by the vodun and the dead. Earth is a flat surface that floats on waters at the point where the calabash top meets the bottom (figure 25). The sky and heavenly bodies are on the inner surface of the calabash lid, and most of the dead live in an indeterminate space somewhere above the surface of the earth. The vodun, along with "the best" of the dead, occupy a world called Ifè, which is located underneath the earth's surface (Maupoil 1943, 62–63).

The word *sinuka*, then, evokes multiple meanings associated with the gourd, the central vehicle symbolizing communion and communication with the unknown, with the worlds of the ancestors and vodun. The sinuka holds the substance of sacrifice, plays the essential role in the process of offering, and hence symbolizes the sacred interaction of the living with the dead, of humanity with the vodun. The asen plays a central role in that same process; as in the case of the sinuka, the purpose of an ancestral asen lies in the process of sacrifice, in the meeting of the invisible with the visible. Asen are used in conjunction with sinuka, yet they do not supplant or replace sinuka, even though food and drink are literally offered on the

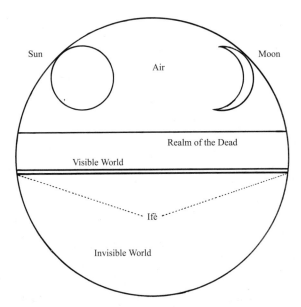

Figure 25. Adaptation of a cosmological diagram proposed by
a royal diviner of Fa that compares the universe to a closed
gourd (Maupoil 1943, 62).

platform-top of asen. The similar yet subtle distinctions in the two kinds of
sacred sacrificial object simultaneously point backward, to the question of
origins of ancestral asen, and forward, to the reasons why Fon peoples may
be deciding to discontinue their use. We first turn to origins, to the inven-
tion of ancestral asen.

2

The Invention of Ancestral Asen

One of the most salient concerns of rulers the world over is that of
sustaining an aura of majesty and mystique.

—Suzanne Preston Blier

The name Asen is homologous to the name Osanyin, the Yoruba
deity of herbal medicines. As a visual form, the asen is an object made of
iron that may vary widely, but that most commonly consists of a pointed
stake with a coniform top. When, why, and how did the asen name and
form become a central element in the honoring of ancestors of the Fon? The
form is borrowed from Yoruba culture, yet asen are not used by the Yoruba
to honor the dead, even though the Yoruba use of sticks (or *cyon*) has been
called a comparable practice (Interviews with Voyon, 9 August 1984; Ada-
mon, 29 September 1984; Ahossi, 5 September 1984).[1] Asen in use on shrines
to vodun tend to take one of two forms: flat-topped undecorated coniform
asen, or simple wrought representations of symbols of the deity. How was it
that twentieth-century ancestral asen came to be elaborated with multitudes
of figures and other decorative and symbolic elements?

Early travelers to the Slave Coast describe shrines and altars, invariably
linking them to deities or "fetishes." Sacrifice is always noted as the central
element of worship. For example, in describing the kingdom of Allada in the
mid-seventeenth century, Olfert Dapper notes that

> "[t]outes les personnes de qualité ont leur Fetisseros, qui sont les prêtres de
> leur famille. Quand quelqu'un de la maison est malade, on mande un Fetissero,
> qui vient immoler des boeufs, des moutons, des poulets, et arrose du sang leur
> Fetisi, qui n'est d'ordinaire qu'un vieux pot de terre, ou quelque patte cachée
> sous une corbeille. . . . Chaque famille a pourtant une assemblée particulière
> tous les six mois, pendant laquelle le prêtre fait plusieurs aspersions aux Fetisi
> qui est couvert d'un pot percé. Si l'offrande n'est pas assez grosse aux yeux du

prètre, le Fetisi ne dit mot, ce qui marque qu'il est en colère, pour l'apaizer il faut doubler la doze, et donner de nouveaux des poulets, des chevreaux et de la bière. Lorsque le Fetisi ou plutôt le prètre est satisfait, on entend une voix fine et déliée qui répond qu'oui. . . . Après quoi le maitre ayant fair remplir un toneau de bière et un sac de farine, lui en fait présent. On en verse un plein verre en l'honneur du Fetisi, auquel toute la famille promet un fidèle obéissance. On boit encore un pot de bière ensemble et chacun se retire."

(All persons of quality have their fetishers, who are the priests of their family. When someone in the household is sick, they call a fetisher, who comes to immolate cattle, sheep, chickens, and who sprinkles blood on this fetish, which ordinarily is only an old pot of earth, or some animal paw hidden under a basket. . . . Each family, however, has a special gathering every six months, during which the priest makes several aspersions on the fetish, which is covered with a pierced pot. If the offering is not large enough in the eyes of the priest, the fetish says nothing, which means it is angry; in order to pacify it, they have to double the dose and once more give it chickens, goats, and beer. When the fetish, or rather the priest, is satisfied, they hear a delicate slight voice that responds yes. . . . After that, the master, having had a vessel of beer and sack of flour filled, presents it to him. They drink a full glass in honor of the fetish, to which the entire family promises faithful obedience. They drink yet another pot of beer together, and then everyone withdraws.) (qtd. in Verger 1957, 41)

While nearly all of these early accounts mention only shrine objects in unbaked clay, pottery, or wood, one European who visited Savi, the capital of the coastal kingdom of the Hwedah, around 1714 notes the use of metal shrine objects that clearly resemble asen:

Les Negres un peu hors du commun ont chacun chez eux leur Dieu particulier non compris le general, ce sont des morceaux de fer en cloches sur lesquels il y a diverses figures en relief, ces cloches tiennent a des branches de fer qu'ils piquent en terre; des pots de terre et autres choses pareilles, c'est sur ces fetiches de fer qui ont un morceau de fer ou une pierre dedans pour fair du bruit et sur ces pots qu'ils respandent les sang des animeaux qu'ils leur sacriffient dans leurs maisons

(The somewhat higher-ranking blacks each have in their home their own God, not including the general one, these are pieces of iron in the form of bells on which there are different relief figures, these bells fit on branches of iron that they stick in the ground; some clay pots and other similar things, it's on these iron fetishes that have a bit of iron or a stone inside to make noise

and on these pots that they pour the blood of animals that they sacrifice in
their houses. (AOM)[2]

Two things are notable about these early accounts. First, they link the build-
ing of shrines and the use of sacred paraphernalia specifically to people of
some wealth. The Savi visitor even goes so far as to contrast the well-to-do
with poor country folk who, he argues, focus their ceremonies on small trees.
Second, they stress "fetishes," rather than ancestral spirits, as the object of
sacrifice and ceremony. What is unclear is whether any of these shrines may
have honored the collective family dead.

By the mid-nineteenth century, visitors to Dahomey regularly describe
shrines at homes and along roads, but virtually always erected in honor of
some deity or "fetish." However, the practice of "spreading a table" for the
ancestors by that period had become part of common parlance. Yet no one
mentions either shrines for the dead or metal objects as a centerpiece for
ancestral devotion. The earliest writer to record the name *asen* appears to have
been the Victorian explorer Richard F. Burton, who made an official three-
month visit to Dahomey in 1863–64 as an envoy of the British government.
Within Burton's two volumes of extensive observations are three mentions
of asen. The first two are to tiny asen that were part of a shrine in the interior
of Burton's lodgings in Abomey, dedicated respectively to honoring twins
and averting disease. The third mention, in a general chapter on religion,
is to burial practices: "When a human sacrifice is made the head is placed
upon the grave, and the body is interred alongside of the corpse so honoured.
Usually they plant over the dead an Asen, or short cresset-shaped iron, upon
whose flat top water or blood, as a drink for the deceased, is poured" ([1864]
1893, vol. 4, 108).[3] Burton is echoed by J. A. Skertchly, who visited Dahomey
in 1871. He notes that a new grave, prior to the completion of final funeral
ceremonies, would be marked: "[T]he grave is filled up and smoothed over
with swish, and usually some token, such as a cresset-shaped iron, is set up
upon it, and upon certain days offerings of water and food are made upon
the shrine" (1874, 501).[4]

Burton uncharacteristically shows no curiosity about the etymology of
the word *asen*. A polyglot, he worked hard to learn a good deal of language
during his brief stay in Dahomey, and he takes care to explicate nearly all of
the words in Fongbe that he includes in his text, often noting comparable
terms in Yoruba. Perhaps the diminutive size of the asen in his quarters
in Abomey made him assume that they were objects of little significance;
from the context it is clear that he did not witness the placing of an asen on

a grave. Burton appears to have seen larger asen at court, but he does not connect them to the name of the smaller shrine objects that he describes in his temporary home. For example, he describes court "fetishers" carrying objects that appear to have been asen: "The second party, consisting of ten men, bore in their hands as many iron fetish sticks, from 4 feet to 6 feet long, capped mostly with a barrel cone like a modern Moslem cresset, apex downwards, and topped with rude iron imitations of land tortoises."[5] Burton at five additional points mentions "fetish sticks of iron," "huge cressets," or "iron sticks," but he never links them to asen, nor does he record the word *sinuka* ([1864] 1893, vol. 4, 4, 37, 80, 83, 145). In short, despite being an indefatigable ethnographer, Burton left Dahomey having learned only that asen are small shrine objects and that sometimes they are placed on a grave. We will return to his account shortly, for Burton missed an opportunity to clarify the point at which ancestral asen appeared in the ritual life of the kingdom.

J. A. Skertchly was an entomologist who traveled to the Gold Coast some seven years after Burton's visit to Dahomey to make zoological observations and collect scientific specimens. Unable for political reasons to work there, he moved east, expecting to do his collecting along the coast of Dahomey, and arrived in Ouidah in July 1871. When Kpadonu Quénum, the head of the king's traders, asked him to go to Abomey for a week to demonstrate the use of a new shipment of firearms, the affable Skertchly agreed. Perhaps because his attitude differed so much from the arrogance of Burton, "Kerselay" became a favorite of King Glele, who made him a prince of the realm and insisted that he remain in Abomey to witness, sketch, and record details of the cycle of annual ceremonies known as Hwetanu, or Customs. Frustrated at being unable to do his scientific work, Skertchly nevertheless spent more than four months in the capital meticulously recording details of ceremonies, including our first descriptions of the use of royal ancestral asen (figure 26).

Skertchly was present on several occasions when asen were dedicated publicly, while King Glele explained the meaning of their figurative motifs to the assembled courtiers. One asen, for example, "consisted of the usual extinguisher-shaped cresset, with a long stalked cover above it, upon which a silver ball rested. To the iron rod supporting the cresset, . . . a combination of a gun and a hoe stuck out at an angle with the upright." Glele explained that the ball referred to a children's game in which one child would hide balls in the hand, asking others to guess how many balls were held, and no one knowing for sure until the hand was opened. "So he [Gelelé] is the ball which his father Gézu held in his hand during his life; and though every per-

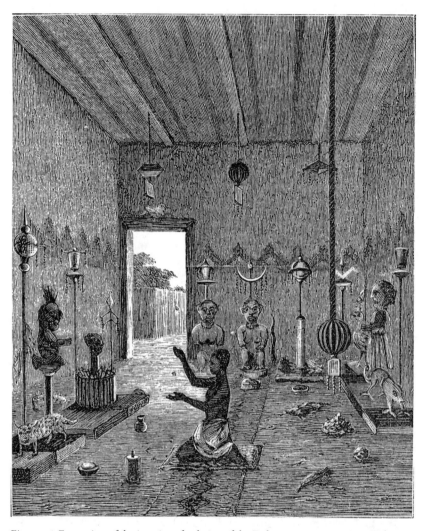

Figure 26. Engraving of the interior of a shrine of the Dahomean crown prince Hahansu. Note the juxtaposition of asen with statues, some of which were likely carved of wood and sheathed in metal. Abomey, 1871 (Skertchly 1874, 463).

son knew that he would be king, until Gézu died, and thus opened his hand, they did not know what sort of king he would be." The image was a comment suggesting the positive effects of a major change in the process of succession in the kingdom, for Glele was the first king of Dahomey to be designated heir by his father and to successfully gain power. Similarly, the combination

gun and hoe affixed to the same asen represented a moral imperative to a kingdom in which commercial agriculture was being promoted along with war. Glele explained that "men must till the soil to raise food, but they have always plenty of war palaver going on, so that when a man went to work in his field he first looked this way and that way to see if any enemies were in sight" and thereafter frequently paused to look around. The combination gun and hoe signaled enemies that Dahomeans were constantly ready and, not incidentally, signaled Dahomeans that even warriors might be expected to till the earth (Skertchly 1874, 428–29).[6]

Skertchly initially saw a royal ancestral asen in use during the So-Sin portion of Customs, in association with the deho, or house of prayer, for King Gezo:

> The shrouded hut, or Gézuyeho, was then unswathed, revealing a square shed closed by matting on three sides, and open to the front. The posts were spirally draped with green and white chequered cloth; while two umbrellas of same material were opened as a verandah before the door. Within it was a large Asen, wrapped up in white calico, and a couple of Tansino, or Ghost-mothers, kept watch beside it. . . . This strange building was supposed to contain the spirit of King Gézu, and the monarch alone is permitted to remove the calico which enshrouds the iron extinguisher within its sacred walls. (1874, 202)

Asen used in royal ceremonies continue up to the present to remain covered with cloth until their unveiling at the moment of prayers, when their surfaces are exposed to receive the spiritual essence of the dead (figure 27).[7] The office of Tansino (Tassinon) still exists, its ranks filled by women who are daughters in the royal family and who officiate in the performance of prayers for the deceased kings. Skertchly was also told that Tassinon were trained to receive the spirits of the kpojito, the female reign-mates or "queen mothers" of the various kings (1874, 208). In this, their function was parallel to a second group of initiated women, those that he termed Bassajeh, spirit mediums whose ceremonial function was to become possessed by the spirits of the kings.[8]

Skertchly saw the uncovering of asen as prayers and sacrifices were made to the kings during a series of rituals called Sin Kwain (literally, water sprinkling), when water ceremonially carried by female members of the royal lineage from the sacred Dido spring was offered to the deceased monarchs.[9] During the Sin Kwain cycle, the living monarch visited the outlying royal compounds of his predecessors in turn, spending a few days at each, while

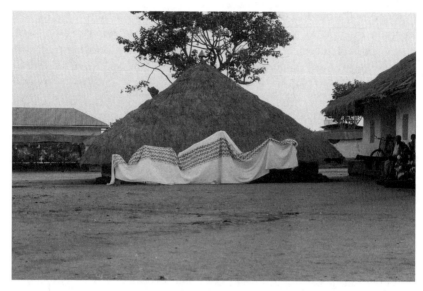

Figure 27. Deho in Abomey's central palace prior to ceremonies in honor of all the kings, 1972. The cloth covers a series of asen dedicated to the monarchs of Dahomey. Photo: E. Bay.

"[t]he spirits of the deceased monarchs are invoked and solicited to lend their aid to the living representative, by the sacrifice of men and animals, whose blood is sprinkled not upon the tombs, but upon the mysterious fetiche-irons which are swathed in calico envelopes and guarded in the spirit-houses of each of the kings" (Skertchly 1874, 391). In fact, the ceremonies in 1871 were clustered, so that Sin Kwain was performed in only three sections: for the initial three kings together—Daho (Dakodonu), Aho (Wegbaja), and Akaba—and then for the next four kings—Agaja, Tegbesu, Kpengla and Agonglo—and finally for the reigning king's father, Gezo.[10]

Skertchly provides the most detailed description of the first of these Sin Kwain ceremonies, those for Daho, Aho, and Akaba. Entering an inner court-yard of what is called the palace of Dahomey, Skertchly saw three circular thatch-roofed buildings, which he describes as the tombs of the kings but which in fact were deho (figure 28). Atop each structure was a *hotagantin* (literally, iron tree on the head of the house), yet another form of asen. The three hotagantin asen were elaborately fashioned of precious metal and topped with bird motifs, the latter made of wood covered with a thin silver skin:

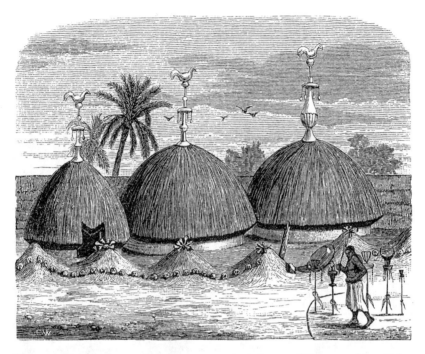

Figure 28. Ritual structures (deho) for ceremonies in honor of Dahomean kings Daho, Aho (Wegbaja), and Akaba, believed by J. A. Skertchly to be the tombs of those kings. In the right foreground are asen being used in Sin Kwain ceremonies, 1871 (Skertchly 1874, 392).

> The summit of Aho's tomb was crowned by a silver ornament represent-
> ing an umbrella with fetiche ornaments supended from the lappets by silver
> chains. On the top of this, supported by a tall stand, was a silver cock. Daho's
> tomb was likewise decorated with a similar ornament. The apex of the mau-
> soleum of Akabah was crowned by a silver wheel placed horizontally, with
> a silver affair like an elongated acorn rising from the axle; on the top of this,
> the umbrella-shaped ornament upbore a third silver chanticleer. (Skertchly
> 1874, 392–93)

Roughly three yards in front of the three structures stood three asen "of enormous size," all covered with cloth. "These are supposed to be the spirits of the three kings, and they are the fetiches which are sprinkled with Nesu water and blood during the Custom" (1874, 393).

Skertchly found the court engaged in an intense debate in the spiritual presence of the royal ancestors, arguing about ways to approach and capture

the Dahomeans' nineteenth-century military nemesis, the city of Abeokuta. After listening for some time, King Glele came into the courtyard center, where he interacted with two groups of women spirit mediums: the Bassajeh, possessed by the spirits of Glele's eight predecessors, and the Tassinon, similarly possessed by the monarchs' reign-mates (figure 29). "The king took each

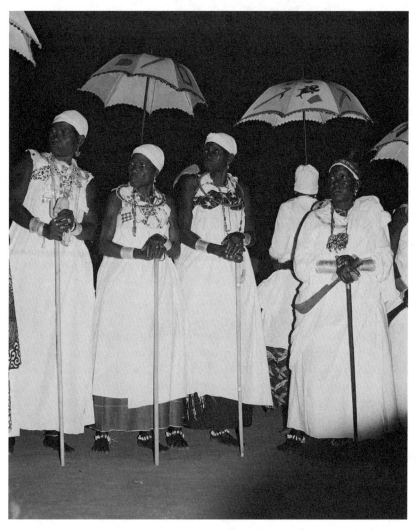

Figure 29. Daasi, women trained to receive the spirits of the deceased kings (called Bassajeh by Skertchly), on the fourth day of ceremonies. Central palace of Abomey, 1972. Photo: E. Bay.

of the Bessajeh by the hands, and raising them to a level with their faces, in this way shook hands with his deceased ancestors. . . . He then held a long conversation with his ancestors in a low voice, and finally, again shaking hands all round, the Bassajeh retired, and a similar performance was gone through with the Tansino." After the king had given the deceased kings and kpojito offerings of rum, cowries, and cloth, they responded through the bodies of the possessed women, "who delivered the answers of their indwelling king-spirits in an oracular manner," telling Glele that he should attack Abeokuta (1874, 394).

On the following day, Skertchly watched as sacrifices were made before the three asen, "which were unswathed and a trench about a foot deep dug round each." Rum, water, and the blood of a sacrificed man and numerous animals were sprinkled on the asen "until the ground in the neighbourhood of the Asen was literally a sanguinary swamp." Finally, tables for each ancestral king were brought out and covered with cooked food and fruit, so that "the feast of the deceased monarchs commenced," followed by a sharing of food with all the assembled spectators (1874, 396). Skertchly's final experience of ancestral ceremonies was a visit to the home of the heir to the throne, Hahansu, where an abbreviated version of the monarch's Sin Kwain was performed: "To the right a small shed covered a large asen, and before this a number of ducks, sheep, fowls, and other animals were decapitated, and their blood sprinkled on the asen. Grog and cowries were then distributed to the people" (1874, 440–41) (figure 30).

Though he was the first European to describe ancestral asen, Skertchly was not the first to record an account of Sin Kwain. Frederick Forbes, a British naval envoy who witnessed Customs in 1850, was first to mention the ceremony, which he spells phonetically Se-que-ah-ee, and which he claims was instituted by King Agaja (ca. 1716–40) (Forbes [1851] 1966, vol. 2, 88). Forbes followed the court through the multiple sites of Sin Kwain, including the ceremonies performed in honor of the kpojito. Like Skertchly, he writes in most detail about the initial Sin Kwain in the palace of Dahomey, describing "three small thatched mud huts, and in the doorway of each was a pillar of cloth. Each hut was surmounted by a large silver ornament, and encircled by thousands of human skulls, thigh, jaw, and other bones" ([1851] 1966, vol. 2, 92). The "large silver ornament" is clearly a description of hotagantin asen, but if other asen were present, Forbes makes no note of them. Rather, he concentrates on a long debate about warfare and military targets that parallels Skertchly's description of debate in the spiritual presence of the kings and kpojito. Forbes presumably misses the offering of water, sacrificial blood,

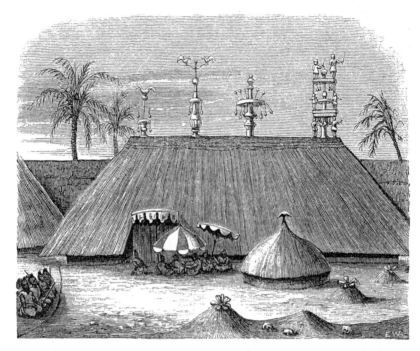

Figure 30 Ritual structure (deho) for ceremonies in honor of Dahomean kings Agaja, Tegbesu, Kpengla, and Agonglo, believed by J. A. Skertchly to be the tombs of those kings, 1871. Note the four elaborate hotagantin asen along the roof line (Skertchly 1874, 399).

and food to the spirits of the king, for he leaves the ceremony at three in the afternoon, having learned that human sacrifice was about to take place.

Burton's stay in Dahomey fell between those of Forbes and Skertchly and shortly after the installation of King Glele as successor to Gezo. He knew about Sin Kwain and insisted on attending. Irritated when the Dahomeans made him wait outside the walls of the palace of Dahomey while they completed a portion of the ritual, Burton left, though he noticed several hotagantin showing over the top of the walls and recorded a description of Sin Kwain given to him by a witness. "An enclosure of cloth surrounded the stool, or some similar relic of the departed; a Tansi-no woman entered within it and prayed; and lastly, the King, after performing his orisons, sprinkled on the ground, to the right of the throne, rum, water, and native beer" ([1864] 1893, vol. 4, 116).

What can we draw of the history of ancestral asen from these descriptions? How old was the tradition of use of royal ancestral asen when Skertchly wit-

nessed it in 1871? Did Forbes see ancestral asen in 1850, perhaps wrapped in cloth, and simply not mention them? Does Burton's secondhand account from the 1860s of "a stool, or some similar relic," in fact refer to an asen? Clearly, the ambiguity of descriptions and the silences of Forbes, Burton, and virtually every other visitor to the kingdom before Skertchly make it impossible to prove the use of elaborate ancestral asen before the 1870s. Is it likely, or even possible, that ancestral asen could have been in use to honor the kings from the earliest days of Dahomey? Is the lack of evidence until Skertchly's arrival simply because no visitor was perspicacious enough to notice ancestral asen? Even more, since small asen were used in the nineteenth century as grave markers for the non-royal dead prior to final funeral ceremonies, might ancestral asen have existed throughout Fon culture, at all social levels, as was true by the mid-twentieth century? We cannot prove a negative—that ancestral asen did *not* exist prior to the nineteenth century, either for kings or commoners—but we can find a good deal of evidence suggesting two things. First, ancestral asen for the kings and kpojito were almost certainly invented in the nineteenth century. Second, elaborate ancestral asen comparable to those used at the level of the royal family were not in use by common people prior to the twentieth century, and it is unlikely that even simple undecorated asen were in use by simple folk for "feeding" their ancestors before the colonial period.

Gezo, who ruled from circa 1818 to 1858, was known as a remarkable innovator and reformer, a giant among the kings of Dahomey. Having begun his reign by freeing the kingdom from a tributary relationship with the Yoruba empire of Oyo, Gezo profited from the civil wars in Yorubaland that followed in the wake of Oyo's collapse, warring and selling captives when possible but otherwise settling Yoruba slaves on plantations to produce the palm oil that Europeans accepted as "legitimate" commerce. More importantly, Gezo was a renowned patron of the arts, establishing artisans and musicians in Abomey, providing them with land, palm groves, slaves, wives, and other gifts so that they could concentrate on producing works solely for the king and court. Many of those artisans were Yoruba speakers; the Azanli Quarter of Abomey, for example, is today peopled with descendants of Yoruba slaves brought to Dahomey in the nineteenth century.

Visitors to court by the 1840s described locally made as well as imported artistic treasures paraded as part of the kingdom's wealth, and descendants of smiths of the period tell of intense efforts to create new artistic forms and adopt new technologies, particularly at moments of the grand ceremonies that came with the succession of new kings. Artistic innovations are cred-

ited to the monarch himself, so Gezo, for example, was reputedly the inventor of hotagantin asen, the designer of a glass coach on wheels seen in use at midcentury, and the creator of a massive piece of cloth that supposedly contained a sample of every fabic ever imported into the kingdom (Mercier 1952, 15; Forbes, [1851] 1966, vol. 2, 65; Skertchly 1874, 341; Bay 1998, 127–28). Continuing the tradition of artistic innovation, Gezo's son Glele is credited with the creation of the Gubasa, the sword dedicated to Gu with its engraved markings and blade of cutout designs, and of course the famous Gu figure currently housed in the Musée du quai Branly.

The flourishing of artistic creativity in the first half of the nineteenth century was paralleled by a dramatic expansion of ceremonial life. A partial list of the ritual "inventions" attributed to Gezo includes the establishment of the Oyo Customs, which took place in the town of Cana where tribute to Oyo had formerly been paid; the Gun Custom, which involved the firing of a succession of guns by sentries spaced along the entire sixty-mile route from Abomey to Ouidah, with the sound traveling wavelike to the coast and back; the Customs for the king-as-prince, rites that were mistakenly interpreted by visitors as honors for a "King of the Bush"; and the ceremonies called Sin Kwain, which, as we have seen, featured the use of ancestral asen (Bay 1979; Bay 1998, 214–22; Skertchly 1874, 421). The ritual innovations of the reign of Gezo were part of a larger spiritual reordering in the kingdom. As described in chapter 1, religious practices in Dahomey were changing in the early years of the nineteenth century in part as a continuation of processes of consolidation of ritual-political control by the dynasty.

With the decline of the overseas trade in slaves and corresponding economic decline in Dahomey at the turn of the nineteenth century, the ruling lineage began an ideological shift that anchored the dynasty even more securely at the religious center of the kingdom. The cult of the Nesuhwe, which deified certain ancestors of the royal family, became the vehicle for this augmentation of the royal lineage's place in the religious order, and Sin Kwain was directly related to Nesuhwe rituals. The drawing of water from the Dido spring near Abomey as described by Skertchly, for example, remains the essential first step in the opening of the Nesuhwe cycle of ceremonies (figure 31). Nesuhwe involves the possession of adepts, or vodunsi, by deified ancestors, who retain control over their descendants over several days of ceremonies. In effect, Sin Kwain in the precolonial period was the first stage in the cycle of Nesuhwe ceremonies, which would have taken place in the various quarters of Abomey following the completion of Customs or Hwetanu by the king.

Figure 31. Women returning from the Dido spring with sacred water for
the Sin Kwain ceremonies. Near Abomey, 1972. Photo: E. Bay.

The institution of the annual royal ceremonial cycle of Hwetanu is attrib-
uted to the reign of Agaja (ca. 1716–40). The practice of Nesuhwe, how-
ever, began later, imported from Mahi country to the north after Tohosu,
monstrous spirit-children fathered by the kings, were said to have created
disturbances in Dahomey during the reign of Tegbesu (1740–74). The ances-
tral spirit-figures honored by Nesuhwe include Tohosu and certain leading
sons and daughters of the kings, all of whom are organized into chapter
houses by reign. In effect, Nesuhwe in late precolonial Dahomey operated

as a mechanism for the deification of politically important individuals in the kingdom, persons in addition to the kings and kpojito themselves. By the late nineteenth century, Nesuhwe had become the central cult in Dahomey and was being used by the monarchy to order and control vodun not directly linked to apotheosized ancestors. No annual ceremonies for any vodun could take place until completion of Customs and the Nesuhwe cycles in the various branches of the royal family. Commoner families, however, if linked to one or another branch of the royal family through ties of patronage, could honor Tohosu in their own families at the time of the Nesuhwe celebrations of their patrons' branch of the royal line. In effect, the changes in religious practice by the second half of the nineteenth century worked to enhance the importance of ancestors generally, to enlarge the numbers of ancestral vodun, to promote their recognition and honoring through ceremony, and to subordinate and weaken the so-called popular vodun such as Sakpata and Heviosso (Bay 1998, 250–59; see also Hérissé 1911, 119; Verger 1957, 552–60).

The nineteenth century also saw the rise to preeminence in Dahomey of the geomancy of Fa, which had previously been only one of several competing systems of divination. Fa was growing in importance during the reign of Gezo, but Glele's accession signaled the elevation of diviners, or bokonon, of Fa to a central political position in the new administration as close advisors to the kings. Fa's importance was enhanced too by the presence of large numbers of Yoruba-speaking wives in the households of Dahomean princes, and numbers of sons of the royal family were sent to Yorubaland to train as diviners in their mothers' families (Bay 1998, 190–91). Fa was of course directly linked to the medicinal leaves of Osanyin/Asen, and it would have been an easy and perhaps obvious step for the dynasty to appropriate the tall asen form of the asen acrelele and its association with the healing properties of the vodun. Rites that centered on an emblematic object like an asen, a form borrowed from the worship of the vodun but enlarged and elaborated with rich motifs, would have visually reinforced the divine nature of the royal ancestors. Moreover, appropriation of a form in common use for honoring the vodun, and a form prominent in monumental size in the practice of divination, would have appealed to a dynasty that had struggled over the years to control and contain the potential political power of vodun, their priests, and their congregations. Glele, for example, hinted at the tensions between popular vodun and the dynasty when he told Skertchly that "his father Gézu had told him that if he made two calabashes [asen] for him, when his spirit came to drink it would come to the calabashes, and would

there tell him if he would be successful in his undertakings, so that he need not be deceived by the fetiche people" (1874, 381).

Our evidence thus points to the nineteenth century as the likely period of adoption and adaptation of asen forms for the honoring of royal ancestors. The combination of greater emphasis on the glorification of deified ancestors of the kings and kpojito, the expansion of royal ceremonies, the increased importance of Fa divination with its distinctive tall asen form, and the flourishing of arts under the patronage of the kings makes the introduction of the royal ancestral asen in this period very likely.[11]

But what of the question of ancestral asen use by common folk? The descendants of the kingdom's royal artisans insist that elaborate ancestral asen, and even simple asen, were forbidden at lower levels of society until the twentieth century (Interviews with Agbakodji, 3 August 1984; Akati, 9 August 1984). Moreover, the importation of iron and other metals needed to manufacture asen was carefully controlled by the monarchs in the precolonial period. Iron in particular was a crucial commodity used for the manufacture of farming tools and the making of weapons, and as early as the eighteenth century travelers reported that the kings monopolized its importation and distribution (Dalzel [1793] 1967, 208). Skertchly reported that nearly all was imported from Europe, though "a very little" iron was bought from peoples to the north. He believed that no iron was smelted in Dahomey, though Abomey smithing families claim that iron was smelted by Yoruba slaves in Afomai village along the banks of the Kouffo River during the nineteenth century (Skertchly 1874, 387; Interview with Badiji, 3 October 1984; Adande 1997, 5). Silver, which was often used on royal ancestral asen, was imported principally in the form of specie and was similarly controlled by the center (Burton [1864] 1893, vol. 3, 117 n.3 and 122 n.2). It was not until the colonial period that larger quantities of metal became commonly available, particularly in forms such as steel containers and vehicles that, having fulfilled their initial function, could become sources of raw material for the manufacture of ancestral asen.

There is additional scattered evidence that suggests that even simple undecorated asen were generally not in use in ancestral ceremonies on lower social levels in the precolonial period, though proving such a negative is impossible. Today, ancestral asen in Fon compounds are not visible to casual visitors, though anyone invited to witness ceremonies that fit the rubric of feeding the dead sees them, either brought out of storage and set up out-of-doors or ranged inside the deho. Significantly, asen are never mentioned in nineteenth-

century travelers' accounts of comparable ceremonies for "setting a table" for the dead. Ancestral asen were prominent in local markets by the 1930s, where they were exhibited for sale in large quantities. Yet sixty years before, Skertchly, who describes in detail the "hardware" and "fetiche department" of Ouidah's main market, does not mention any object that might be an asen. In Abomey, Skertchly visited the quarter of the smiths and noted that most work was done to order, with the exception of "the more common knives and fetiche-irons," the latter term most often used by him in reference to smaller, unelaborated asen associated with vodun (1874, 57–58, 387). And, of course, the conflation of the terms *asen* and *calabash*, which often led Skertchly to call asen "calabashes," underlines the likelihood that ancestral asen were an innovation of fairly recent date.

By the end of the nineteenth century, things were beginning to change. A French trader at Ouidah in the late 1880s, like the 1714 visitor to Savi mentioned above, described the products that Dahomean smiths made of iron, including "de petites lanternes en fer supportées par une tige de fer sur lesquelles sont représentées des figures d'animaux, des serpents, des crocodiles, des sonnettes, des clochettes, des gourdes et des instruments de répression pour les esclaves. Ces lanternes servent à orner les fétiches" (small iron lanterns mounted on an iron stake on which are represented figures of animals, snakes, crocodiles, hand-bells, small bells, gourds, and restraints for slaves. These lanterns serve to decorate the fetishes) (Chaudoin 1891, 299–300). Might these "lanterns" have been ancestral asen? The Dahomean dynasty typically permitted high-ranking officials and members of the royal family to surround themselves with some of the accoutrements of royalty—for example, umbrellas, the toga-like style of men's garments, and jewelry made of silver. As the nineteenth century drew toward its close, certain officials of royal and common birth were effectively apotheosized through being honored by the cult of the Nesuhwe. It is possible that elaborate ancestral asen would have been permitted in their honor.

Auguste le Hérissé, a French colonial official who served as head of the *cercle* (circle, or administrative division) of Abomey in the first decade of the twentieth century, provides what may be the first image of an ancestral asen topped with a figurative tableau that was *not* made for the kings (figure 32). The objects represented are directly associated with rituals for the dead: the stool symbolizing the honored ancestor, the sacrificial knife, the cock sacrifice, and the calabashes containing the sacrificial foods (1911, 363–65). Hérissé comments that in Abomey, ancestral asen at the beginning of the

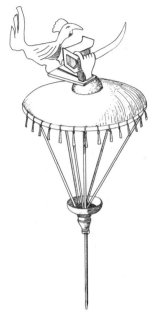

Figure 32. Drawing of an ancestral asen illustrated by A. Le Hérissé (1911, 364).

twentieth century were of different sizes and models according to the wealth of the purchaser. These harbingers of change point toward what became commonplace in the late twentieth century, the ubiquitous use of ancestral asen by the Fon people of Dahomey/Benin.

Given the evidence at hand, it appears likely that elaborate ancestral asen came into use in Abomey in the nineteenth century. While Gezo's reputation as a patron of the arts and ceremonial innovator suggests that they may have first been used during his reign, the links of asen with Fa divination suggest possible origins as late as the opening of the reign of Glele, when artisans would have been challenged to invent new forms to honor the deceased Gezo during Ahosutanu, the massive celebrations that constituted the final funeral of one king and installation of his successor. Whether Gezo or Glele is credited with the invention of figurative ancestral asen, however, neither king was personally a maker of these new objects of art. The people who fashioned the finest ancestral asen, and whose artistry so impressed late nineteenth-century visitors, came from a particular lineage of smiths, the Hountondji. Their story is the subject of the next chapter.

3

The Hountondji Family of Smiths
and Dahomean Royal Patronage

The blacksmith in these lands is not an object of superstition;
the highest craftsman is the King's Huntoji or silversmith.
—Richard F. Burton

Court dress in nineteenth-century Dahomey was luxurious. Euro-
pean spectators marveled at the elegant gowns and wrappers, the wealth of
beads and silver jewelry, and the carefully crafted hairstyles of women and
certain men. Yet one man was notably different. Unlike all other Dahomeans,
who on pain of death never wore any kind of foot covering in the sacred
presence of the sandaled king, the head of the lineage of favored smiths,
Daa Hountondji, came to court wearing footgear and Europeanized dress.
His descendants boast that he was called *yovo* (white person) and would
be conveyed in a hammock, a means of luxury transport normally limited
to European visitors, high officials, and the king himself. On meeting Daa
Hountondji, Richard Burton assumed that his "long calico gown, white pan-
taloons, straw hat, slippers and European chain" signaled his membership
in the coastal community of Afro-Brazilian merchants ([1864] 1893, vol. 4,
22).[1] Burton was correct to notice that Hountondji was dressed unlike any
other Dahomean, but he could hardly have been more wrong about the
man's ethnic origins.

The Hountondji family of Abomey trace their origins to Aja-Tado or Tado,
west of Abomey in what is now Togo, the place of origin of the Dahomean
royal lineage. Their family traditions incorporate elements of the ruling
dynasty's founding myths. According to the Hountondji, the lineage founder
was the first-born among siblings who included the founders of the kingdoms
of Dahomey, Allada, and Porto-Novo. Their ancestor migrated from Tado
with his three junior brothers, who had been forced to leave home because of
their bad behavior. When the three younger brothers parted ways at Allada

to establish their separate states, they insisted that the senior brother return home to be guardian of the family's shrines. He refused, and Wegbadja, the first king of the Dahomean dynasty, agreed that the elder should stay in the new country but charged him and his descendants with keeping all the sacred clan *tabus* of Tado on behalf of the other brothers. The responsibility was memorialized in a praise name: *E djè kou do houn ton dji*, meaning "he is concerned with his blood" (his family line), from which comes the name Hountondji ([Hountondji] n.d.).

Descendants of the royal family are known as *ahovi*, literally children (*vi*) of the king (*aho*). In contrast, and in recognition of their position as elders and guardians of sacred tradition, the Hountondji are called *ahononvi*, the children of the *ahonon*, the guardian or "mother" (*non*) of the king. As "brothers" of the kings, they enjoyed important privileges in precolonial times. For example, they were permitted to follow the royal family practice of affiliating all children born of either men or women of the family, rather than claiming only those fathered by the line. All family members bore two vertical scars on each temple, distinctive marks alerting all to their sacred relationship to the royal family, marks that not incidentally also kept them from being impressed into the armies of Dahomey. The tabus that the Hountondji practiced in recognition of their mythic arrangement with the founder of the kingdom included abstaining from the use of salt at certain times and requiring all children in the family, female and male, to undergo a puberty rite that proved their virginity ([Hountondji] n.d.; interviews with Agbakodji, 18 August 1984; and Abiala, 7 August 1984). That virginity ceremony undertaken by them, the Hountondji point out, freed princesses of the ruling family to enjoy the sexual freedom much remarked upon by European visitors and scholars.

Curiously, these myths of origin say nothing about how and why the Hountondji came to work metal, though they hint that the family were smiths from the beginning, for they claim that the Hountondji brought their Gu, their god of iron, with them from Tado. Moreover, their traditions indicate that they did not migrate to Abomey with the Dahomean royal family but arrived at a later date. They departed Allada, leaving a branch of the family in residence there, at the request of King Agaja (ca. 1716–40), to establish their line in the town of Cana, where a branch of the family continues to reside. The family arrived in Abomey only during the reign of Gezo (ca. 1818–58), when a Hountondji son named Kpahissou came from Cana at the request of the king ([Hountondji] n.d.).

Like other artisans established in Abomey through the patronage of the kings, Kpahissou was granted wives, slaves, and control over villages that provided foodstuffs so that Kpahissou and his apprentices might practice

their art in comfort. An indication of the rapidity with which this branch of the Hountondji grew under royal patronage can be seen in the more than seventeen branches of the Abomey Hountondji that are recognized as having descended from Kpahissou, of which at least six, and probably more, are descended from slaves integrated into the lineage and trained as smiths. Those large numbers enabled the Hountondji to take apprentices only from within the lineage, a practice they still continue. Over time, additional branches of the Hountondji were established in areas that were effectively frontier outposts for the kingdom, so that by the time of the conquest of Dahomey, there were Hountondji established in a series of significant towns: Abomey, Allada, Cana, Ouidah, Toffa, and Cove ([Hountondji] n.d.; interview with Abiala, 7 August 1984). In Abomey, the Hountondji family lives in a quarter that bears their name, directly across the broad public plaza fronting the gates of the central royal palace (figure 33). Hountondji Quarter is one of the oldest in the city and is today the most densely populated. Criss-crossed by a labyrinth of narrow winding paths, the city section is home to numbers of artisans. The Hountondji say that they were placed there to maintain con-

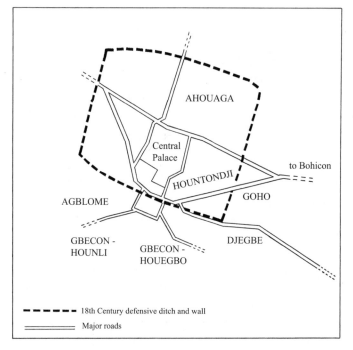

Figure 33. Map of contemporary Abomey showing central city quarters.

trol over various newcomer-artisans brought in as the administration of the kingdom expanded (Anignikin 1986, 35).

By the mid-nineteenth century, the Hountondji were celebrated as the premier smiths in a kingdom increasingly concerned with warring and the production of the tools of military action. Yet what distinguished them then, and continues to do so today, was not their ability to work iron, the essential element of warfare, but their creative skill with rare metals—brass and silver in particular. Family traditions do not explain when or how they came to work these prestige materials, and it is unlikely that they were the first smiths to work precious metals in Dahomey. Historical records indicate that there were skilled artisans employed by the kings of Dahomey well before the Hountondji became visible in the nineteenth century. Observers as early as the 1720s reported that the palace contained "great Quantities of Plate, wrought Gold, and other rich Things"; that the leading wives of the king carried "Silver-gilt Staffs in their Hands" during a procession; and that some of the king's women "had on their Arms, many large Manelloes, or Rings of Gold of great Value" (Smith [1744] 1967, 173, 184; Snelgrave [1734] 1971, 35). Archibald Dalzel, who lived in Ouidah during the late 1760s, documented the existence of local metal artisans using prestige materials: "Besides black-smiths, there are a sort of braziers or silversmiths, who make manillas or bracelets, handles to cutlasses, rings for the fingers, and other trinkets of brass or silver, which they melt in crucibles of their own making" (Dalzel [1793] 1967, xxv). And somewhat later, at the turn of the nineteenth century, it was asserted that "Gold and silver . . . are not used in the shape of money; but both are manufactured into ornaments" (M'Leod [1820] 1971, 92). The name Hountondji appears nowhere in these references.

Yet assuming that the Hountondji oral traditions are correct, members of the lineage would have been living in Dahomey in the eighteenth century, though not in Abomey. Were they at that point already engaged in making objects of personal adornment and court regalia? If so, they were one among several smithing lineages working in precious metals, and it seems reasonable to suppose that Kpahissou would have been brought to Abomey from Cana because he was particularly skilled. Certainly, the displays of Hountondji workmanship described later in the century were impressive. Skertchly commented on the prayer house for Gezo, which was twice the size of those of the other kings, its pillars covered with "splendid cloths of native manufacture." The roof was decorated with

> a very creditable specimen of blacksmith's work. This was a brass apron, composed of forty rectangular sheets of brass, each hinged to the others, the

whole covering a space of about six feet square. Each of the brass sheets was embossed in a fanciful pattern, the general effect being very beautiful. To the lower edge of the apron a row of seven and thirty bells was attached by brass chains. The apron was suspended by four chains, composed of flat pieces of brass attached to an embossed ridge piece of the same metal, to the top of which thirty-eight bells were attached. From the centre of this brazen ridge-tile a brazen affair of a dumb-bell shape supported a small coronet, from which hung four small brazen human heads, and above this a large wheel supported eighteen bells which tinkled in the wind with a weird music, which was supposed to be Gézu's spirit calling to his son. (1874, 413)

Hountondji lineage traditions note only that Kpahissou, who clearly established the family reputation, "exerça le métier traditionnel de forgeron" (practiced the traditional occupation of smithing) ([Hountondji] n.d.).

Perhaps in addition to Kpahissou's skills, the answer to the mystery of the Hountondji rise to prominence includes a characteristic of their approach to technology. The Hountondji smiths prided themselves on their ability to adapt and even duplicate the technology by which an object was created. The family cites a legend about the conquest of the kingdom of the Hweda (Ouidah) in 1727 as illustrative. The Dahomeans had purchased muskets through the Hweda, who controlled access to the coast. However, before passing them along to their Dahomean enemies, the Hweda had taken the precaution of removing the flints so that the guns would not fire. With the help of an Abomean princess married to King Houffon of the Hweda, the Dahomeans received the missing flints, and the Hountondji repaired the sabotaged firearms (Gavoy 1955, 54–55; interview with Domonhedo, 14 September 1984).

Similarly, a family member commented that "King Agaja called Hountondji 'yovo' because he could make anything that the Europeans brought—guns, swords, whatever—he could copy it perfectly" (interview with Agbakodji, 2 September 1984). Unabashed imitation alternated with ingenious adaptation in the Hountondji approach to European models. For example, visitors in the late 1840s were intrigued by a glass coach, "the handiwork of Hoo-ton-gee, a native artist—a square with four large glass windows, on wheels." More than twenty years later, King Glele rode in the same carriage and was described as riding "in a glass chariot . . . , a cumbrous affair, like a square photographic studio on wheels" (Forbes [1851] 1966, vol. 2, 65; Skertchly 1874, 341). Imported objects as often as not were modified to suit Dahomean tastes. When he met the Yovogan (chief for contacts with the Europeans at Ouidah) in the fall of 1849, Frederick Forbes noted that the official wore armlets "of silver, reaching from the wrist to the elbow, embossed with the lion of England and the

heads of George the Third and his queen" ([1851] 1966, vol. 1, 49). Fourteen years later, Richard Burton saw similar armlets and explained the source of the designs: "These are made of dollars beaten out thin, hollow cylinders, half a foot long, fastened with hooks and holes" ([1864] 1893, vol. 3, 97 n.2).

The kings ordered objects from Europe, often specifying forms, sizes, and colors in great detail, and many a hapless envoy was disconcerted to find that gifts presented were greeted with disdain for being other than what had been specified. Burton, for example, brought among other gifts a forty-foot circular crimson silk damask tent and a coat of mail. The Dahomeans complained that both were too small, and Burton grumbled that the only thing people admired was "the gingerbread lion on the pole-top" ([1864] 1893, vol. 3, xix, 215). One of the more intriguing European-made objects that survived into the colonial period to become part of the collection of the Musée Historique d'Abomey was an asen surmounted by a naturalistic dog in cast brass (figure 34), apparently commissioned by King Glele and presented to him by the Portuguese in honor of his father, Gezo (Interview with Nondichao, 11 September 1984).[2]

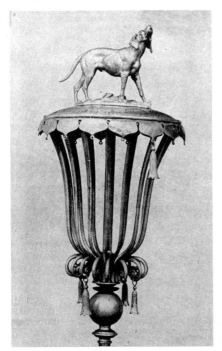

Figure 34. Ancestral asen commissioned from a European source by King Glele (Mercier 1952, 92).

Certain other European models for Dahomean treasures appeared from time to time. Skertchly noted in procession "a silver candlestick of Brazilian workmanship" and "a couple of silver soldiers, in the dress of Spanish buccaneers, fighting a duel—a present to Gézu from the King of Portugal" (1874, 255, 260). One of the most dramatic objects provided by a European was a gift to the deceased King Gezo that was buried with him. It was presented by Domingos José Martins, a leading Cuban slave trader of the 1850s: "Un grand plateau d'argent sur lequel brillaient clairement 170 nouveaux dollars, et une belle reproduction d'un chêne en argent, de 30 pouces de hauteur environ, aux feuilles duquel étaient attachés de petits crochets, et à ces crochets étaient suspendus quelques centaines de cigares les plus fins de La Havane" (A large silver tray on which brightly glittered 170 new dollars, and a pretty model of an oak tree in silver, about thirty inches high, with leaves that had little hooks attached, and to these hooks were suspended some hundreds of the finest Havana cigars) (Verger 1968, 471). Possibly inspired by Martins's gift, two silver trees, one "about five feet high, with candles of silver," and the second some four feet tall, both said to have been the work of the Hountondji workshop, were noticed by Skertchly. He was told that they had been made in advance to be buried with King Glele and that the trees were meant to show that "like a flourishing tree, his kingdom prospered under his reign" (1874, 256).

Glele's trees make another point. The Hountondji did more than copy European objects for use in an African context. They transcended and transformed their foreign models, infusing them with meanings that at times are explained in the sources, but at other times remain inexplicable. For example, Skertchly also describes a silver hotagantin on the apex of the roof of the house of prayer of Gezo (figure 35):

> [A] square disc of silver with a raised border, and a string of silver hearts depending from its lower edge. Above this an elephant, standing in the middle of a number of silver trees, like laurels, had overthrown a soldier. On the back of the elephant was a ship, with a mast and three soldiers, two of whom rivalled the mast in altitude, while the third, much smaller, held a cannon in his lap, on the top of the mast; the whole being much after the style of the ships on wheels, sold for a penny in England. (1874, 437)

Formally, the ship may have resembled a British child's toy, but in fact the motif had a wholly Dahomean allegorical interpretation. The soldiers were elephant hunters, symbolizing the enemies of Dahomey, who when going out to hunt were often killed by their prey. Dahomean enemies should similarly

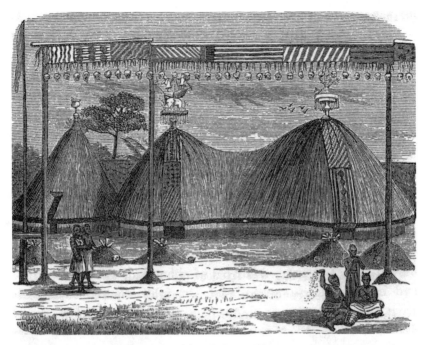

Figure 35. Ritual structures for ceremonies in honor of King Gezo, 1871. The silver hota-gantin described by Skertchly is atop the central dome (Skertchly 1874, 437).

beware. The ship symbolized, as it often did in Dahomean iconography, the numerous foreigners who came to Dahomean shores.

Crucifixes worn by the king and court officials intrigued visitors, for rather than using human imagery, they showed numerous animals and birds. A priest introduced at court in 1861 was disconcerted to notice that nearly all the dignitaries insisted on showing him crosses that they wore: "C'étaient de très belles croix travaillées à la manière européenne mais, hélas, sur plusieurs qui avaient dû avoir l'image de N.-S. crucifié, on avait mis à sa place une image ridicule travaillée par des orfèvres dahoméens" (They were very beautiful crosses worked in the European manner but, alas, on several that ought to have had the image of Our Savior crucified, they had put in his place a ridiculous image worked by the Dahomean jewelers) (*Journal* 1997, 73–74). No visitor was told why animals were shown as victims of crucifixion. Yet the motifs make sense in a context where as part of the royal ceremonies, Skertchly saw a crocodile, cat, and hawk being sacrificed to alert the animal spirit world to the honors that the Dahomeans were bestowing upon the royal

ancestral vodun, and where witnesses regularly noted that sacrifice victims
included birds, cattle, and chameleons, to name a few (1874, 352). Such an
interpretation—that the crucifixes signaled Dahomean devotion to ancestors
through the sacrement of sacrifice—is underlined by the sources: only the
king had the right to sacrifice human beings, and only the king is mentioned
in travelers' accounts as wearing a crucifix with a human figure.

Many of the objects of royal regalia were made of combinations of wood
and metal (figure 36). Relatively large animal figures, for example, were carved
and then covered with a thin coat of silver, copper, brass, or iron—or some
combination of these metals to provide color contrast. The metal skin was
virtually always decorated by chasing, stippling, or repoussé. Tradition claims
that the idea of sheathing wooden objects came from the famous friend of
King Gezo, the Brazilian slave trader Francisco Félix de Souza. Made viceroy
of Ouidah after he assisted Gezo in the 1818 coup that brought him to power,
de Souza was deeply influential as an intermediary between European and
African cultures and is credited with any number of innovations. In this case,

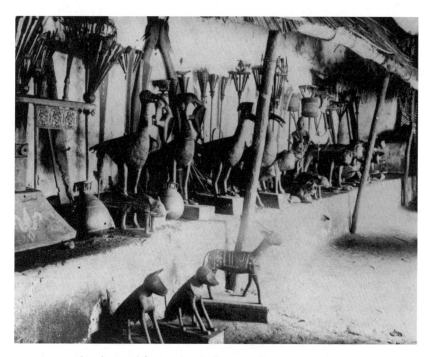

Figure 36. Bird and animal figures sheathed in metal on display in the palace of Glele.
Undated photo. C-42–3060–40. Formerly Photothèque, Musée de l'Homme.

de Souza is said to have given as a gift to the king "de minces plaques de laiton dont il fit recouvrir quelques meubles vermoulus. Sous son successeur Glèlè, les forgerons reçurent permission de façonner aussi le métal jaune (*gan-vovo*) notamment pour en faire des objets exposés aux intempéries" (thin plates of brass that he had made to cover some worm-eaten furniture. Under his successor Glele, the smiths received permission to also work copper [*gan-vovo*] especially to make objects that would be exposed to bad weather) (*L'Art* 1922, 20–21).

The quality of the jewelry, sacred objects, and royal regalia astonished nineteenth-century visitors, too, because of the relative simplicity of the royal artisans' tools (figure 37). Burton was characteristically blunt: "The instruments are rude in the extreme; the anvil is a half-buried rock, the bellows are of common African type, the hammer is a cone of iron held in the hand, and the grindstone is a bit of fine close granite, shaped like the article with which the English mower whets his scythe" ([1864] 1893, vol. 3, 98 n.1). Skertchly provided more detail after visiting a group of Abomey smiths near the palace. The methods he described differ little from the technology of smiths in southern Benin today. Work was done in a low-walled open shed under a roof—then thatch and now metal—the dirt floor dug lower than ground level and the open fire built in a hollow in the floor. Double bellows made of hollowed wooden tree trunks covered with leather bags heated the fire, which burned charcoal and palm-kernel husks as fuel. Double bellows still existed in late twentieth-century Benin, though additional forms included accordion bellows, some pumped by bicycle wheels. Hammers were made of heavy iron, some flat and others concave to assist in making hollow objects. The smiths' tools are still hand-forged and carefully designed for specific purposes. The anvils were old cannons or blocks of granite placed at a sharp angle, and the smith would work standing behind the apex of the anvil and facing its downward slope (Skertchly 1874, 386–87).[3]

The source of metals for the kingdom of Dahomey was virtually always the European trade. As noted in chapter 2, a small quantity of iron was likely smelted in Dahomey, and a little was imported from the north, but the bulk of metals came from the coast in the form of bars and rods. Precious metals varied in quantity and kind over time. Gold was remarked upon in the early eighteenth century, when Brazilian gold was a significant import commodity apparently much desired by King Agaja, the conqueror of Ouidah. With the decline of the gold-mining industry in Brazil by the 1760s, gold was used far less often. In 1823, a captain traveling along the coast reported that the use of gold was "almost unknown" in Ouidah, and by 1860, a British envoy

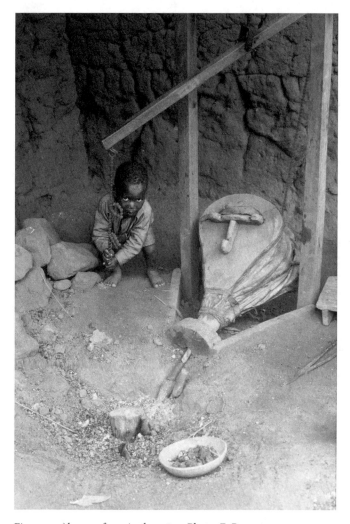

Figure 37. Abomey forge in the 1980s. Photo: E. Bay.

to Abomey asserted that "gold has no value here" (Adams 1823, 170; Burton [1864] 1893, vol. 4, 22; see also Law 1990). Silver became the prestige metal of the nineteenth century, leading some scholars to assume that Dahomean tastes demanded it. More likely, silver was the most easily available luxury metal. With the abolition of the slave trade by the British in the early nineteenth century, and the resulting development of a clandestine trade in slaves, Brazilian, Spanish, and American merchants began operating in silver dol-

lars. Dollars remained the predominant currency of the trade until they were replaced by British sterling coin in the 1870s (Manning 1982, 47, 55).

X-ray spectroscopy analysis by New York's Metropolitan Museum of Art of the metal content of two late nineteenth-century silver figures, one a hollow elephant and the second a silver-covered wooden buffalo, found that the silver was consistent with European coin standards of the period (Howe 2000). The findings suggest that there was minimal alteration of the silver coins, something confirmed by contemporary observations that the smiths seemed to try to maintain the coins' imagery when they hammered out thin silver bracelets. Brass and copper were also used in the nineteenth century. Oral traditions tell of soldiers gathering empty cartridges on battlefields to be used by the Hountondji. The Fongbe term *gan sokpeta* (literally, metal of cartridges) confirms the importance of this source of metal. It also suggests that a characteristic of metalworking in the twentieth century, the careful reuse of metals imported in other forms for other functions, has deep roots in the precolonial past.

Lost-wax Casting in Abomey

Smithing lineages still active in Abomey stress that there was vigorous competition among them in the precolonial period to capture the attention and admiration of king and court. Competition was the key motivation that led the Hountondji to introduce the casting of brass into Dahomean artisanal traditions, an innovation that would prove a key to Hountondji fame in the colonial and postcolonial periods. Surprisingly, for the near hinterland of the West African coast is well known for the antiquity of its knowledge of casting in metals, the beginning of brass casting came late in the life of the kingdom. Nevertheless, Hountondji casting uses a version of the same process as older traditions in the region (figure 38). In its essence, lost-wax (or *cire perdue*) casting is a process by which a figure is molded in beeswax, then covered with a clay vestment that forms a mold. The beeswax is melted out of the mold, and molten metal is poured in. Since the mold must be broken to reveal the casting, and hence lost for additional casting, the process creates what are literally one-of-a-kind objects.

Dahomey lies within a broad belt of West African culture where lost-wax casting has been practiced for centuries. To the east lie areas of Nigeria boasting lost-wax casting traditions of great antiquity. The archaeological finds at Igbo Ukwu, for example, that include delicate naturalistic and decorative castings, have been dated to the tenth century, and the famous life-sized bronze

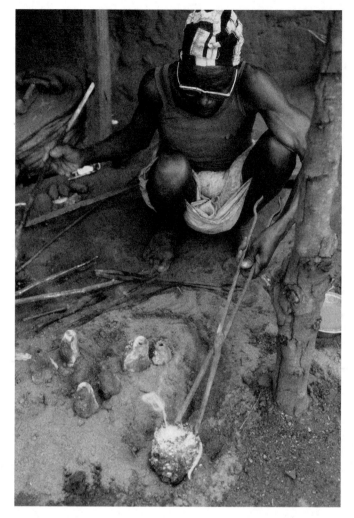

Figure 38. Aloha Agbakodji, a smith of the Hountondji family, in the
process of casting, 1984. Photo: E. Bay.

heads from Ife are estimated to have been cast between 1000 and 1400 CE.
More to the point, eighteenth- and nineteenth-century Dahomey was vir-
tually surrounded by states where casting was actively practiced, including
Asante and other Akan states to the west and the Oyo/Yoruba/Benin poli-
ties to the east. It is little wonder that Africanist art historians have readily
assumed that the Dahomeans, like their neighbors, cast metal from time

immemorial. Melville Herskovits, who carried out field research in Abomey in 1931, remarks that "Dahomean brass-casting . . . must be regarded as a part of the widespread West African complex of art work in metal, best known through the Benin bronzes, the metal art objects of the Yoruban peoples, and the Ashanti gold weights. Yet though an undoubted historical connection exists with the metal-working techniques of neighboring folk, Dahomean art in brass stands distinct in stylistic treatment" (1938, vol. 2, 354). Most contemporary scholars have followed Herskovits's supposition, though at least one has gone a step further to claim that it was Yoruba smiths who introduced casting to Dahomey (Etienne-Nugue 1984, 220, 222; see also Fagg 1959, plates J-6 and J-7; Mercier [1951] 1966, 158; Delange 1974, 95; and Gillon 1984, 226).[4]

These speculations are contradicted by a detailed oral tradition preserved by the Hountondji family. It is a story that is strikingly consistent from branch to branch of the family, and it includes details that are corroborated by physical evidence from the turn of the twentieth century and by early documentary records about casting in the area. Astonishingly, given the long traditions of casting in West Africa, the Hountondji's knowledge of lost-wax technology was learned from a European source in the early 1890s. The occasion for the transfer of technology was the process of royal succession.

King Glele died in the last days of December 1889, leaving Dahomey at a moment of grave political crisis. The French were threatening at the coast, and the court was deeply divided over how to respond and over who should lead the kingdom. Glele's son Behanzin seized power and began to treat with the French. Meanwhile, he and his followers started the process of ceremonial legitimation that within two to three years normally would lead to the performance of Grand Customs, or Ahosutanu, the elaborate final funeral ceremonies for the past king and the installation of the new. Grand Customs was a massive spectacle that demanded innovation and originality on the part of all the royal artisans. Ahosutanu for Gezo had inspired the famed Gu figure by Akati, a rival smith to the Hountondji. In 1890, the Hountondji set about meeting the challenge posed by the Grand Customs for Glele.

One of the better smiths among the Abomey Hountondji in this period was a man named Toti (Totin), the son of Hunkpatin Hountondji and a woman of the Nyawhi, a prominent Ouidah family. Toti was born during the reign of Gezo, so he would have been at least in his early thirties in the 1890–92 period when the Hountondji were under creative pressure to innovate in the name of the new king. He apparently had spent time in Ouidah and was familiar with individuals in the Afro-Brazilian community. But Toti first looked for

inspiration to smiths who lived in a village that lay exactly six kilometers southwest of the gates of the palace of Abomey: Hoja.

The population of Hoja village consisted of Akan refugees from Asante who had settled there in the late eighteenth century under the patronage of King Kpengla (1774–89). Smiths and jewelers, the Hoja villagers produced small bells, or *crotals*, for bracelets and anklets (figure 39). Called *yoyoe,* these bells are identical to items made through a disappearing tradition among the Takyiman Bono of northwestern Akan country in present-day Ghana (Silverman 1986) (figure 40). Kpengla liked the work of the Akan newcomers and gave them a monopoly on the manufacture of yoyoe during his reign. However, when King Kpengla died, royal interest in their products waned, and the Hoja folk developed a market for their bells among the adepts of vodun, who remain their central customers.

The technology of lost-wax casting practiced in Hoja village is more difficult and complex than that done by the Hountondji. The Hountondji cover each of their modeled beeswax figures with a simple mold, leaving a channel to the outside so that the melted wax may be poured out and recovered. Metal is then melted in a crucible and poured into the heated mold. The castings emerge in a rough form that needs a good deal of finishing—polishing and applying fine details through tooling. The Hoja villagers, in contrast, form the top and bottom of each small bell by rolling fresh beeswax vermicelli-thin, then wrapping it in a spiral over a rounded clay core. A loop of slightly thicker wax is attached to the point where top and bottom meet, and a long thin runner is added to the loop, with the whole covered with a layer of thin clay slip, followed by successively thicker layers to form the beginnings of a mold. A clay mold is formed over numbers of bells placed together, their runners or sprues joined to meet in a pouring cup. After the mold is dried, it is heated and the wax is poured out, then a metal-filled crucible is attached and enclosed in the overall mold. A casting forge some 3.5 feet tall is used to heat this closed mold, which is placed in the furnace with the crucible end on the bottom. When the fire reaches the point that the metal melts, the entire mold is inverted, and the molten metal pours into each of the separate bell forms. After the mold is broken, virtually no finishing work, save removal of signs of the runners, is needed on the cast yoyoe.

The Hoja people have no oral memory of any visit to their village by Toti Hountondji, though they preserve a taunting song that says the Hountondjis can cast but find casting yoyoe impossible! The Abomey smiths today marvel at the Hoja process and claim that to preserve their mastery, the Hoja smiths never permit anyone to watch them cast. The Hountondji maintain that,

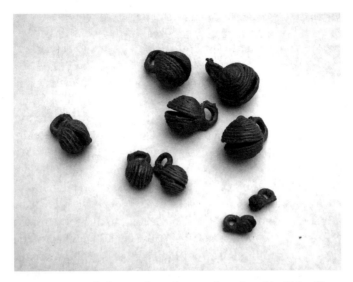

Figure 39. Yoyoe bells worn by vodunsi and produced in Hoja village. Bells were collected in Abomey in 1984. Photo: E. Bay.

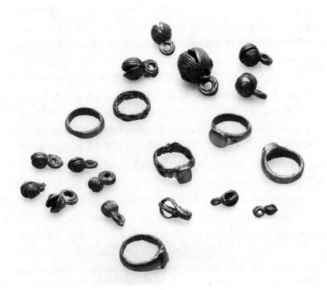

Figure 40. Crotals (bells) and rings produced in 1980 by Osei Kojo of Buoyem village, ten kilometers from Takyiman, in the northern Akan region of Ghana. Raymond A. Silverman commissioned the work from the retired caster, who "appears to be the last traditional brass caster among the Takyiman-Bono" (Silverman 1986, 60). Photo courtesy of R. Silverman.

inspired by Hoja, their ancestor Toti tried and failed to cast using candles for wax.

The story of Toti then moves to Ouidah, where he stayed for a period of time with his mother's family. Oral traditions claim that it was there that in 1892 he was taught to cast successfully by "the Portuguese" (Interviews with Hunkpatin and Alitonu, 26 September 1984; Nyawhi, 22 September 1984; Abiala, 7 August 1984; Agbakodji, 27 September 1984; Ahossi, 5 September 1984). Unfortunately, we know no more about the individual or individuals involved in this transfer of technology than that single moniker, and "Portuguese" could refer to any of three distinctive sets of people present and active in Ouidah during this period: envoys of Portugal itself; representatives of the government of Brazil; and Aguda or Afro-Brazilians, members of the coastal culture created by immigrants from Brazil, most of whom were manumitted slaves originally from West Africa. Of the three possibilities, a member of the Aguda community is most likely, since these returned Africans and descendants of Africa brought with them numerous artisanal skills. Whatever the source of his knowledge, after mastering the technology of casting in Ouidah, Toti traveled to the other centers of Hountondji smithing, carefully instructing only members of the family in the new technique.

The impact of Toti's new knowledge was not immediately felt, for 1892 was the year that the French sent an invading force up the Oueme River and into the heart of the Abomey plateau. The army of Behanzin was decimated, and the French in November of that year entered a capital city set ablaze by the retreating Dahomeans. Behanzin was never able to mount the Grand Customs in honor of his deceased father. Rather, he found himself by early 1894 aboard a ship bound for exile in Martinique. His successor, King Agoliagbo (1894–1900), was put in place by the French, and he ultimately succeeded in gathering adequate resources to perform Ahosutanu for Glele. However, we have no evidence that any cast objects were part of the materials made for the funerary celebrations in honor of Glele. Rather, there is scattered evidence that only small objects, particularly jewelry items, were being cast around this time. The Musée d'Ethnographie de la Ville de Genève, for example, has a significant collection of cast rings and other small objects in brass and copper believed to date to the end of the nineteenth century or the early twentieth century (figure 41). Most of the Geneva castings depict symbolic or decorative motifs regularly found in other media: a lizard, a frog, a pair of chameleons, a pair of royal sandals, and several small human figures (Savary 1967, 92–93; see also Cordwell 1979, 488).

Figure 41. Ring made of brass decorated with a female figure, cast through the lost-wax process. Diameter: 2.5 cm; height: 4.2 cm. Acc. 010810. 1925. Musée d'Ethnographie de la Ville de Genève.

The knowledge of lost-wax casting, then, was still in experimental form when the monarchy was finally abolished by the French in 1900. King Ago-liagbo was exiled to Gabon, and the royal artisans were left without their patrons. How the Houndtondji and other Dahomeans met the challenge of the colonial period is the subject of the following chapter.

<div style="text-align: right; font-size: 3em; font-weight: bold;">4</div>

From Tourist to Sacred:
Colonial Culture and the Creation
of Traditions

> *Le monde de l'artisanat n'était pas figé; il était capable d'innover, d'abandonner des techniques périmées, de fabriquer des objets nouveaux.*
>
> (The world of craftsmanship was not static; it was capable of making innotations, of abandoning outmoded techniques, of producing new objects.)
>
> —Hélène d'Almeida Topor

Culture and the Colonial Period

Resettlement and readjustment were central themes in the French colony of Dahomey (Benin) immediately following the European conquest. On the Abomey plateau, the fall of the kingdom decimated the army, and in the absence of enforced control, thousands of persons who had been slaves began to leave the area to make their way home (Chautard 1894; "Early" 1960). Free villagers returned to farming as their main occupation, while leading members of the royal family negotiated with the colonial authorities to try to preserve their former privileges. During King Agoliagbo's reign (1894–1900), the royal artisans continued to receive a degree of royal patronage, albeit much reduced. The king's cash income is estimated to have dropped from 150,000 to 10,000 francs per year (Glélé 1974, 224). A major source of strength to artisan workshops, the granting of wealth in the form of persons—captives and wives—was forbidden. However, produce paid as tribute to titled persons appears to have continued informally, which meant that smiths like the Hountondji may have had access to some farm produce from villages

attached to their name. Nevertheless, all of the former royal artisans felt the drastic decline in income. A smith of the Akati line commented on the hardships of adjustment: "The family never made anything commercial; it was all for the king. They never made anything else for anyone. After the kings were no longer there, the family found it was not specialized to commercialize its products, and it had to change" (Interview with Akati, 30 July 1984).

Despite his severely reduced income, King Agoliagbo devoted substantial resources to rebuilding the royal treasury and restoring a portion of the palace. And the French, even as they deposed Agoliagbo himself in 1900, showed serious interest in maintaining Dahomean culture, if not African political power. As early as 1901, there was talk among colonial officials of preserving the enormous central palace complex as a museum (Administrator at Abomey, ANB). This interest in cultural preservation and production during an immediate post-conquest period, when the newly colonized population and their rulers were struggling with the creation of a new order, was indicative of a form of cultural flourishing that would be particularly important in the midcolonial moment between the World Wars.

Artisans in the twentieth century might never again enjoy the material rewards possible in the nineteenth, but new products emerged as the talents of craftsmen were turned to broader markets. Moreover, the fundamental eclecticism of Fon culture and its delight in change and innovation remained. The midcolonial period following World War I was one of relative prosperity in which new materials and a greater variety of manufactured products came into Benin. Those industrial products became inspiration and at times raw material for artists, who did not hesitate to move beyond the original imported form and function to devise something that better met their own needs and imaginations—cutting, melting, pounding, sewing, casting, modeling, soldering, and otherwise transforming used and new objects into items of value to colonial subjects and rulers (figure 42). The spirit of invention that had prompted nineteenth-century kings to create institutions, expand ritual, inspire the imagination of artists, and even reorder the hierarchy of the gods did not die with the monarchy but became available to all with reasonable means. In a kind of democratization of the creative arts, people of all social levels became consumers of objects newly adapted or invented for secular and sacred needs. And perhaps more importantly, commoners' creativity went further than the consumption of objects as people began to imagine new ways to link the visual to the verbal arts.

The rapidly changing social, political, and cultural setting of the early twentieth century proved to be a stimulus to the arts. The reasons for cul-

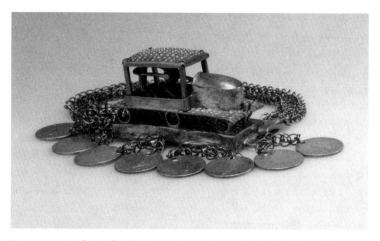

Figure 42. Armlet with vehicle pendant and attached coins. Silver. Diameter 3 in. The Metropolitan Museum of Art, Gift of Charles and Harriet Edwards, 1989 (1989.387.12).

tural vigor at the very period when colonialism was imposing major political and economic changes, some of which were highly negative, are complex. Cultural resistance, while arguably present at times, is inadequate to explain the flowering of cultural production across a broad range of expressive arts. What is apparent, however, is that two intertwined patterns discernable in Benin during the early decades of the twentieth century suggest that the fall of the kingdom of Dahomey and the imposition of French colonial rule stimulated creative energies toward the construction of a hybrid francophone African culture, on the one hand, and a rethinking of a Dahomean past and renaissance of Fon cultural practice, on the other hand.

The first pattern saw the promotion of the use of the French language and participation in French culture as an avenue for the expression of African values and sensibilities, while the second was characterized by the imaginative adoption by a broad spectrum of the population in southern Benin of elements of ceremonial and material culture that had been limited by state control in the precolonial period. In effect, the destruction of an African polity, which ushered in struggles between colonizer and colonized in the early twentieth century, appears paradoxically also to have fostered opportunities for forms of cultural flowering.

Certainly no one in Benin, to say nothing of Africa as a whole, welcomed the loss of autonomy signaled by the imposition of colonial rule. Yet once

the military defeat of Dahomey was complete, the quotidian impact of colonialism on southern Benin was relatively less brutal than in many other areas of French rule, for Benin lacked obvious natural resources to be forcibly exploited. With little income to support schooling, which in 1905 was declared the sole province of secular authorities in French West Africa, the French in Benin permitted the bulk of educational efforts to remain in the hands of Catholic and Protestant missionaries.

Mission schooling had been practiced along the coast from the mid-nineteenth century, and at the opening of the colonial period a generation of literate Afro-Brazilians, Aguda, had been quickly integrated into the colonial service. As it developed, the colonial school system in southern Benin, though restricted to a tiny fraction of the school-age population, was directed to broader pedagogic goals than the limited nature of French lay education elsewhere in French West Africa, where the purpose was to train boys minimally for low-level positions in the colonial service or in forms of industrial apprenticeship (Balard 1998, 69). This largely explains the predominant characteristic of Benin in the colonial period: its people's intellectual accomplishments, and its proud moniker of "Quartier Latin de l'Afrique" (Latin Quarter of Africa). The colony's most distinctive export became people, in the form of educated civil servants who migrated from post to post across the West Africa region to staff a large part of the French colonial administration.

A major influence on the shaping of the intellectual elite was the missionary Father Francis Aupiais of the Société des Missions Africaines of Lyon, who arrived in the colony in 1903 and was named head of the mission school in the capital, Porto-Novo, at the end of World War I (figure 43). Aupiais differed from the mass of missionary priests of his time. Missionaries generally considered the African system of belief that lay at the heart of family and social organization, "fetishism" in the eyes of the church, to be the greatest impediment to the mission enterprise. To make conversions, they preferred to work on the margins of society, ministering to orphans or freed slaves, individuals whose distance from the bonds of family made them, in the eyes of the missionaries, least inhibited to change. Aupiais, in contrast, believed that conversion required that Roman Catholicism appear to be in concert with social mores broadly accepted by the African community as a whole. Recognizing the centrality of ritual in life in southern Benin, a phenomenon that he termed *cérémonialisme* (ceremonialism), Aupiais worked to make Catholic ritual attractive by incorporating African cultural elements. For example, Aupiais became a close friend of Zounnon Medje, the ritual leader of Porto-Novo who was known as the King of the Night (figure 44). In the 1920s he collaborated

Figure 43. The Reverend Father Francis Aupiais. Undated photo courtesy
of the Société des Missions Africaines.

with this representative of African religious thought, who happened also to be
a talented raconteur and dramatist, to develop a festival for the celebration of
the Epiphany. Their partnership produced a highly successful dramatization
of the Adoration of the Magi, *Mystère de la Nativité,* in which Zounnon Medje
himself played the biblical black king, bearing the culturally appropriate gift
of water (Balard 1998, 79–81). Aupiais's ideas about the process of evangeli-
zation paralleled closely the philosophy of conversion that would later grow
out of Vatican II and that, as we will see in chapter 7, would be spearheaded
in postcolonial Benin by African clerical intellectuals.

More important for our understanding of trends in the 1920s and 1930s
was Aupiais's philosophy of education and his work with young Beninois

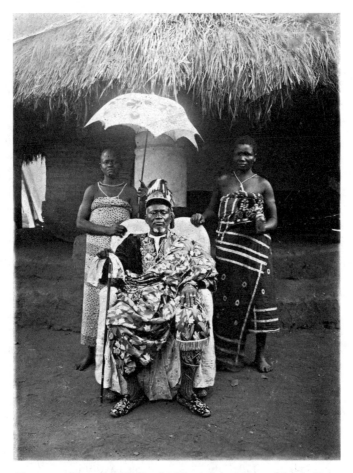

Figure 44. Zounnon Medje, the King of the Night of Porto-Novo.
Undated photo courtesy of the Société des Missions Africaines.

catechists. Influenced by the French ethnographer Maurice Delafosse and
the colonial educator Georges Hardy, Aupiais was convinced that ethnog-
raphy "est l'outil indispensable pour mener une politique éclairée de gestion
des peuples colonisés et, surtout, que la promotion d'une élite indigène en
constituerait l'instrument essentiel" (is the indispensable tool for carrying out
an enlightened policy for the management of colonized peoples and, above
all, that the essential instrument for its implementation is the training of an
indigenous elite) (Balard 1998, 62).

The priest designed a pedagogy that sought to develop an African elite whose thinking would be rooted in moral principles of African culture yet simultaneously embrace Western, and specifically French, forms of modernization. Selecting cadres of bright and hard-working young men, Aupiais provided extra training before and after school each day, forming classes of teacher/intellectuals. Aupiais's students did historical and ethnographic fieldwork, collecting oral traditions and folklore, and publishing their work initially in a short-lived journal founded by the priest, *La Reconnaissance Africaine* (1925–27), and later in scholarly journals such as *Anthropos*. Most famous of the students mentored by Aupiais was Paul Hazoume (figure 65 p. 119), who became a respected ethnographer and creative writer, author of the first published book-length ethnographic study by an African, *Le Pacte de Sang au Dahomey* (1937).

The young Beninese mentored by Aupiais were at the forefront of a celebration of African culture not unlike the *négritude* movement of the time, which involved francophone intellectuals from around the Atlantic world and most famously Léopold Senghor of Sénégal and Aimé Césaire of Martinique. Like the négritude writers, the Beninese intellectuals found that the search for a sense of modernity that simultaneously insisted on the centrality of African cultural values within a colonial hegemony was not without tension. In the words of Aupiais's biographer, this first generation of intellectuals mentored by the French priest "se trouvait confrontée à un terrible problème de détermination de son identité, tiraillée entre l'assimilation à la culture de la puissance colonial qui pouvait être comprise comme une adhésion au régime et la revendication d'une identité culturelle africaine que l'expression française rendait suspecte" (found themselves confronted by a formidable problem of the fixing of identity, caught between assimilation to the culture of the colonial power that could be counted as adherence to the regime and the claim of an African cultural identity that French expression would render suspect) (Balard 1998, 284).

Related to the elite's grappling with questions of identity was a reworking of attitudes toward the kingdom of Dahomey that was also taking place in the first third of the twentieth century and that involved intellectuals along with a broad sweep of society. Part of the ambivalence apparent toward the French in southern Benin was due to the fact that the colonial authorities had replaced a dynasty known for authoritarian and arbitrary rule, one that traded in slaves raided from the area and that practiced human sacrifice. The second half of the nineteenth century had seen serious economic decline in the kingdom of Dahomey, with a concomitant tightening of controls and increased pressure in exacting taxes. Peoples in areas bordering the kingdom

still maintain oral narratives of their own resistance to Dahomey, while the flight of a large proportion of the population of Abomey from the area in the early colonial period speaks to their lack of integration into the precolonial social order. Early colonial administrative reports from the Abomey plateau reek of self-congratulation as they insist that people readily accepted French rule. Nevertheless, those reports appear to bespeak certain realities associated with a loosening of rigid Dahomean control over the movement and activities of people.

The French may have replaced a repressive precolonial state, but paradoxically the replacement of that state by a foreign colonizer opened the way to a reworking of memories of Dahomey that would turn the kingdom into a heroic representative of the sentiments of colonized Africans. A major sign of the memory shift is evident in the work of the Aupiais protégé Paul Hazoume. Born in the kingdom of Porto-Novo, which was a precolonial rival to Dahomey, Hazoume nevertheless was intrigued enough with the Dahomean state to write an ethnographically rich historical novel, *Doguicimi* (1938), set during the reign of King Gezo and extolling the virtues of a wife of a royal prince. Even before the publication of *Doguicimi*, Hazoume played an important role in the reconstitution of the reputation of King Behanzin, the last independent monarch of the kingdom. Although historical records from 1893–94 indicate that the defeated and deposed monarch was cursed and condemned by members of the royal family, Hazoume argued that Behanzin's apparent humiliation was in fact a secret plot by the royal family to place his brother Agoliagbo on the throne. The royal lineage was only pretending that there was a rift in the family to fool the French into enstooling the family's choice (Bay 1998, 299–302).

Behanzin ultimately came to embody Dahomey itself and to symbolize the legitimate yearnings of a nation stripped of its autonomy. By 1979 the postcolonial government would erect at the entrance to Abomey a larger-than-life statue of Behanzin as a hero of African resistance (figure 45). And Hazoume's was only one of many scholarly and popular voices that celebrated the accomplishments of Dahomey. The twentieth-century historiography of the kingdom includes numerous hagiographies of the kings and paeans to the accomplishments of state building, along with more balanced interpretations of the kingdom's nature. Nearly all, however, take the perspective of the center, of the state itself, and only in recent years have historians begun to listen for the voices of peoples who stood in opposition to Dahomey.

The enhancement of the reputation of the kingdom of Dahomey was reflected in historical and popular writings, song, and theater. It was also signaled in the popular adoption of the material culture of the monarchy, in

Figure 45. Statue of King Behanzin at Goho, on the eastern outskirts of Abomey. Photo: E. Bay.

the cultural diffusion of signs and symbols associated with privilege among a broad cross-section of Fon culture. Legal power had been removed from a ruling dynasty, but the rulers' political and social capital remained. Status based on a precolonial social order was intact, and some of the old Dahomean elite had discovered new routes to the maintenance of privilege and acquisition of wealth: for example, colonial military service became a common qualification for appointment to a chieftaincy, while education prepared many princes for careers as colonial civil servants. The new colonial elite was almost exclusively an overlapping mix of the precolonial privileged from the political and trade centers of southern Benin, enhanced only occasionally by the incorporation of individuals from groups that had not enjoyed favor in the earlier period. But whatever their social origin, elites adopted the marks of office associated with the Dahomean state. Material signs of rank and authority, carefully controlled from the center in the precolonial period, began to be adopted by a broader range of persons who had moved into positions of status through emerging colonial opportunities. With the loss of royal patronage over artisans and the ending of the rulers' monopoly on their services, anyone of accomplishment and wealth could have access to the material culture of the kingdom and surround him- or herself with the trappings of precolonial prestige.

The Hountondji: Transforming Tourist Art into Sacred Object

The end of centralized royal patronage of the arts was thus paradoxically an opening to new possibilities, for the French-decreed political fragmentation of the Abomey plateau led to the commoditization of royal regalia. The French, despite their desire to minimize royal prerogatives, named descendants of the royal family and their close associates to the newly created chieftaincies. Canton and quarter chiefs on the Abomey plateau and in Abomey itself received salaries and were given rebates on the taxes they collected. Using their status as members of the royal family, they began to make demands on the peasants under their control for labor or produce. They thus became a newly reinforced ruling class that combined the prestige of the monarchy with the authority of the French colonial regime. In effect, the French had ended a monarchy but perpetuated a dynasty.

The new colonial chiefs built small-scale courts around themselves, naming officials and retainers on the model of the kingdom and hence reproducing royal privilege and ceremony. Over the years, rivalries among them for recognition as heir to the stool of Dahomey would lead to the continued employment

of some of the former royal artisans, most particularly smiths, appliqué artists, musicians, and carvers. Annual ceremonies honoring the kings took place in the households headed by the new chiefs and other prominent members of the royal family, creating a demand for royal asen in each of those households. As deaths occurred among the royal descendants, elegant asen began to be made to honor not only the kings but also the deceased chiefs, and additionally other leading children of the kings (figure 46). In similar fashion, the use of royal regalia was adopted by common people of rank, particularly those who gained Western education and wealth in the colonial system. Thus the court dress of Abomey and the other precolonial polities of southern Benin became the idiom of prestige and status in the midcolonial period.

The market for religious items associated with the cults of the vodun proved to be enduring, and it likely expanded in the colonial period. The monarchy in precolonial times had kept strict political and financial control over the religious life of the kingdom, and particularly over the so-called popular vodun, those cults of spirits such as Sakpata, Gu, and Heviosso that were not deified members of the royal family. While the French did not wish to expand the numbers of vodun devotees, they did not seriously try to suppress the cults. Even during the difficult war years of the early 1890s, it was

Figure 46. Family asen in the compound of a canton chief and member of the royal family. Near Abomey, 1984. Photo: E. Bay.

reported that adepts of the cults along the coast passed their spare time working imported rods of brass into fans, pins, bracelets, and broad anklets (Foa 1895, 133). The release of the talents of the royal artisans opened the way for commissions for the brilliant cloth costumes, for the profusions of necklaces and bracelets, armlets, and anklets worn in performance, and for the woven raffia caps and other ceremonial paraphernalia used in religious ceremonies. Similarly, masquerade societies had been forbidden in precolonial Dahomey, but during the colonial period, descendants of Yoruba immigrants to Abomey introduced Oro and Egungun, the latter being renamed Kutito in Fongbe.

Smiths in general and the Hountondji in particular were able to build a clientele out of these opportunities. Ritual objects, including asen and ceremonial jewelry, appear to have been created by smiths for chiefly patrons and adepts of the various vodun from early in the colonial period. The economics of the times would have enabled the Hountondji to supply many of their clients with silver objects, as large-denomination silver coins were being replaced in the period leading up to World War I by small-denomination franc coins made of copper and lead (figure 47). The new coins were in short supply and great demand, but the silver coins were discounted and were likely melted and reworked into prestige items (Manning 1982, 160). The smiths did not limit themselves to ritual products, for the market for iron tools for farming

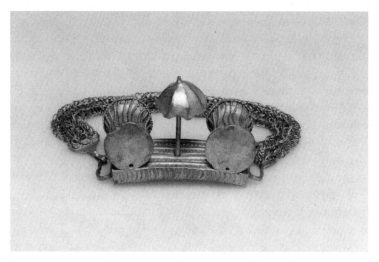

Figure 47. Armlet with umbrella and two pressure drums. Silver. Diameter: 4 in. The Metropolitan Museum of Art, Gift of Charles and Harriet Edwards, 1989 (1989.387.11).

was strong, and the quantity of imported metals remained stable through-out the 1890s and the first decade of the 1900s, including "tin, steel, copper bars, laminated zinc sheets for roofs, and 30–60 tons of iron bars imported each year for use by smiths" (Manning 1982, 131). A secondary source of raw material, metals recycled from imported motor vehicles and from containers of all sizes, was in operation by at least the period of World War I.[1]

While the artisans struggled to adapt to new markets, the French colonial authorities too were concerned about their fate. The early twentieth century was a period of imperial pride, when the government was intent on impress-ing voting citizens in the metropole with the significance of the lands that had become a part of a greater France and, not incidentally, a part of the expenses of the French budget. Colonial authorities were eager to produce evidence of the vitality of subject peoples, and colonial expositions became a frequent feature of the colonial period. Agricultural and commercial prod-ucts, art objects, and colonized peoples themselves were dispatched to the metropole to be exhibited as part of the displays.

Typical of the exotica requested by the metropolitan organizers of these fairs is a list of products and people requested for the 1931 Exposition Colo-niale et Internationale de Paris that is preserved in the Benin archives. Responding to Paris, the local colonial authorities found themselves staffing a lakeside village to be constructed on the exposition grounds at Vincennes. The village was to be populated by three fisher families sent from Benin, along with three handmade canoes large enough to hold two persons each. Nets, traps, baskets, and a quantity of smoked fish and shrimp were also to be collected to enhance the sense of authenticity. Other plans for the same exposition called for four Dahomean jewelers working gold and brass and three families of dancers, plus quantities of musical instruments, masks, thrones, silver and brass objects, and locally made textiles (Memo on the Exposition, ANB). Gathering materials for these frequent expositions was a chore for colonial administrators, as archival correspondence attests, yet it was also embued with a kind of competition among colonies. French officials across the empire scoured their colonies for unusual objects and recruited colonial subjects to be part of expositions.

The artisans of Abomey were obvious candidates for exposition travel, and one of the earliest to visit France was a young Hountondji by the name of Gnassounou. Having shown skill in creating cast human figures, Gnas-sounou was invited by the administrator of the cercle of Abomey to attend the 1906 Colonial Exposition in Marseilles. Apparently still in his teens when he went to the exposition, Gnassounou remained in France for nearly three

years and received some training in the arts (Cordwell 1979, 487–90). He returned to Benin in about 1909, where one of his early clients was the head of the French administration, Governor Merwart, who served a single year in 1911–12. Merwart's collection of art from Benin was originally exhibited at the 1922 Exposition Coloniale de Marseille. The catalog that accompanied the 1922 exhibition makes clear that the cast figures included were a recent innovation. It mentions Gnassounou (Niassounou) by name, calling him the head smith of Hountondji Quarter and saying that he had trained good students who were continuing the tradition (*L'Art* 1922, 21).

The several dozen cast figures of the Merwart collection are nearly identical in style to works that are created by Hountondji smiths today. Naturalistic, slightly elongated human and animal figures are covered in a wealth of tooled detail, their hands and feet disproportionately large.[2] Departing from African wood-carving norms of frontality and symmetry, and from the static postures characteristic of the metal-covered carvings of precolonial Dahomey, the Hountondji figures turn and twist, rendering action in genre poses: men hoeing, women pounding grain, hunters with guns at the ready, animals struggling with predators, and the like.[3] Groupings of figures are mounted on rectangular wooden platforms, providing a kind of tableau: a chief walking with his attendants; a palm-nut cutter climbing a tree; executioners raising their machetes above their heads, their victims kneeling at their feet. The objects are well modeled and differ stylistically from similar figures cast later in the twentieth century only by their greater bulk. Refinement in the Hountondji style over the years would consist of little save the smiths' growing ability to use less weight of metal by modeling slimmer figures.

Oral traditions confirm that Gnassounou introduced the style to Hountondji family members, particularly at two sites, Abomey and Cove/Zagnanado, the two areas in Benin where Hountondji-style casting continued to be practiced throughout the twentieth century. Whether through the prestige associated with their links to the kings or special favoritism on the part of the colonial authorities, the Hountondji established and maintained a monopoly on the creation of naturalistic genre castings for sale in southern Benin. Only members of the family through the paternal line were permitted to learn to cast, and no one save a Hountondji trained by a Hountondji could cast in their style. For example, as late as the 1980s, when a young member of the royal family was trained to cast through a development project in Ouagadougou, Burkina Faso, the Hountondji smiths initially refused to permit him to practice his craft. Later they compromised, agreeing that he could cast,

but only the Burkinabe-style hunter figures characteristic of Sudanic West African tourist art.

The interest in artisanal production displayed at the various colonial expositions prompted French officials to try to encourage manufacture for tourism and export. Benin was promoted as a center of "fetishism" whose exotic arts were among the most collectible. At least by the 1920s, the Hountondji cast genre figures were attracting a European clientele, and by the early 1930s they were being sold in neighboring colonies as well: Nigeria, the Gold Coast, the Ivory Coast, Niger, Togo, Cameroon, Upper Volta, and Soudan (*L'Art* 1922, 20–21; Reste 1934, 177). Melville Herskovits argued that there were differences in quality evident by the time of his field research in 1931, with the better figures being crafted for a market consisting of Dahomean chiefs, who displayed them in their homes as secular *objets d'art*. Herskovits believed that at least some of the subject matter for the groupings of figures sold to Europeans was innovative, which suggests that the smiths were continuing to seek new subject matter. He remarks that a scene of an initiate emerging from seclusion in a house of vodun was "inspired by the fact that the White visitors had spent so much time at the lengthy ceremonies," an apparent reference to the activities of himself and his wife (Herskovits 1938, vol. 2, 358–59).

Herskovits was aware that Hountondji brass castings by 1931 were also appearing on asen, and he collected the top of at least one asen. Now in the collection of the Schomburg Center of the New York Public Library, the asen has a single motif, a massive casting of a lion, probably meant to honor a descendant of King Glele, whose emblem is the lion. Herskovits, however, was anxious to show that Dahomean culture broke the stereotype that "primitive" art was produced only for particular functions, and he argued that the art collected by well-to-do Africans, which had no practical use, paralleled the fine-arts traditions of the West: "Thus in brass-casting, the embellishment of an *asê* for the soul of a dead King or chief may be regarded as an applied form of this art; the brass figures, acquired by those who can afford to possess them for the pleasure of seeing these objects of beauty about in their dwellings, furnish a psychological parallel to a painting or a piece of sculpture in western civilization" (Herskovits 1938, vol. 2, 314).

Herskovits, in his haste to find an aesthetically sophisticated art-consuming class in Africa, had missed a key point. During the second half of the twentieth century, scholars and connoisseurs of African art would regularly lament the degeneration of the arts on the continent as commoditization pushed artists into production for a tourist market. In Benin, the opposite had happened. By the end of the first quarter of the century, Hountondji

smiths had transformed an art form introduced and encouraged as tourist art into a sacred tradition. They would continue throughout the remainder of the colonial period to produce works simultaneously for sacred and tourist markets.

We do not know precisely when Hountondji cast figures began to be attached to the circular tops of asen, but it would likely have been contemporary with the development of the genre figures collected by Governor Merwart in the second decade of the twentieth century (figure 48). Asen elaborated with human and animal figures that were not cast were known in the precolonial period at the level of the monarchs. As we saw in chapter 2, ancestral asen use may have been forbidden and was certainly not a prominent feature of ceremonial life among common people in the precolonial period. However, asen used to honor the ancestors existed by the early 1900s and by the 1920s were relatively commonplace. While many ancestral asen were plain, wrought-iron or cut-sheet metal figures appeared atop some

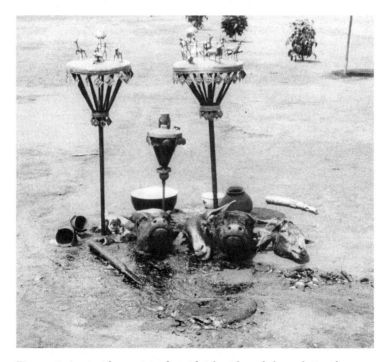

Figure 48. Asen with remains of sacrificial cattle and sheep during funerary services of the family of "chief Hénou." Kinkinhoue, Benin, 12 March 1930. Musée Albert-Kahn, Département des Hauts-de-Seine.

ancestral asen by the first decade of the twentieth century and would con-
tinue to be produced throughout the century.

During the first third of the twentieth century, dramatic changes had taken
place in the technology of production and the use of ancestral asen. Demand
for ancestral asen had risen in light of the disappearance of royal prohibitions
against their use by commoners and the increased importation of metals.
Asen had become available to any person of means who wished to honor an
ancestor, and a technology that had not been known in Dahomey in the days
of the kings, lost-wax casting, had been adapted to their decoration. Auguste
le Hérissé noted that asen varied in size and style according to the wealth of
the buyer; in his day, those made in honor of the kings tended to be of silver
(Herissé 1911, 365). It is probable that many smiths fashioned ancestral asen,
as was true in the second half of the twentieth century, but it is likely that
the Hountondji's skills in working precious metals and their reputation as
jewelers to the kings gave them a competitive edge. Their monopoly of the
art of casting and their adaption of cast figures to asen positioned them to
maintain their prestige throughout the century. As was true later in the cen-
tury, the finest and most expensive ancestral asen would have been products
of Hountondji forges.

But changes in technology and the expanded use of ancestral asen were
not the only developments associated with funerary rites in the early colonial
period. Following World War I, the representational motifs atop ancestral
asen began to undergo a dramatic transformation in subject matter and
meaning. Building on the allegorical and laudatory imagery characteristic
of the royal asen of Dahomey, colonial-era ancestral asen began to incorpo-
rate additional motifs that spoke with verbal-visual insight of Fon people's
responses to the colonial system.

5

Messages of Power: Asen Tableau to the Early Twentieth Century

Ils sont surmontés, lorsqu'il s'agit des rois, ou d'une personne d'importance, d'un motif symbolique faisant allusion au mort.

(They are topped, in the case of the kings or an important person, with a symbolic motif that alludes to the dead person.)
—Pierre Verger

The decorative tableaux atop ancestral asen are not essential to their function as power objects, to attract and hold spirits and hence to serve as communication channels between the living and dead. Yet the various representational elements that adorn many asen have over the years become increasingly central in the eyes of the living. Directed to the eyes of the dead, these ornamental motifs speak eloquently but often enigmatically from a changing collective consciousness. Their subject matters range from the divine power of invincible monarchy to the workaday world of weavers and fishermen. At times, they focus intensely on relations between living and dead. They sing praises of the ancestors, boast of the devotion of descendants, advertise the skill of artist-smiths, and underscore ideologies of kin solidarity. Begun as a court art that stressed creative ingenuity at the level of the kings themselves, elaborate ancestral asen in the twentieth century have reflected the genius of a verbal visual collaboration between smiths and their patrons.

In this chapter and the next, I analyze the representational patterns of the three distinct yet overlapping periods of ancestral asen art that correspond roughly to the political transitions from monarchy to colonial rule, and then to the contemporary nation-state. The transitions and boundaries between

these periods are gradual and never absolutely complete. Within each period, artists and their clients designed and created asen to reflect and praise the character of specific ancestors and to speak individual messages of power, piety, and commitment. At the same time, however, certain representational themes, along with the material and style of asen construction, collectively reflect some of the political, economic, and social realities of their day. In the messages of asen elaboration, we will read a social history of transitions from the rule of monarchs through French colonial authority to the globalizing trends of the postcolony. Like all social messages, those of asen elaboration, despite being expressed visually, have their roots in speech acts. Thus we explore first the visual-verbal nexus of Fon artistic production.

Word and Image

The key to understanding the meaning of the motifs of ancestral asen, and the tradition as a whole, lies in the word, in the rich body of Fon orature that preceded and inspired the images fashioned to decorate asen surfaces. Asen figurative art is based on a skillful use of visual allusions to proverbs and praise poetry and to symbols associated with historic events, legends, or personal identity. Going further than the directly representational, asen also speak through rebuses, images of objects whose names in Fongbe pun syllables that in turn allude to praise names, proverbs, and myths—to elements drawn from Fon oral expression. Yet the asen decorative tradition is far from unique. Much of the corpus of Fon representational art over the past two centuries across a broad range of media—wall paintings, appliqué products, mud bas-reliefs, carved gourds, and *makpo* (scepters or dance wands)—can be characterized as allusional rather than narrative.[1] Moreover, the motifs used to evoke the oral arts are frequently shared across several media.

How does this allusional art work? Motifs at first glance would appear to be mnemonic devices, and some function as such, as for example the common image that instantly evokes the eighteenth-century King Tegbesu, a buffalo with a cloak over its shoulders (figure 49). The reference is to a famous legend about Tegbesu, whose traitorous brothers opposed his enstoolment. They laced a ceremonial tunic that he was required to wear for an entire day with leaves, stinging nettles, and other substances designed to make the garment literally unbearable, but the king, symbolized by the buffalo, prevailed. The Tegbesu buffalo is one of the most common symbolic images associated with the monarchs, appearing for example on a royal asen preserved in the collection of the Musée Historique d'Abomey and consistently shown on appliqué cloths commemorating the kings.

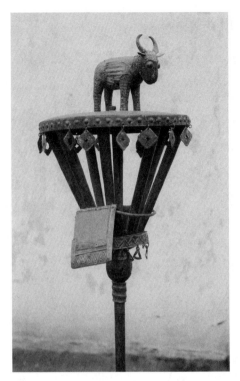

Figure 49. Royal asen made in honor of King Tegbesu. Collection Musée Historique d'Abomey. Photo: E. Bay.

Images associated with the bas-reliefs fashioned on the palace walls in the precolonial period were often representations of specific historic events and defining moments of war campaigns, and in that sense they tended to be narrative. However, a large number of bas-reliefs alluded to the verbal traditions that surrounded the seat of power in the kingdom. A seated monkey holding an ear of corn, for example, is a reminder of a story attributed to the reign of King Adandozan (1797–1818) (figure 50). Dahomey at the time was a tributary state of the empire of Oyo, required to send large quantities of foodstuffs annually to Oyo. When the Dahomeans protested the amount of tribute by sending an umbrella appliquéd with the image of a greedy maize-eating monkey, the king of Oyo responded by sending a hoe, thus admonishing the Dahomeans to do more farming (Waterlot 1926, planche IX).

Praise poetry often yields what are called "strong names," monikers that represent an abbreviated form of a sentence or praise phrase characterizing an individual. A strong name may be represented visually by a single motif in any number of media. For example, the most common image associated

Figure 50. Mud bas-relief from the Palace of Gezo (Waterlot 1926, planche IX).

with the late nineteenth-century King Glele is the lion, *kinikini,* a motif drawn from the praise phrase *kinikini lan wa du bo adra hwa gbe* (the teeth of the lion have grown, and he is feared by all) (figure 51). Laudatory strong names are well known for the kings and are represented on bas-reliefs, appliqués, and makpo over the course of the late period of the kingdom and throughout the twentieth century. Less well illustrated are the strong names for queen mothers, or *kpojito,* though like the kings, over the course of their reigns the kpojito took literally dozens of praise names alluding to events associated with their lives or personal qualities of character.

Rebuses also reference praise poetry associated with names. Auguste le Hérissé, who developed a profound knowledge of Fon culture at the opening of the colonial era, was the first French colonial official to move around Abomey without an armed escort or interpreter. When people suggested that such behavior might be dangerous, he would effectively shrug his shoulders. Responding "n'makambio" (it doesn't matter) to virtually all warnings, whether about his personal safety, the hot sun, or obstructions in a path, Hérissé became *Yovo n'makambio* (the white who doesn't show concern). At one point the Hountondji smiths created a ceremonial makpo in his honor based on a rebus. It included an image of a local tree, *oun,* and its leaves, *ama,*

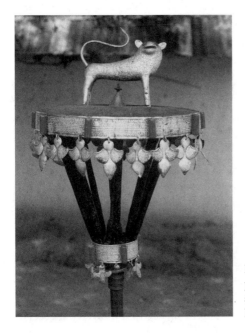

Figure 51. Asen said to date from the period of World War I preserved in a branch of the family of King Glele. Near Abomey, 1984. Photo: E. Bay.

encircled with a cord, *kan,* and with an interval between its branches, *biyo.* Together, the imagery—*oun-'ma-kan-biyo*—puns his nickname, N'makambio (Waterlot 1926, planche XXIII).

Proverbs typically are suggested by commonplace motifs: animals, plants, tools, and ritual objects. A snake in the act of swallowing a frog illustrates a familiar proverb, that a frog about to be swallowed by a snake will be saved by an invisible hand—unseen powers are available to protect us (figure 52). A banana plant stands for the proverb "the banana always leaves its child," for everyone knows that the banana tree produces a stalk of fruit only once before it dies, but that it leaves a shoot that produces the next plant. A pig may be a reminder that "as long as the pig is free, no grass will grow in front of my father's house," an allusion to personal responsibility and order in its evocation of the cleared area that should exist around any building.

It is in the realm of commonplace images that the complexities and ambiguities of verbal-visual signals emerge most clearly. Many distinctive motifs, such as the cloak-clad buffalo of Tegbesu, are universally interpreted in the same way. Others, though, may evoke a number of possible interpretations. For example, when is a lion an allusion to King Glele or his descendants, and when is it an allusion to a folktale or proverb that uses animal imagery?

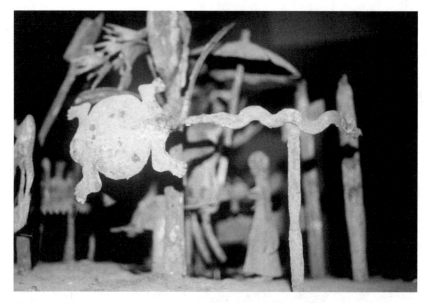

Figure 52. Detail of an asen illustrating the proverb that a frog will be saved by an invisible hand. Michael C. Carlos Museum. Ex coll. William S. Arnett.

When do three round objects suggest the *adjí* seeds associated with Fa divination, and when do they represent cooking stones? When is a snake meant to symbolize wealth and long life, and when is it an allusion to any number of proverbs about serpents? The problem is compounded by standards of verbal artistry that revel in ambiguity and double-entendre. A young friend in Ouidah, for example, described the contemporary version of gourd carvings circulated between lovers—hand-drawn sketches on paper meant to speak a private visual language of courtship. A young man might send a girl a picture of a broom and house, meaning, "I need you to sweep in front of my house," a proposal that speaks volumes about expectations of women in Fon culture. She might refuse by returning a drawing of a clock showing 11:45, "I'm not yet ready" (Interview with de Souza, 16 June 1999).

A cross is one of the most contested motifs of Fon verbal artistry. As we have seen, it appears in precolonial times as body art worn by courtiers in the form of a crucifix used to suggest ideas associated with sacrifice. A bas-relief from the section of the palace built by King Agaja (ca. 1716–40) shows a European ship with a seated, long-haired human figure holding a cross, which in the 1910s was said to represent a Portuguese priest (figure 53). A twentieth-century researcher claimed that the cross on an asen "signifie que la personne après sa mort est allée voir Dieu et lui demander des bénédic-

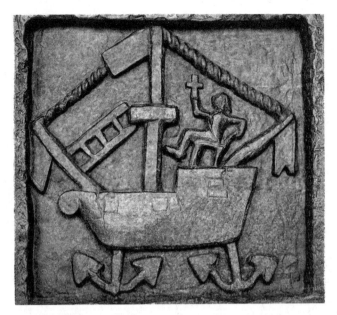

Figure 53. Mud bas-relief from the palace of Agaja (Waterlot 1926, planche V-B).

tions pour la famille" (means that the person after his death has gone to see God and ask blessings for the family) (Falcon 1970, 156). However, these associations of the cross with the religion of Europeans are contradicted by contemporary Beninese who insist that the cross represents Mawu, the female creator deity of the pantheon of vodun. In 1931 Herskovits similarly found that people read a cruciform design on gourds as *dja hwele yehwe* (by the grace of Mawu) (1938, vol. 2, 347). That same reading of crosses was ubiquitous during the period of my initial field research on asen in the 1980s.

Yet it is clear that the ambiguity of meanings associated with visual images is not a problem for Fon culture. Rather, it constitutes an invitation to invention, to the imaginative application of verbal understandings to images that may be read and reread for messages that speak to the changing concerns of the present. This phenomenon is apparent, for example, in the changing dialogue of the tour guides of the Musée Historique d'Abomey who lead visitors through the restored palace of King Glele. In a tour of the museum in late 1989, I was surprised to hear an interpretation of a bas-relief representing the capture of a slave as a reference to King Adandozan, a monarch overthrown in a coup d'état in about 1818 whose memory was dropped from all official oral histories. Though people informally acknowledged that Adandozan

had reigned, never before had I heard his name invoked within the palace itself. Adandozan, the guide now explained, was overthrown because he had stopped the slave trade, the economy had ground to a halt, no money was coming into the country, people had no work, and there was nothing to eat. It was no coincidence that at that moment Benin was in the midst of grave national crisis: the then-president had been thoroughly discredited for mismanagement, the country was effectively bankrupt, civil-service salaries were months in arrears, no one was working, and rumors of people lacking food abounded. When I toured the museum in 1999, news had recently broken of the smuggling of village children out of Benin to work in other countries. A bas-relief that showed two figures in the process of hanging a third, it was explained, represented a Yoruba who came to buy children as slaves but was caught and hanged by the Dahomeans (figure 54).

The problem, or opportunity, of multiple interpretations is compounded when a series of objects are represented together on an appliqué, an asen, or a carved gourd. Some motifs may have been intended to be read together as rebuses; others may be symbols of proverbs or allusions to stories; occasionally figures are specific to a given moment in time. Yet the whole is meant to

Figure 54. Mud relief from the Palace of Dahomey, now the Musée Historique d'Abomey. Photograph by Eliot Elisofon, 1971. Image no. EEPA 16585, Eliot Elisofon Photographic Archives, National Museum of African Art, Smithsonian Institution.

allude to a complex but unified verbal referent. At times it is only the individual whose imagination created the message and the artist who produced a repertoire of images to represent it who know the precise meaning of the motifs and their relationship to each other. In effect, in the world of verbal-visual representation in Fon culture, the word is supreme. It precedes the image and may be revealed only partially by it.

Royal Asen in the Period of the Kingdom of Dahomey

As we saw in chapter 2, the creation and use of elaborate ancestral asen appears to have been pioneered in the nineteenth century at the level of the monarchy and been limited to individuals associated with the dynasty, most prominently the kings and kpojito. Two major sources provide insight into the messages and meanings of asen imagery during the period of the kingdom: 1) the detailed descriptions of royal ancestral asen and their meanings as recorded by J. A. Skertchly in 1871, and 2) a 1952 catalog written by Paul Mercier that surveyed royal asen preserved in the Musée Historique d'Abomey. Together they underscore the nature of the royal Dahomean asen as voices of power reflecting a self-image of the dynasty as supreme, invincible, and everlasting.

The explications that Skertchly was offered for asen imagery suggest that allusion to orature, to proverbs and symbols, was central to the royal tradition, as was a concomitant need for explication. More than once he notes that the king described the allegorical meanings of the objects not only to him as a foreigner but also to the entire assembled court. Generally, the asen that Skertchly describes in detail were complex constructions involving projections from the supporting asen stake as well as figures atop the asen plateau. One asen, for example, "was of the usual cresset shape, surrounded by vertical hoops of iron, upon each of which a brass frog was fixed. At the base, on two sides of the cresset, were models of houses with a couple of guns on the eaves of the roofs." Skertchly was told that the asen was meant to represent a pond in which there were numerous frogs. Since the presence of frogs around a pond signaled sweet water, the imagery was a metaphor: Dahomey was a pond, and King Glele was the frog, "without which the water would spoil. The water being good, leopards, wolves, and other animals come to it; and although they do not permanently injure the water, yet by stirring up the mud they render it unfit to drink until the sediment is deposited. So men with guns must be stationed to keep off these intruders, and the huts and guns on the calabash are representative of the Dahoman soldiers" (Skertchly

1874, 429). This asen dedicated to Glele's father, King Gezo, was less a monument to the accomplishments of the deceased monarch than a testament to the reigning king's determination to protect and guard the kingdom, to maintain it against invasion by state enemies wishing to "drink" of its pure water. The only other asen whose meaning was explicated in detail to Skertchly functioned similarly, as an object of verbal visual power that spoke of the strength of the living king even though it was dedicated to his father (see chapter 2).

So far as I have been able to determine, apart from those of Skertchly, no other detailed descriptions of the imagery and meaning of royal asen have come down to us directly from the period before the colonial conquest. With the burning of the Abomey palace and the flight of the court in 1892, many of the kingdom's extant royal asen appear to have been destroyed. Nevertheless, a sizable collection of asen dedicated to the kings and kpojito became a core element of the holdings of the Musée Historique d'Abomey when the colonial authorities created a museum on the palace grounds. The museum's asen are likely the products of the artisans who were assembled by King Agoliagbo after his enstoolment in early 1894. Intent on completing the funeral ceremonies for Glele, Agoliagbo charged the royal artists with recreating the royal treasury of arts.

Paul Mercier researched this museum collection of asen in the early 1950s and wrote an invaluable illustrated catalog of it based on documentation that has since disappeared. Crediting the creation of all the asen to the Hountondji, he provides attributions of asen to specific kings and kpojito for 106 of the 169 in the collection. Of those, more than half (54) were said to have been made in honor of Glele, which underlines the probability that they were the products of smiths employed to make objects for Glele's funeral. Five, which presumably date to the twentieth century, were made in the names of the two kings (Behanzin and Agoliagbo) and kpojito who followed Glele (Mercier 1952).[2] Another eight were interpreted as applicable to the kings as a group (figure 55).

While the museum asen tend to be visually less complex than those described by Skertchly, the technology of manufacture is identical to that documented prior to the conquest. Major tableau figures atop the asen are fashioned through one of three different techniques: wrought iron or other metals; sheets of repoussé brass or plates of iron riveted together; or wood carved and covered with a sheath of silver, brass, or even iron and often embellished with chased detail. Several include a *go* (conical base) covered

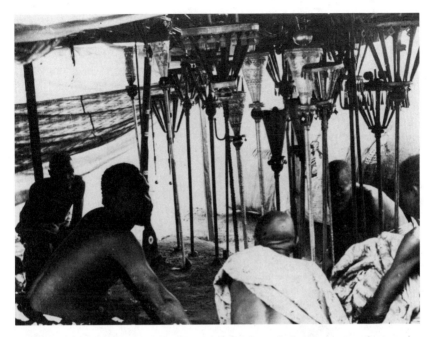

Figure 55. Princes of the royal family, working under a cloth, prepare asen for ceremonies. Undated photo by B. Maupoil. D-35-154-40. Formerly Photothèque, Musée de l'Homme.

with nonrepresentational repoussé designs, a decorative tradition that disappeared in the twentieth century (figure 56).

Like the form of the asen itself, the verbal messages of the museum asen tend to be relatively simple, drawing directly on the strong names and heraldry of the various monarchs and their queen mothers. They are expressed in a relentlessly first-person voice that boasts of the strength of the reigning monarch or his father and that emphasizes force and will as central elements of leadership. At the same time, that first-person voice individualizes the personal qualities of a given king, setting him in a specific historical context. For example, one of the two asen dedicated to Behanzin uses two motifs drawn from his most famous praise names.

One motif is a pair of silver hands holding a solid silver egg, *gbe han zin bo ai djre* (the world holds the egg that the earth desires)—Behanzin is the king that everyone has been waiting for (figure 57). The strong name is simultaneously boastful and ironic, since Behanzin's accession to power

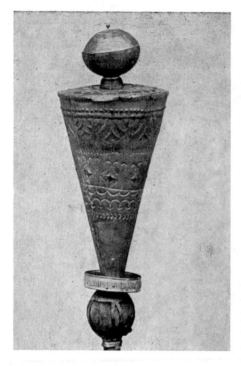

Figure 56. Royal asen from the collection of the Musée Historique d'Abomey (Mercier 1952, 81).

was strongly contested. The image also reflects, perhaps unintentionally, the impatience with which the new king awaited the demise of his father, who languished in ill health for many years. The silver pendants that hang from the top decorative border are in the form of fish, evoking Behanzin's metaphoric strong name as the shark that patrols the sand bar off Ouidah beach, a warning to the Europeans who threatened Dahomey at the time of the king's accession.

One of the most complex of the museum asen uses a rebus to recall a praise phrase offered by Agoliagbo about himself and his father, Glele (figure 58). A wooden horse, *so*, with a brass dog, *avun*, on his back becomes *avunso* or *avunsotoke*, a vampire bat, while two additional bats hang from the horse's brass saddle, and an umbrella sits above all. Said to have been designed by Agoliagbo, the images say, "The bat can tuck his chin and the vampire bat can tuck his chin, but the bird that lowers his head gets a beak in his stomach." In other words, the two kings (the bats), an image reinforced by the umbrella symbolizing royal authority, can do things that no one else can do (Mercier 1952, 32–33). Agoliagbo was a rival to his brother Behanzin, who was defeated

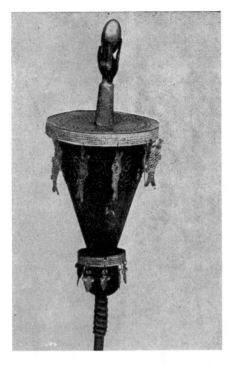

Figure 57. Asen made in honor of King Behanzin. Collection of the Musée Historique d'Abomey (Mercier 1952, 93).

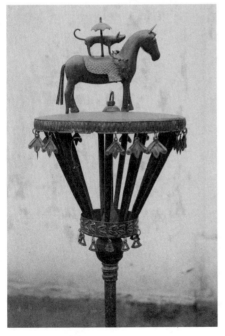

Figure 58. Royal asen from the collection of the Musée Historique d'Abomey. Photo: E. Bay.

and deposed by the French, so there may be a further subtext to this strong name that was not recognized by Mercier, an association of Behanzin with the bird, a creature that sometimes stands as a symbol of the negative use of occult power, of which his detractors accused the deposed king.

Not all of the museum asen evoke a single king. One showing a wooden hand covered with hammered brass holds a cord made of threads of iron. It simultaneously refers to King Glele and to all the kings (figure 59). One of Glele's strong names was *Kosu kosu no ni ka e do me lo me a* (The termite cannot chew a cord that is held by someone). The proverb alludes to the succession struggle at the time of the death of the king's father, when Glele, despite being the official heir to the throne, was forced to compete with rival princes for power. In essence, the cord represents control over the kingdom, and Glele boasts that those who challenged him could not possibly prevail because he was always in control of the cord. The cord, however, similarly evokes *ja hon hen nu alo ma yi* (what is properly held does not escape). Described as a reference to the continuity of the dynasty, the praise phrase is a comment on the history of the kingdom, that the dynasty successfully governed over the years, and an admonishment to new kings to govern well

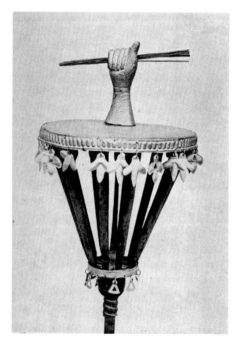

Figure 59. Asen attributed to all the kings. Collection of the Musée Historique d'Abomey (Mercier 1952, 79).

so as to maintain that control (Mercier 1952, 23). Even the relatively less com-
plex figural motifs of the museum's royal asen, then, are open to multiple
interpretations. Mercier's study drew on interpretations collected in 1934 by
Bernard Maupoil. In a number of cases, Mercier found that the interpreta-
tions he was given at the beginning of the 1950s differed from those collected
for the same objects by Maupoil, an indication of the vibrancy of the tradi-
tions of verbal-visual interpretation.

The nineteenth-century royal ancestral asen first established the voices of
tradition for asen design. Whether complex iconographically, as in the case
of those recorded by Skertchly, or relatively simple, as in the case of the asen
of the Musée Historique d'Abomey, these royal asen spoke with first-person
voices of power that equated nation and dynasty. What was important was at
the center: the rivalries near the royal stool, the relations of queen mothers
with jealous co-wives, the parallels between present rulers and their invis-
ible predecessors. The ancestral asen spoke visual languages of ability and
might, of power that would be wielded by a single family in the name of all.
Nowhere was there even a hint of voices outside the center. And yet beneath
what seemed to be the unsettling silence of any other form of voice was the
word of the smith, naming and claiming his role as creator of these remark-
able expressions of the dynasty-centric vision of the ruling class. The signa-
ture of the smith, in the form of specially designed pendants hung from the
circular edges of the asen platform, would become a standard part of asen
visual language in the midcolonial period.

Sign of the Smith

Ancestral asen comparable to those of the days of the kings continued to be
made into the twentieth century. To honor chiefs or members of the royal
family, particularly those descending directly from the kings, they generally
used one of the strong-name motifs drawn from the regalia of the chief's or
prince's ancestral king. At the same time, commoner families in the area of
the old kingdom of Dahomey began to use ancestral asen with visual motifs
once their use no longer represented a form of lese majesty. Herskovits and
Maupoil, whose field research was between 1931 and 1936, published similar
photos of the Abomey market showing a section of ancestral asen for sale.
Many of the larger asen at that time were adorned with figurative motifs.
Nevertheless, Mercier remarked in 1952 that the asen of common people
were rarely embellished with imagery, or if they were, that the motifs were
very general (1952, 11 n.4). His impression was seconded by Pierre Verger,

whose 1954 observation about the use of figurative asen is the epigraph for this chapter (1954, 191). By the time of my initial field research in Benin in 1971–73, however, decorative asen appeared to be in general use, and certainly by 1984, when I began specifically to investigate asen traditions, there was a sense that nearly "everyone" used asen with multiple figurative motifs.

There was a democratizing trend over the course of the twentieth century, as the use of figural asen spread progressively down through Fon social hierarchies from the royal to the most common of Beninese citizens (figure 60). What likely happened was a diffusion initially to the ranks of the politically and economically prominent, persons who may or may not have been members of the royal family but whose prestige was such—for example, as heads of families—that kin and friends considered that they deserved to be memorialized with an asen and probably also to be apotheosized into the ranks of the Nesuhwe. This initial diffusion would have paralleled the adoption of royal regalia by colonial elites in the period between World Wars I and II. At some later point, well into the second half of the twentieth century, asen use became generalized as an essential element of the funerary process for most adult members of families. As late as the 1980s, though, people still would indicate to me that not everyone was honored with asen but rather

Figure 60. Inexpensive asen for sale in the market at Bohicon, 1984. Photo: E. Bay.

only exemplary individuals, whose heirs and friends were willing to make the financial sacrifice necessary for the process.

Exemplary lives or not, ancestral asen were not all created equal. While decorative asen in the precolonial period had been limited to a narrow spectrum of politically central individuals, and ancestral asen in the twentieth century became objects open to use by all, they also began to differ physically according to the financial resources of their purchasers. As early as 1911 an observer commented, "Ces objets se font de taille et de modèles différents en rapport avec la fortune de l'acheteur" (These objects are made in different sizes and models according to the wealth of the buyer) (Hérissé 1911, 363–65). Asen varied by size, by metals of manufacture, by the skills of their smith-creators, and by the visual complexity of their imagery, the whole reflecting class differences in twentieth-century Benin.

Not only did asen vary on the basis of individual factors of purchaser wealth and smith skill; what was most prestigious changed over time according to the relative availability of the materials of manufacture. For example, precious metals, and specifically silver, were still used on some asen as late as the 1920s. By the 1980s, in contrast, when the economy was reaching what was arguably its weakest point in the century, the finest metal used to provide the color of silver had become aluminum. Casting smiths in the 1980s preferred to work with *gan vovo* (red metal), brass acquired from taps and other plumbing fixtures enhanced with copper wire obtained from the treads of burned truck tires (Interview with Agbakodji, 22 August 1984).

Paralleling the move to less expensive materials, the maximum height of asen dropped at some point in the century, whether for economic reasons or reasons of style is unclear. Photos from the early 1930s confirm impressive dimensions. However, by the period of my 1984 field research, asen in the Abomey area were typically no taller than a meter at most. In Ouidah at that time, large asen with wide platforms and heights of nearly two meters could still be found in the deho of a few families, but smiths no longer were making them in such large dimensions.

The one element that remained constant in the changing material configurations of ancestral asen over the course of the century was the reality that asen made by Hountondji smiths, and particularly those adorned with cast brass figures, were the most prestigious (figure 61). A kind of material hierarchy was apparent in the late twentieth century. Virtually all asen were created by smiths, but the finest and most expensive were fashioned by Hountondji master casters in Abomey, which were ordered by clients as far away as Cotonou and Ouidah. Next in price and prestige came asen with one

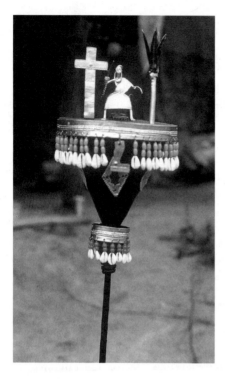

Figure 61. Asen made in 1984 by Aloha Agbakodji, reputedly the finest asen smith of Abomey in the 1970s and 1980s. Photo: E. Bay.

or more cast figures assembled by smiths, some of whom were Hountondji, who purchased ready-made figures from the casters and added them to their own handmade creations. The Hountondji casters joked contemptuously about such smiths, saying, "Vi de su tu xo-o, e no xo tu" (Not everyone can buy a gun, but anyone can buy a bow) (Interview with Agbakodji, 3 August 1984). Then followed numbers of asen assembled by smiths around southern Benin of cut and forged steel, often blackened with pitch or painted silver to disguise the origins of the metal, which might be drawn from steel drums or even auto bodies. Smallest in size and least expensive were ancestral asen with small motifs cut from cans. The inside can surfaces provided color suggestive of more expensive metals, with "gold" figural motifs snipped from tomato tins and "silver" from condensed-milk cans.

Apart from the precolonial period, the Hountondji smiths point to the mid-twentieth century, roughly from the 1930s to the 1960s, as the period when asen creation was at its height and when the finest asen were made. By that point, a relatively prosperous chiefly and administrative elite could com-

mission elaborate asen with cast figures, and competing smiths responded by proudly signing their work. The signatures were not self-evident. Mercier in the early 1950s was puzzled by the meanings of the pendants that hung from the circular skirts ringing the asen platforms and the bases of the conical forms. He attempted a typology of pendants of the Abomey museum asen but clearly had difficulties in assessing either what was being represented or what meaning it might have. As we have seen in the case of Behanzin and his fish motif, occasionally those pendants or *togbe* (a term that most commonly means "earring" in Fongbe) were part of the message of the asen itself. Many more were geometric, floral, or took other forms with no apparent representational meaning. Some togbe, however, were directly associated with the smiths and were effectively an artist's signature. For example, smiths of a leading branch of the Hountondji, the Ayissi, adopted a bilobe form resembling a bean (*ayikun*), which appears in Mercier's typology (1952, 16) (figure 62). The bean recalls the term *ayi*, which means "kidney" in Fongbe, the organ of the body that is comparable to the heart in Western culture, the seat of emotion and thought. Ayissi, which means literally the wife or the dependant of the emotions, was the name of the firstborn son of Kpahissou, the Hountoundji smith who first settled in Abomey ([Hountondji] n.d; Interviews with Agbadodji, 18 August 1984; and Jean Abiala, 7 August 1984). Certain Ayissi Hountondji smiths continued to use their bean signature throughout

Figure 62. *Togbe,* or hanging pendants, representing a smith of the Aissi branch of the Hountondji. Photo: E. Bay.

the twentieth century. Two other togbe illustrated by Mercier were perhaps signs of certain smiths, one representing a bellows and the other a leaf identified with Gu, the deity-protector of smiths (1952, 17–18). Other decorative forms were adopted in the twentieth century as individual signatures; the work of two Hountondji smiths of the 1930s can be distinguished, one by a diamond-shaped togbe with raised edges and a central protrusion, and the second by a series of six scroll shapes issuing from the base of the asen cone. At some later point in time, smiths began to use the word *aflefle* (tin) to describe the dangling "earrings" around the circular platform of asen. With their manufacture delegated to apprentices, who by the latter part of the century snipped these pendants from cheap metal containers and worked them into rudimentary patterns, the aflefle were a sign of the diminishing means of asen creators as well as consumers.

The differentiation in asen according to the economic means of smiths and consumers was a message in itself, suggesting that an asen could be understood as a sacrifice on the part of the individual purchaser. In the 1980s, well-to-do individuals practiced a form of conspicuous consumption, ordering complex asen made of the finest metals available that might cost as much as $250. The lavish expenditure reflected well on the donor and the dead. That sense of agency, of a living person acting on behalf of the dead, was reinforced by the messages of the motifs atop asen platforms during the twentieth century.

6

Mixed Messages and Migrating Meanings

*Il y a également chez eux, une autre coutume également louable,
c'est l'invention des emblèmes par lesquels ils expriment leurs
sentiments quand il y a un décès dans leurs familles.*

(There is also among them another equally admirable custom, the
invention of symbols through which they express their feelings
when there is a death in their families).

—Norbert Agheci

The messages of the royal ancestral asen of the precolonial period
focus on the visible world of state power, on the strengths of the kings and
queen mothers of the dynasty. In contrast, the decorative tableaux of asen
of the mid-twentieth-century, roughly from the 1920s through the 1970s,
speak intimately of relationships within families. They talk of close friends,
of the dead, and of the connection between the living and the dead. A visual
vocabulary of obligation and agency is striking. References to the power and
prowess of kings and queen mothers are replaced with images that pres-
ent punned pledges of kin support, promises of vigilance, and praises of
thanksgiving for the dead. Their voices speak of families and friends, of the
need to preserve and protect kinsmen and survivors, of the desire, despite
hardship and difficulty, to do what is needed to honor the dead and hence
maintain the lineage.

Why an elaborate vocabulary stressing the centrality of the family devel-
oped is not clear. However, the early colonial authorities had replaced a highly
centralized state organized through kinship links with unpredictable foreign
domination. People would have felt an acute sense of insecurity with what
must have appeared highly arbitrary rule. The lineage, which offered access
to land and thus livelihood, would have loomed large as the major social unit
representing continuity and security.

It was early in this period that the complicated messages and meanings of

another medium, funerary appliqué cloths, paralleled what were to become commonplace ancestral asen motifs by midcentury. Did the appliqué cloths, with their messages of intrafamilial solidarity, influence ancestral asen design, or were the art forms parallel developments springing from the post–World War I flourishing of arts and culture in Benin? The evidence is inconclusive, though the striking commonality of motifs underlines a clear connection.

People in Benin these days say that the finest asen have unique messages fully understood only by the donor and the smith. This proved to be true in my field research, as no individual ever claimed to be able to unravel the precise meaning of the complex images arrayed as asen tableaux, except in the case of persons who themselves had commissioned the piece. Nevertheless, asen creators in the middle period drew on a common vocabulary of motifs that was widely quoted and combined in innumerable ways. These same motifs and their meanings were typical of a tiny documented body of funerary appliqué cloths that date to the 1927–32 period. Because of the richness of the documentation of messages embedded in funerary appliqué cloths, we turn first to their use and analysis. Then we explore how similar imagery was incorporated onto asen tableaux. The chapter ends with a consideration of how and why ancestral asen use was being discontinued by the turn of the twenty-first century.

Abomey Funerary Appliqués

The experience of the Hountondji smiths in the first three decades of the twentieth century was not altogether unique. Their genius in adapting cast figures to the sacred form of asen was paralleled in the period by the experimentation of the makers of appliqués, many of whom, like the smiths, had been exclusive purveyors to the king and palace organization in the precolonial period. By the late 1920s, a cathecist trained by Father Aupiais was documenting the production of large figurative appliqué banners used in ceremonies associated with the funerals of prominent individuals. The use of such appliqués appears to have been an adaptation for commoner use of a medium formerly monopolized by the court of Dahomey. Yet the funeral appliqué tradition may have been more—in the absence of evidence of the use of similar funerary banners in the precolonial period, it may have been a deliberate and highly inventive adaptation of a visual medium to convey images drawn from Fon verbal arts.

Appliqué work was common in Dahomey from the early nineteenth century, and the introduction of the skill into the kingdom is attributed to King

Agonglo, who reigned from 1789 to 1797. Beginning at the latest with King Gezo (1818–58), appliqué production was centered in Abomey and monopolized by the state for use on military uniforms, tents, umbrellas, and festival banners. Their motifs paralleled those of the decorative bas-reliefs on the Abomey palace walls: symbols of the kings and other important officials; weapons of war, scenes of battle, and other events in Dahomean history; and images of various vodun. Scattered references suggest too that individuals of note were given opportunities to express ideas through symbols or narrative motifs appliquéd on flags, banners, and umbrellas.[1]

Appliqués were visible at moments when the ancestors were honored, as, for example, late in the nineteenth century at the royal ceremonies to feed the kings and queen mothers, when the deho was draped with an enormous appliqué cover (figure 63). Families of appliqué makers were established in Abomey, much as the Hountondji had been, and were given land for their compounds, slaves and wives for their support, and villages for their provisions. For example, the Yemadje appliqué makers of Hountondji Quarter, who became the most renowned appliqué artists for the tourist trade in the twentieth century, date their arrival in Dahomey to the end of the eighteenth century, when their ancestor was recruited from the town of Tenji to be resettled in the capitol. However, unlike the Hountondji, there was no single family that became most closely associated with the finest appliqué work in the precolonial period. Rather, a number of families located in several quarters of Abomey were involved in the production of appliqués from imported fabrics. Indeed, so large was the kingdom's need for appliqué work in the nineteenth century that women from the palace population were enlisted to sew, particularly for the appliquéd insignia used on the company banners and the military uniforms of the men's and women's armies (figure 64).

Appliqué work, like work in the metal arts, became commoditized in the early colonial period and was commonly visible by the 1920s in the traditional dress and regalia of royal and colonial elites and in the performance costuming of religious and ritual groups. Chiefly regalia included appliquéd symbols on umbrellas, hats, banners, and occasionally dress wrappers. Moreover, by this period elites generally had adopted "traditional" dress that might include appliqué work for occasions of formality. For example, Paul Hazoume and other Benin notables who were not of royal birth were photographed in 1930–31 wearing dress suited to the courts of Dahomey and Porto-Novo (figure 65). The vodunsi of the royal and popular cults also used appliqué work in their performance attire, umbrellas and flags, and hangings for walls and doorways. Appliqué has continued to be a central visual element of their public perfor-

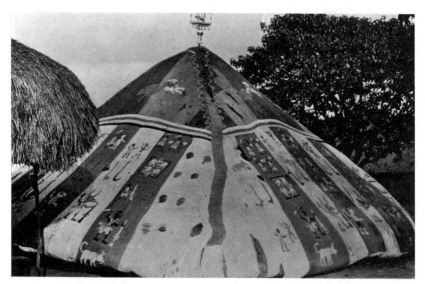

Figure 63. Deho covered with appliqué cloth for royal ceremonies. A portion of a hotagan-tin asen is visible at the apex. E-35–150–40. Formerly Photothèque, Musée de l'Homme.

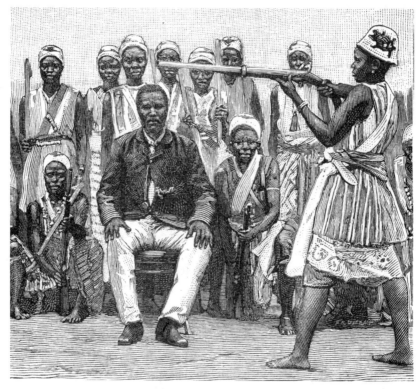

Figure 64. Detail of an engraving of women soldiers, probably from a private company in Ouidah, showing appliqué insignia on uniform caps (Foa 1895, 254–55).

Figure 65. Paul Hazoume at the home of Albert Kahn, Boulogne-sur-Seine, 24 September 1931. Original in autochrome. Photo: Roger Dumas. Musée Albert-Kahn, Département des Hauts-de-Seine.

mances. Meanwhile, Kutito, the masquerade society newly adapted on the Abomey plateau from the Yoruba Egungun, used and continues to use a wealth of appliqué work in the streamers of their elaborate masquerade costumes.

As was the case with cast brass figures, a market directed to the tourist trade and local patrons paralleled the one for sacred and prestige appliqués. In 1931, Melville Herskovits collected several large hangings with imagery drawn from quotidian life: a group of men hoeing, hunters attacking an elephant, a woman nursing twins, and so on. He claimed that such hangings were purchased by Beninese patrons "of rank and power," mainly chiefs, who purchased banners as objects of art and displayed them in their homes. Such works were relatively costly and could not be afforded by most people, Herskovits argued, though he believed that "society banners," the category in which he placed appliqué cloths associated with funerals, were much less expensive (1938, vol. 2, 328–34).[2] The makers of appliqués would continue to practice their art with an impressive degree of imaginative vitality throughout the twentieth century. By the early postcolonial period (1960s–70s), the subject matter of tourist appliqués had become nearly entirely historical, drawn from court heraldry and praise names of kings. In the last two decades of the twentieth century, the style of representation and the motifs showed increasing diversity, as young artists experimented with different colors, representational themes, and textures of fabric.

No precolonial accounts mention the use of figural banners in funerals, either at the level of the kings or commoners.[3] Around 1930, however, Norbert Agheci (Abbécy), a student of Father Aupiais who became a schoolmaster in Abomey, drew the attention of outsiders to funerary appliqués. Born of a lineage of appliqué makers, Agheci presented three funerary banners to Aupiais in the late 1920s and in 1932 sent another three to the Musée d'Ethnographie du Trocadéro (later the Musée de l'Homme) in Paris. Melville Herskovits in 1931 acquired two appliqué banners that were clearly in the style of funeral cloths, and he saw a third banner in the Abomey market carried with a family group purchasing materials for final funeral ceremonies. These nine examples, all from the mid-1920s to mid-1930s, are the only documented examples of Fon funerary banners known to date. Agheci provided detailed documentation of the meanings and use of several in a letter to Father Aupiais that was reproduced nearly verbatim in a 1932 article in *Anthropos* (Agheci 1932, 417–22).[4]

Agheci linked the funerary appliqués to the giving of support to family members preparing for the second or final funeral. Burial in colonial Benin was typically done shortly after death. Months and even years might elapse

before a family would complete a second and final round of funeral ceremonies.[5] In the interval between the two sets of ceremonies, large sums of money and in-kind gifts would be collected to support the costs of the final celebration. Children of the dead and their spouses, friends of the deceased, and friends of family members were all prominent as givers. Zindó, the ceremonial setting for the presentation of this financial support by family members, spouses, and friends, included a kind of competitive gift giving. Individuals would come forward in turn to present their cash gifts, giving speeches, singing songs, and reciting praises. The amounts given would be called out loudly, and at least by the late twentieth century they were carefully recorded in a ledger. It was here, in the public proclamations of affection for the bereaved and affirmation of support for the families of the dead, that Agheci placed the tradition of funerary appliqués.

The imagery of the appliqués drew on Dahomean orature, the rich Fon body of proverbs, metaphor, folktale, and song, to express a complex message associated with ideas of the proper relationship of the living to the dead. The themes of the banners were devised by the giver, who might be a friend or close relative of the deceased. The giver would develop a song based on his or her experiences with and relationship to the deceased and would then commission an appliqué cloth to illustrate the message. He or she would teach the song to a group of associates.[6] Arriving at a zindó, the donor and chorus would perform the song several times, and then the giver of the cloth would explain in everyday language the meaning of the various motifs. In effect, the appliqués illustrated a complex message through suggestive figural motifs, some of which operated as rebuses, or visual puns in Fongbe.

Agheci described one of the cloths that he presented to Aupiais as follows (figure 66): The donor of the cloth was a man who had been afflicted with illness for a number of years and who had been impoverished by the need to pay for his medical treatment. He was only beginning to regain his health when the mother of his close friend died. He and the friend had sworn a blood pact together, which meant that they were linked until death under mutual obligation to assist each other in times of crisis, and particularly in the case of funerals of close kinsmen. The man sold his tools (Agheci does not indicate his trade) and gave the proceeds to the friend, but he was still not satisfied with his contribution. The funeral appliqué that he designed was meant to express his profound regret at being unable to assist his friend to a greater extent.

Near the top left of the banner, the convalescent friend shows himself with his regrettably empty hands. To the right is a metal scraper used by smiths

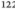

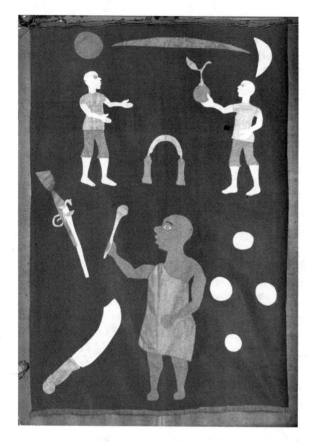

Figure 66. Funerary appliqué presented by Norbert Agheci to Father Aupiais. Photo taken at the Exposition of Black Art, Orléans, 14 December 1927. Original in autochrome. Musée Albert-Kahn, Département des Hauts-de-Seine.

and coopers, an object called *awa* in Fongbe. *Awa* is an allusion to the verb *wa* (to come), meaning that the donor has come, has arrived to be of help. The figure to the right of the scraper is a man holding a fruit called *vô,* another rebus that this time suggests the homonym *vô* (assistance). Taken together, the three figures assert that, despite his poverty, the man has come to be of assistance at the funeral of his friend's mother. At the top of the banner are representations of the sun next to a blue crescent symbolizing its route from east to west, with the moon represented at right standing in opposition to the sun. The sun, a symbol of perseverance, is a reference to the donor's pledge to be faithful to his friend, for the sun rises every morning to march without fail to the western horizon.

On the lower left is another cluster of motifs—a gun, a rounded Dahomean sword, and a leper—calling to mind a familiar parable of courage. The

Dahomean army once attacked a village that had been forewarned and where everyone had fled save a leper. The leper, despite having no fingers or toes (note the stumps in the representation), held up a club and challenged the Dahomeans: "Il ne sera pas dit que vous êtes venus dans un village de lâches et que vous n'y avez rencontré personne pour lutter contre vous; quoique malade, je veux seul me dévouer pour mon pays et le défendre" (Let it not be said that you came into a village of cowards and found no one to fight against you; even though sick, I wish only to devote myself to my country and defend it) (Agheci 1932, 421). Like the leper, the donor of the cloth, despite his financial handicaps, proclaims that he will stand up without shame to try to help his friend with the funeral of his mother.

Finally, four cream-colored ovals represent fried balls of beans (atá or aklà) that are meant to remind the audience of a common Fon proverb. Atá, typically eaten as a snack, is compared with akasá, soft balls of boiled maize flour usually eaten as a meal with a sauce. Akasá, however, can also be diluted into a gruel and drunk. When you have no akasá, goes the proverb, you cannot thin atá in hot water to drink—you must not do something that you should not do; no matter what the circumstances, you must do what is required or expected. Agheci summed up the overall meaning of the cloth:

Voici que je n'ai rien en mains et je viens tout de même pour vous assister. Vous savez que le soleil n'abandonne jamais son chemin qui le conduit de l'orient à l'occident, cela prouve qu'on ne doit pas abandonner non plus le chemin de l'amitié pour aucune raison. . . . Il a été entendu que nous devons nous assister dans des circonstances pareilles; malheureusement voici que je me trouve à présent, dans l'indigence, mais cela ne doit pas m'empêcher de venir vous assister au moins pour vous servir, c'est pourquoi je vous rappelle la parole que le brave lépreux adressa aux guerriers. . . . En outre, ne croyez pas que je vais à cause de ma misérable situation, délayer des boulettes de haricots pour boire à la place de l'akassa dont je suis dépourvu.

(Here I am with nothing in my hands, and yet I come all the same to assist you. You know that the sun never abandons the path that leads it from east to west, which shows that similarly one must never abandon the path of friendship. . . . It was understood that we must help each other in similar circumstances; unfortunately, here I find myself at present in poverty, but that must not keep me from coming to help you, at least to serve you, which is why I remind you of the word that the brave leper addressed to the warriors. . . . In other words, don't believe that because of my miserable situation, I will put balls of bean in water to drink in the place of the akassa that I do not have.) (1932, 422)

Clearly, the funerary appliqués documented by Agheci were extremely complex, presenting symbols of meanings that were ambiguous even to people of the area, with their full messages undecipherable in the absence of the designer's musical context and verbal explanation. Moreover, Agheci claimed that the images were unique to each cloth: "Chaque déces nécessite de nouveaux emblèmes et de nouvelles chansons" (Each death requires new symbols and new songs) (1932, 417). The commissioning of a funeral banner required a good deal of creative energy, to say nothing of a substantial sum of money. Yet Agheci presents them as if they were a tradition widespread in Fon culture, or at least in the Abomey area. Unfortunately, we have no evidence of the use of funerary appliqués, save for that brief period of 1927–32.

Whatever the temporal point of its invention and the length of its existence, the use of funerary appliqués had been completely discontinued by the early postcolonial period. Knowledgeable informants in the Abomey area in the 1980s confirmed that it had existed but said simply that people no longer had the money to buy appliqué cloths. However, if cost was the sole cause of its disappearance, the presentation of appliqués at funeral ceremonies may have ended well before independence in 1960. Cotton was relatively plentiful and cheap up to the beginning of the Great Depression. However, in the mid-1930s, the French dealt a severe blow to cotton imports by renouncing a convention that had assured most-favored-nation status to British cotton. Customs duties rose sharply, and the volume of textile imports dropped and then fell even more severely with the onset of World War II. By the 1950s, cotton constituted only 10 percent of the value of total imports into the colony (Manning 1982, 236). Moreover, the imported cotton cloth that was the basis for funerary appliqués, unlike metal, could not be reused or recycled from other uses. As cotton prices rose, appliqué artists had no recourse but to pass higher materials costs on to their clients. By the time of independence, appliqué work continued to be used in the regalia of chiefs and costumes of cult adepts, but the main market for this textile art had clearly become a tourist market.

Paralleling the creativity that energized technological innovation in the metal arts, the flourishing of a tradition of funerary banners was evident at a particular moment in the midcolonial years. Others have noted a linking of verbal and visual expression in a number of media in twentieth-century Benin: appliqués, bas-reliefs, and carved gourds, for example. What is remarkable in the case of the appliqués is that the enigmatic imagery of the funerary banners, with their complex visual-verbal wordplay and messages of piety and devotion to the dead, precisely parallel the form and meanings

of representational motifs common to ancestral asen of the mid-twentieth century. It is not at all clear if funerary appliqués preceded the depiction of complex messages on ancestral asen and effectively transferred their meanings to the metal arts, or if the two parallel traditions existed in the 1930s. That remains a mystery. However, an exploration of those messages in metal, and how they have changed as their use expanded over the course of the twentieth century, is the subject of the next section.

Ancestral Asen Messages in the Middle Period

Older people in Abomey in the 1980s noted that asen had tended to replace appliqués in funerary ceremonies. Though most funerary appliqué cloths had been given by close friends of the deceased, usually by the institutionalized "best friend" noted by Herskovits in the 1930s, asen by the 1980s tended to be purchased by family members (Interview with Nondichao, 11 September 1984). People explained that asen might be commissioned or purchased by a sibling, child, or spouse, and only rarely a friend of the dead. At some point before or after the final funeral ceremonies, but most often at one of the several types of memorial rituals that have become increasingly common in the twentieth century, the donor of the asen would formally present it to the assembled family, backed by a chorus of friends singing *hanye* (funeral songs). The donor would explain publicly the meaning of the asen, and after appropriate prayers, sacrifices, libations, and incantations, it would be added to the other asen in the deho of the family of the deceased.

Underlining the centrality of the agency of the living donor of the asen and the importance of the individual honored by it, asen tableaux of the mid-twentieth century often included representations of one or both, the living and the dead, often placed in dialogical juxtaposition. The honored ancestor is typically represented in a seated position on a stool, a symbol of authority, or on a chair, a similar symbol in the case of asen from Ouidah. Donors can be recognized because they kneel, as is appropriate for one in the presence of a distinguished elder, or they stand, suggesting the strength of the position of elocution. Dress for living and dead follows the conventions of Abomey court rank and authority: the highest-ranking male wears a toga with the right shoulder bare and the cloth draped over his left; lower-ranking men wear their wrappers rolled around the waist with torsos nude; high-ranking women wear wrappers over the breasts with shoulders uncovered; and lower-ranking women wear wrappers tied at the waist, their breasts uncovered (figure 67). Cast figures of the donors and the dead are modeled and finished in typical

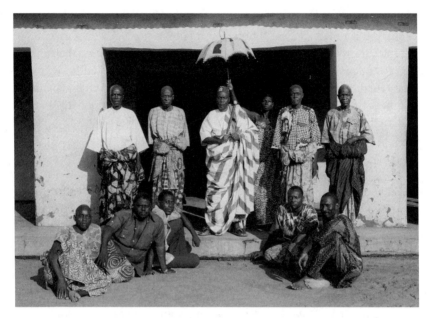

Figure 67. Princes and retainers with the head of a branch of the royal family. Lesser-ranking princes roll their six-meter wrappers around the waist in the presence of the family head. Only the chief may wear sandals. The umbrella is held by a wife, who wears her wrapper in the traditional fashion, bare-shouldered and tied over the breasts. Photo: E. Bay 1984.

Hountondji style: elongated bodies; large eyes, hands, and feet; garments carefully tooled to indicate the figurative patterns of cotton cloth. In effect, these are portraits in an idealized sense, with individuals distinguishable as donor or dead only by their dress style and stance. Ironically, since these forms of dress were limited to the royal family in precolonial times, the conventions of asen representation potentially make every man a king, every woman a queen mother, thus underlining once again the democratizing use of asen in the twentieth century.

Kings were not depicted as such on precolonial asen, yet their voices resounded with metaphorical and allegorical images of their accomplishments. In contrast, the purchasers of asen in the middle period are the ones who speak, articulating pledges that are directed to the dead, who are in turn depicted in idealized form. The living boast not of their secular or spiritual power in the political realm but of their ability to honor the ancestors, to keep the memory of the dead alive, and hence to help their spirits flourish.

Typically juxtaposed in and around human figures on asen of the middle period are scattered objects, animals, and plants, fixed in space without regard to narrative composition or relative scale, though the creator-smith may have taken care to create an interesting arrangement of forms. Certain motifs appear repeatedly, the power of their meanings making them an essential part of common asen parlance. The calabash, for example, appears again and again, sometimes set before the honored dead and sometimes held aloft by a kneeling donor. This powerful and polysemic emblem speaks of the unity of the worlds of the living and dead, of the cosmos, of the totality of Fon concepts of the universe. Doubling the idea of the sinuka, the vessel of sacred food set before the ancestors so that they may feast with the living, is the sinuka-asen, the vehicle that serves as transit point where the spoken words of living and dead meet and pass and where communication results in knowledge crucial to the well-being of both.

The braided rope, symbol of the dynasty in precolonial times, is interpreted on middle-period asen as the cord of continuity of the family (figure 68). Often passing through the hands of living and dead, the cord represents the

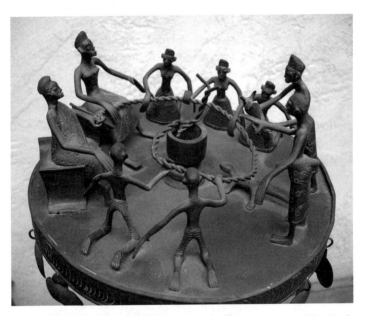

Figure 68. Detail of asen showing the braided rope threaded across the hands of family members that symbolizes solidarity across generations. Note the royal-style dress of the seated figures. Photo: E. Bay.

accomplishment of the ancestors, who lengthened and strengthened it over the course of their lifetimes, and the challenge of the living, who are responsible for continuing to plait it. The cord speaks, too, of the links between the visible and invisible made manifest in ceremony, sacrifice, and prayer before the assembled asen of the family. The cross is an often-present albeit ambiguous sign of the protection of spiritual power, whether of the God of Christianity or of Mawu. Though interpreted nearly universally as a sign of Mawu, many argue that the same divine essence is always present, that Mawu and God are simply different words for the creator of humanity.

Several rebuses and proverbs appear repeatedly, reaching the status of unambiguous, if not trite, phrases of asen piety. The *awa*, the scraping and gouging tool used by smiths and carpenters, which was represented on funerary appliqués, appears frequently on middle-period asen (figure 69). By punning *n wa* (I have come), the awa represents the fundamental pledge of donors of asen, that they will appear regularly to honor, feed, and serve the ancestors. A foot (*afo*) and a yam (*te, tevi*) together pun the phrase *n do fo te* (I am wholly ready, I am wholly sincere), an allusion to an individual's physical and moral strength, ready to perform ceremonies in honor of the dead. A final central image, the horned rainbow snake, Dan Aido Whedo, is held aloft by human figures on many asen. Its layered meanings draw on the snake vodun as symbol of the oldest and most distant of the ancestors, as supplier of wealth and well-being, as emblem of the essential parallel humanity of man and woman, and as participant in the original act of creation (figure 70). In Fongbe, the word *nyi* has multiple meanings, including "rainbow," the verb "to be, to name, to call," and the noun "name." As used on an asen, the meaning of *nyi* (the rainbow) is simultaneously an allusion to the bounty and goodness associated with the horned serpent, Dan Aido Whedo, as well as an allusion to the family of the dead, to the name that must be maintained forever, just as the cord of continuity must be plaited in perpetuity.

As in the case of the funerary appliqué analyzed above, the composition as a whole is intended to make a statement drawing on Fon oral arts. Because of people's reluctance to interpret asen that they did not commission, and because of the importance of creative interpretation in traditions of orature in Benin, I present here as an example of a unified message represented on an asen the story of an asen that I commissioned from a master smith and caster, Aloha Agbakodji, in 1984. The asen was created to honor my former mother-in-law, Elizabeth Raymond Ganga, who was killed in a car-train accident at the age of forty-seven, leaving six children, the youngest of whom was eight at the time. I explained to Agbakodji that all the children had grown

Figure 69. A smith scrapes the metal platform of an asen with an *awa* to polish it. Abomey, 1984. Photo: E. Bay.

to maturity, married, and become parents, and that I considered it sad that the woman had not lived to see any of her numerous grandchildren. Making no specific requests for any particular motif, I left the choice of motifs and design of the piece to the smith, who over the course of seventeen days cast and built an asen.

The outer circle of figures (figure 71) represent the members of the Ganga family, with Elizabeth and her husband seated on stools on one side facing two standing figures, my former husband and me. Completing the circle

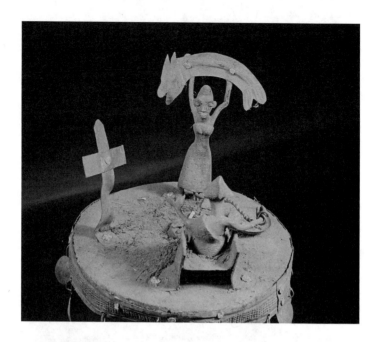

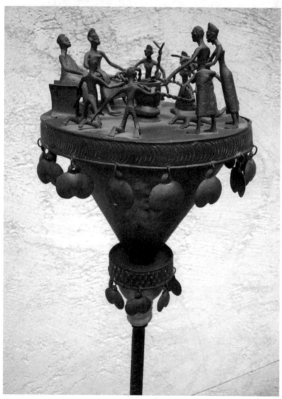

Figure 70. Detail of an asen showing the rainbow-snake associated with wealth, Dan Aido Whedo. William Arnett Collection.

Figure 71. Asen made by Aloha Agbakodji in honor of Elizabeth Raymond Ganga, 1984. Raymond Ganga Collection.

are the kneeling figures of Elizabeth's five other children, three women and two men. All are dressed in garments appropriate to the royal family of Dahomey, with all the men except the father wearing their wrappers rolled at the waist. I hold an image of the rainbow snake, which has a ribbon of copper inserted lengthwise on his body to make him fittingly multicolored. According to Agbakodji, my commissioning an asen was a way to uphold and celebrate the family name. A rope symbolizing kin continuity winds its way from the hand of the father, the head of the family in patrilineal Fon society, through the hands of each of the family members, then dips into a mortar at the center of the asen plateau. A mortar is called *tò* in Fongbe and has a homonym that means country, town, or village. Thus the cord refers to a family story based in another country. A final comment was included in the form of a large bush lizard, *ve*. *Ve* too has a homonym, a verb that means to be sorrowful, to be hurt, to be touched or moved. *Ve* is associated with things that are regrettable, painful, and sad, yet dear. In brief, the *ve* is the smith's comment on the story of a life cut short.

The Late Twentieth Century

No distinct point, or even series of years, marks the moment that changes in asen iconography began to move meanings away from the mid-twentieth-century messages of mutual obligation and service between living and dead. Nevertheless, the visual verbal vocabulary used to honor individual ancestors was making a dramatic shift in the years after independence in 1960. At its most insistent, the postcolonial trend discarded allusion altogether in favor of literal representation of the dead. Abandoning the complex and ambiguous imagery of rebus and proverb, late twentieth-century asen makers began to memorialize the dead through occupational portraiture and replaced the oral arts with the literality of the written word. Images of donors began to disappear; only the dead remained. In the Abomey area, the new trend was reflected too in the formal placement of motifs on asen plateaus. The mid-twentieth-century style had been characterized by a lack of frontality and central focus; an asen could effectively be twirled, the motifs viewed and read from multiple positions. Now, the figures began to be placed in careful balanced relationship to each other, always with clear indications of the single point from which the asen was to be viewed (figure 72).

In deho prayer rooms around Abomey by the 1980s, one would occasionally see asen with small metal plaques affixed to what was clearly meant to be the front focal point. On the metal plaque was impressed the name of the individual for whom the asen was made. The idea of the labeling of a

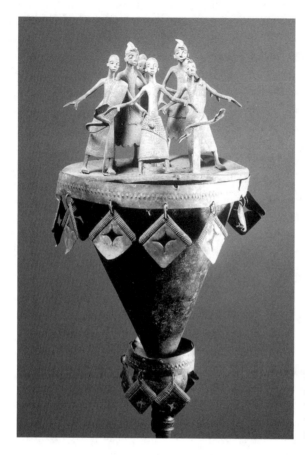

Figure 72. Asen plateau
depicting a group of
vodunsi, or servers of a
vodun. William Arnett
Collection.

figure with a personal name was not new in Fon artistic iconography. For
example, the National Museum of African Art owns a carved wooden lion
from Benin ridden by a pith-helmeted human figure, the whole covered with
a thin sheath of repoussé silver (figure 73). The European-attired lion rider
holds a metal plaque showing the names of Charles Noufflard, governor of
the colony of Dahomey from 1912 to 1917, and Oudji, the King of Porto-Novo
from 1913 to 1929.[7] Presumably made as a gift to Noufflard, and hence datable
to the period of World War I, the figure provides evidence of an early use of
lettered labeling.

However, the move toward an individual labeling of ancestral asen is not
apparent until sometime after independence, and judging from the place-
ment of plaque-bearing asen within typical deho, it became most evident

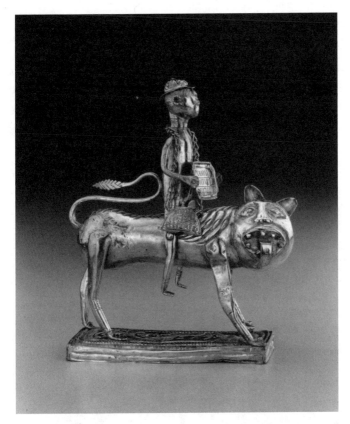

Figure 73. Male figure riding a lion presumed to have been presented to Charles Noufflard, governor of the Colony of Dahomey from 1912 to 1917, by King Oudji of Porto-Novo (reign dates 1913–29). Silver. Height x width x diameter: 19 x 18 x 6.5 cm (7½ x 7¹/₁₆ x 2⁹/₁₆ in.). National Museum of African Art, Smithsonian Institution. Museum purchase. 95-9-1. Photograph by Franko Khoury.

in the last quarter of the twentieth century. In Abomey in the late twentieth century, plaques were personalized with letter dies that cut names into rectangles of metal roughly 12 by 8 centimeters in size; in Ouidah, larger metal placards cut from scrap sheets of steel and painted silver carried the names of the honored dead painted in bright colors.

In Abomey and Ouidah, the asen incorporating plaques identifying the dead often also included figures made to represent the deceased in occupational stances. For example, a Hountondji asen created in Abomey by commission

in the mid-1980s was dedicated to a shopkeeper trading in cloth (figure 74). Several figural motifs around the asen platform were a combination of familiar verbal-visual elements of pledges between living and dead: the foot and yam rebus that signals the donor's presence and perseverance; the tiny *gbejihen* bird perched on a millet stalk that evokes a proverb about the donor's devotion to the deceased; and the crutch-like staff associated with the verb *kpanzon* (to support, to find protection in something or someone), which on an asen served as a reference to the ancestors' reciprocal sustenance of the living.[8] These motifs were arranged in a balanced circular pattern on either side of a plaque noting the name of the dead. Standing directly behind the plaque on the opposite side of the platform, the dead merchant himself faced forward, brandishing a pair of scissors next to a rack on which hung samples of the cloth that represented his métier. A similar asen created at the same period featured a weaver, his warp threads stretched out far in front of him, his right hand poised to throw the shuttle, and his name inscribed for perpetuity in front of his portrait (figure 75). When I visited a Ouidah forge in 1999, the smith

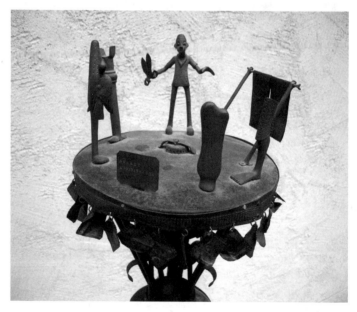

Figure 74. Asen commissioned in honor of Aïhade Aguidigbadja, whose name is on the plaque in front of his representation as cloth seller. Symbolic motifs are arranged to the right and left. This asen carries mixed messages, one associated with the importance of the family, and the other with the accomplishments of the deceased. Photo: E. Bay.

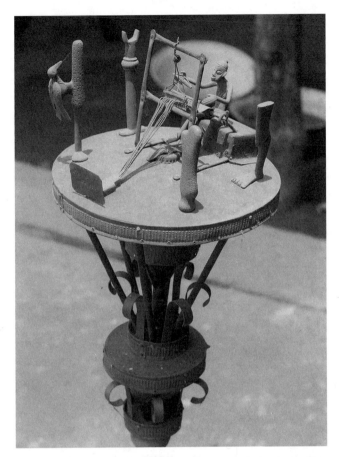

Figure 75. Asen with a representation of a weaver. Commissioned in Abomey, 1984. Photo: E. Bay.

was completing a single asen made to honor five deceased family members. It included a large plaque that not only gave the names of each individual but also indicated their occupation. Cecevi, a student, sits enstooled with a pen in hand and folio paper on her lap; Tereza, a seller of fish, sits by a circular basket loaded with a perpetually fresh catch; and the remaining three merchants—Couaba, Meho Gbokpe, and Adjovi—quietly sit behind on their stools of honor. Another asen featured six persons, including a carpenter wielding his saw, fishermen with a tangle of nets, and a customs official seated at his desk holding a disproportionately massive pen (figure 76).

With the elimination of motifs alluding to the reciprocal obligations of living and dead to each other, asen iconography began to move from a visual

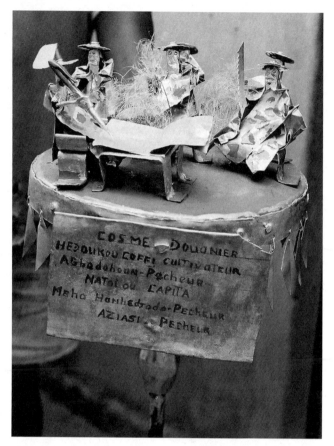

Figure 76. Asen with representations of six family members. The plaque identifies them as Cosme, a customs official; Hedoukou Coffi, a farmer; Agbadehoun, a fisherman; Natalou, a boatsman (?); and Meho Honhedrode and Aziasi, both fishermen. Ouidah, 2001. Photo: E. Bay.

conversation about the relationship of the spirit and visible worlds to a narrative of life ended or, better put, interrupted. The dead no longer sit enstooled in postures of lineage authority and spiritual repose but stand or sit at work, as if caught by death in a snapshot of everyday life. Dress on cast figures of the dead no longer represents royal attire but includes thoroughly modern, Western shirts and pants (figure 74). But most strikingly, the naming of the departed through writing suggests a profound change in perspective about the power of words. In his study of healing among the Ketu Yoruba, Pierre

Verger notes that "[t]he spoken transmission of knowledge is considered the vehicle of àsè [aché], i.e. the power within the words which remains ineffective in a written text. Words, in order to become active, must be spoken aloud" (1995, 30). By the end of the twentieth-century, Verger's observation about the power of the spoken word had been reversed in the prayer houses of Abomey families. The written word was triumphant, and Western literacy was proclaiming its links to a different form of prestige and power. Family solidarity was disappearing, as asen became monuments to individuals, sculptures that resembled tombstones as they recalled the dead in all their individuality to the world of the visible alone.

7

Death and the Culture Wars:
The 1990s

> It is our impression that little significant change has taken place
> in the inner life of the natives; that is to say, that the absence of
> influence exerted by European contact extends to those aspects of
> life that are quintessentially African—to religion, to art, and to the
> organization of social life in general.
> —Melville J. Herskovits

> *J'ai peur de mes amis même toi.* (I fear my friends, including you.)
> —Sign on the dashboard of a taxi in Cotonou, 1999

When I began this book, I expected to argue that ancestral asen had been invented and now are being abandoned for specific sociocultural reasons. I believed that the important point about their existence nevertheless remains unchanged—that people continue to venerate and honor their ancestors, though they are replacing asen with "modernized" tools such as photographs. In short, I expected to agree with Herskovits's epigraph, to say that the "inner life" of the extended family in Benin is intact and that underlying the use of asen are principles of kin solidarity effectively unaltered by a century of intense culture contact between Benin and Europe. I no longer believe that. As I have reflected on trends abundantly apparent by the last decade of the twentieth century, I have come to believe that a shift in sensibility and practice has taken place. The cumulative effect of capitalist development, or lack of development, with its emphasis on cash transactions, the pressures of social agents offering solace and opportunities to individuals rather than kin groups, and the impact of technologies that represent Western social practices as normative to a global forum has slowly eroded other values. Capitalist individualism is too strong a term for the result. A more appropriate picture stresses the proliferation and growth of individual support systems outside the shelter of kinship. Ancestral asen, as objects

that are quintessential markers of kin solidarity across space and time, were necessarily destined to be diminished by these trends.

Ancestral asen are being abandoned by many in southern Benin. In Abomey, master smiths complain that people are no longer willing to invest large sums to commission their finest work. Instead, the bereaved expend enormous amounts of money on urban mortuaries that maintain the dead for weeks, even months, while families gather far-flung kin and cash to support what used to be the two separate rites, burial and the final funeral, now combined into a single elaborate ritual. If and when ancestral asen are sought, people are often content with the inexpensive, ready-made asen with generalized motifs that are available in markets. In Ouidah, branches of prominent Aguda (Afro-Brazilian) families have gone so far as to discard their asen, occasionally also razing the deho, the house of prayer. Other families have preserved the deho but removed the asen and lined the walls with shelving for portrait photos of the dead. Elsewhere in Ouidah, photographs are arrayed around the grave of the deceased (figure 77).

Figure 77. Interior of the home of an Aguda family in Ouidah showing the grave of a family member, 1999. Burial of a body in the individual's bedroom continues to be practiced among some Beninese. Photo: E. Bay.

In Ouidah and Abomey, the sense of decline in an artistic tradition is pal-
pable. Shown photos of elaborate asen from Ouidah that have found their way
into museum collections in the United States, Ouidah smiths in 1999 assumed
that the asen had been made in Abomey because they were of much higher
quality than those they themselves make. Nowadays, the smiths reported,
only local Fon families order the asen that they fashion; Yoruba and Hweda
families resident there do not (smiths of Adjovi, Sodoganji, and Atelele fami-
lies). Robberies of deho and storage rooms holding asen seem to be more
common of late. Whether their cause is a decline in respect for asen as sacred
objects, making potential thieves less fearful of spiritual sanctions, or simply
the temptation of sale into an international market, or both, is unclear.

When did the changes begin that led ultimately to the decline in use of
asen by families in southern Benin? It is impossible to say, but certainly the
subtle processes whose result was evident by the turn of the twenty-first
century had beginnings prior to the mid-twentieth-century flourishing of
ancestral asen. Some might even speculate that the disappearance of asen
was foreshadowed earlier, with the arrival of the colonial era and its modern-
izing impulses. But to say that ancestral asen use would ultimately succumb
to modernizing trends begs the question of complex processes of change in
the nineteenth and twentieth centuries and leads only into what has become
a massive scholarly debate about definitions of modernity.

In this chapter, I explore instead a series of trends that culminated in open
cultural and political struggles in the 1990s. First, I review and speculate upon
the changes in kin relationships that were associated with the political econ-
omy of southern Benin during the twentieth century. What was the impact
of colonial rule and postcolonial national politics on individuals' relationship
to their own kin systems and kin groups' relationship to the social-economic-
political order? Second, I outline a geographical shift in dominating centers
of culture in southern Benin in the twentieth century. Finally, I look at reli-
gious expression and the use of ancestral asen in the context of the Benin
culture debates of the 1990s. Asen there became a central issue, condemned
by all sides as being at best retrograde and at worst a spiritual error in need
of elimination. These public debates of the 1990s openly articulated changes
that were quietly taking place in the privacy of Fon households.

Families, Asen, and Benin Society

In the previous chapter, I explored the iconography of ancestral asen over
three overlapping periods that roughly correspond to precolonial/early colo-

nial, midcolonial, and postcolonial times. I return here to those periods and their social history to draw a general picture of the ways in which individuals' relationships to their kin groups changed over the course of the twentieth century and how extended families or lineages reworked their relationships to broader Beninese society.[1] Those issues in turn suggest that the centrality of the family as a marker of social cohesion in southern Benin was gradually lessening during the course of the century. At the same time, the realities of colonial and postcolonial political and economic changes meant that the prestige that had formerly been associated with Abomey and Ouidah as centers of a political and economic universe dissipated over the years, leaving those cities as focal points of historical heritage and precolonial nostalgia with relatively little appeal as contemporary centers of status creation.

Ancestral asen were employed in the period of the monarchy as multivalent emblems of the power of the state as embodied in the person of the king. Precolonial state power, based upon economic controls and military might reinforced by the supernatural support of the deified ancestors of the royal lineage, was conceived on the model of kinship. The kingdom was a family writ large, with the king as paterfamilias of the nation. Prior to being installed, each king proved his ability to amass living followers and his facility for working with supernatural powers—magical, ancestral, and divine. With his female reign-mate, the king ruled supreme over the visible and invisible worlds.

Everyone in the kingdom, living or dead, theoretically could be placed under the ruler in a complex hierarchy that was described in the language of lineage relationships. The royal dynasty itself was divided into branches corresponding to the numbers of monarchs. Each new reign produced a new branch that subordinated all previous branches to it. Each nonroyal lineage and all of its dependants and slaves was in turn subordinated to the branch of the royal family that had originally settled some of its members in Abomey, and, in theory at least, all lineage members fell ultimately under the authority of the royal family. Outside the capital, rural villages were linked to Abomey-based lineages to which they owed tribute and which similarly controlled their family members. The cult of the Nesuhwe described in chapter 2 was the vehicle for the ritual articulation of these fictive kin relationships. In effect, in the eyes of the monarchy, everyone in the kingdom was under the control of the king through ties of subordination and allegiance that made family and state one.

The emphasis on kin ties leading hierarchically to the center was reinforced by state policies that suppressed institutions that might encourage

crosscutting social ties. For example, Dahomean society lacked the kind of community-based initiation processes that created age groups in other African cultures and fostered lifelong generation-based ties of solidarity. Masquerade societies were forbidden. Dahomean cooperative work groups and village-based military units, among the few non-kin networks, were associated with allegiance to an authority figure—a chief, wealthy trader, or official of the kingdom—which effectively tied the potential of such efforts back into the kin hierarchy. The congregations of the so-called popular vodun, those divinities that were not kin-related, were carefully controlled by the monarchy, receiving allowances for ceremonies and reporting to a minister of religion (Bay 1998, 92–93, 252–53).

The French defeat of Dahomey in 1892 and abolition of the kingship in 1900 interrupted these complex lines of authority and fealty. At the same time, the colonizers shrank from serious social revolution. They made chiefs out of members of the royal lineage and other individuals of previously high rank. This French ambiguity toward the previous sociopolitical order meant that the colonizers simultaneously tried to undermine and to undergird the older authorities. On the Abomey plateau, each of the new colonial chieftaincies became a mini-court modeled on that of the kingdom, with ceremonies, protocols, and regalia reminiscent of the past. Colonial chiefs thus met French ambiguity with mixed signals of their own, building personal status on the combined basis of present French power and past Dahomean prestige. The use of ancestral asen with motifs similar to those of the late precolonial period would have been a natural step for these colonial elites.

The disappearance of the kings also signaled a loosening of the repressive controls over individuals and their kinsmen that had characterized the late precolonial period. Chiefs and the heirs of high officials associated with the kingdom, particularly those on the Abomey plateau, throughout the twentieth century continued to exercise a certain amount of authority over their subordinates and to receive gifts from them. However, those relationships of necessity became voluntary ones, in which subordinates could calculate the relative value of the good offices that their superiors could provide and would act accordingly. The royal cult of Nesuhwe, meanwhile, continued to celebrate historical links between individuals and families, royal and non-royal, but its networks increasingly echoed only relationships in the world of the spirits.

The coming of colonialism freed Dahomeans from an authoritarianism that they had come to understand. In its place, colonialism offered the insecurity of arbitrary rule by foreigners who would prove to be unpredictable. It

was in this context that patrilineal households and the lineages of which they were a part stood as the central form of social security, perhaps more centrally than in the precolonial period. Southern Benin remained a predominantly agrarian culture until late in the twentieth century, one that depended on labor-intensive farming practices organized on the basis of kin links. In this setting, individuals were owed life and livelihood through maintenance of a series of family rights and obligations (figure 78). The degree to which people in southern Benin could still rely on these connections was apparent as late as the end of 1989, when the state failed to meet the civil-service payroll for seven months. Continual strikes and the absence of cash infusions paralyzed the country, yet people spoke proudly of the fact that urban dwellers were still able to eat, thanks to kin networks in the countryside.

Given the importance of family connections to social life throughout the twentieth century, it is little wonder that ancestral asen became a central vehicle for the ritual interactions between living and dead kinsmen and for the visual-verbal articulation of family solidarity. Without precolonial prohibitions on the use of elaborated asen, anyone in southern Benin might use the circular platform of an asen to speak of the dead. And speak they did, as the previous chapter testifies to the myriad messages of solidarity and mutual dependence—of the living on the dead, and the dead on the living. The potential was limited only by cost, which opened the way to the twentieth-century commoditization of ancestral asen. Yet vestiges of the older system of status and class prestige appear to have remained during the first half of the century, which may account for the fact that the broadest use socially of decorative asen came in the second half of the century. In the earlier period, not only were there variations in cost, but not all family members were deemed worthy of an elaborate asen. Only heads of families, chiefs, or exemplary individuals who lived to a great age might be assured of an asen in their honor. By late in the century, however, Beninese stressed that having an asen had little to do with one's achievements and contributions to the support of the family; rather, being honored with an asen was associated with having a descendant who would fulfill his or her obligations to a parent (figure 79). A young clerk in a shop in Cotonou by the 1980s thus was capable of purchasing an asen for her mother and providing the gifts necessary for its installation in the lineage deho in Abomey. In effect, precolonial prestige in the form of elaborate ancestral asen had filtered down through society until it was accessible to all. But the democratization of prestige raises a troubling question: What happens to the social value of prestige that is accessible to all?

At the same time that ancestral asen flourished as reminders of kin cohe-

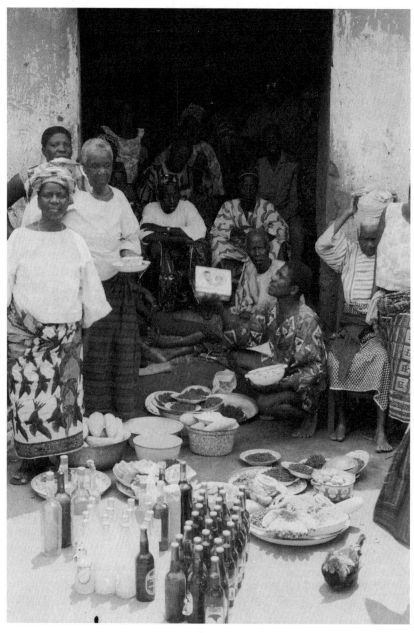

Figure 78. Food offerings for the ancestors being presented to the compound head in the presence of assembled family members. Abomey, 1972. Photo: E. Bay.

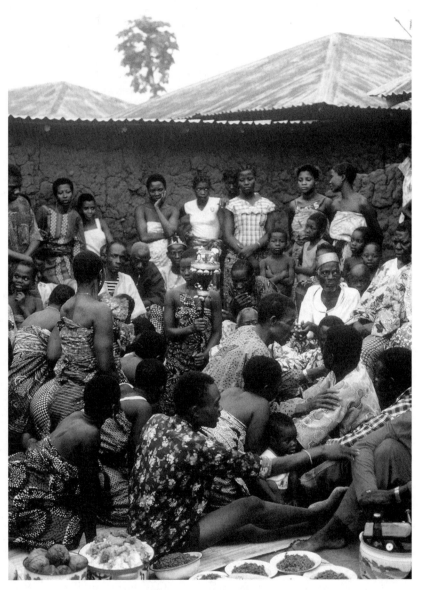

Figure 79. Asen being presented to the assembled family for consecration and placement in the deho, 1984. Photo: E. Bay.

sion, there is evidence throughout the twentieth century of the two-sided nature of family relationships. The family was the source of sustenance and the font of oppressive demands. In the precolonial period as in the twentieth century, hierarchies based on age ordered relationships within families and coexisted uneasily next to hierarchies associated with achievement and the amassing of relative wealth. Though wealth was meant to be shared with kinsmen, households within a lineage, siblings, and even spouses might effectively fall into different socioeconomic classes, a phenomenon that became more acute as cash sources of income multiplied in the twentieth century. Jealousies within households were common, particularly between co-wives and their children, yet individual rights were secondary to the needs of the family. Children might be sent as pawns to provide the labor-value of interest on a debt. Girl-children could be pledged in marriage even before their births, and young men needed permission, and financial support from their families, for the negotiations that would lead to marriage. The death of a vodun initiate meant that another person in the extended family had to be selected, and required by the family, to become an adept. The levirate, which ensured that a widow would remain in the family of her husband by assigning her a new partner, continued, though it gradually became less common in the late twentieth century.

Not only did the head of a family govern personal relationships, but also work and financial demands were common. For example, all adult family members were assessed a sum to contribute for funerals, and individuals had no choice but to pay. Individuals who did not meet family obligations were received with hostility by kinsmen. And those who shared their wealth beyond the minimal demands of the family might be suspected of having gained it in the first place at the cost of the well-being of nearby relatives. Indeed, accusations of witchcraft fell most frequently on family members. Kin tensions in turn were reflected in popular culture. A song collected in the mid-twentieth century urged individuals:

> Si vous rencontrez celui qui vient de loin, il faut le prendre comme ami. Si vous rencontrez quelqu'un de votre maison ou de votre quartier, méfiez-vous de lui. Car le souris qui se trouve dans votre maison, mange vos pagnes ou vos nourritures et vous fait du mal; mais le rat de la forêt ne vous fait rien. Il n'a pas besoin de vous.

> (If you meet someone from far away, make him your friend. If you meet someone from your home or from your neighborhood, beware. For the mouse that lives in your house eats your cloth wrappers and your food and does you

ill; but the rat in the forest does nothing to you. It doesn't need you.) (Falcon 1970, 48–49)

In the early 1970s, a hit pop song sung in Fongbe, "Me Dida" (Bad person), played constantly on the radio in southern Benin. It warned people to hide, that members of the family—elders, older brothers, uncles—think only of your death, that they will kill you and say that the ancestors did it. Thus Fon popular culture played out the contradictions of apparent family unity: those upon whom we depend the most, and who are the most dependent upon us, have the most reason to harbor resentment and do us ill.

Nevertheless, the importance of the family persisted, in part because no one could succeed in life without support from numerous directions. The family ancestors, since they were devoted only to their living descendants, upon whose sustenance they themselves depended, were said to be a central element of the success of everyone, and the family depended upon the intercession of the ancestors to ensure its own prosperity. Given the social realities of the middle and late colonial periods, it is little wonder that asen spoke insistently and loudly of family solidarity, of the pledges of the living to the dead, and of the unity of the line. Funerals and ceremonies on behalf of the ancestors were cited as major expenditures throughout the twentieth century. As early as 1911, Auguste le Hérissé observed,

> Le culte des morts chez les Dahoméens n'est pas seulement un des beaux côtés de leur caractère, il constitue aussi le levier le plus important de leur énergie productive. Comme chaque famille tient à honorer dignement ses mortes, elle engage des dépenses extraordinaries en l'occasion et de ce fait résulte une recrudescence de son travail.

> (The cult of the dead among the Dahomeans is not only one of the fine sides of their character; it forms the most important lever of their productive energy. Since each family is keen to honor its dead with dignity, it spends an extraordinary amount on such an occasion, and from this fact results a fresh application of its work.) (1911, 157)

Hérissé was echoed by Melville Herskovits in the 1930s, who asserted that "[t]he ancestral cult must be regarded as the focal point of Dahomean social organization" (1938, vol. 1, 194). A Catholic priest complained in 1968 that people were forced to sell gold jewelry, palm groves, and other items of great value to cover the costs of relatives' rites. Even worse, "On a vu des personnes âgées mourir dans l'abandon et la mendicité, mais dont les funérailles ont été des plus grandioses" (We have seen old people die abandoned and in poverty,

for whom the funerals have been among the most grandiose) (Souza 1968, 88). Late in the century, Roger Brand, who worked with non-Fon peoples in the lower Oueme River basin, commented that the cult of the ancestors among the Oueme peoples was less strong than in other areas, most notably around Abomey, but that the living nevertheless were constantly concerned that their failures to fully satisfy the ancestors might lead to problems (1991, vol. 1, 178, 181).

Within two linked rituals, funerals and ceremonies for the collective dead, new trends emerged over the course of the twentieth century. Sometime during the final third of the century, funerals began to change from a two-part ceremonial cycle. The standard practice had involved an immediate burial with an additional major ceremony, in some locations called a "second burial" or final funeral, some months later.[2] Over time, presumably because of the difficulty of bringing far-flung kin together more than once, and because technology made it feasible to keep a body unburied for a long period, funerals began to involve only a single cycle of ceremonies that occurred well after death. By all accounts, these new funerals, which became common in urban areas, increased costs dramatically. Whereas preparations for funerals had earlier included only zìndó, festivals of giving on behalf of the bereaved to support the rituals, now more elaborate practices, including massive payments on the part of the husbands of daughters in a family—demanded under the guise of bridewealth—became the norm. Elaborate church funerals, in which the entire congregation was expected to file forward to give even more public gifts, preceded processions to Abomey, Ouidah, or rural areas for burials and local feasting.

At the same time, services of thanksgiving and supplication for the ancestors became more frequent, though each individual cycle became less costly. Kapleple, a relatively elaborate offering of gifts to the ancestors, used to be done every three years or so. Kapleple was in fact a much-reduced version of Customs or Hwetanu, the annual ceremonies that were a centerpiece of activity in the kingdom of Dahomey. Adult family members were expected to come to Kapleple with a major contribution: food, drinks, money, and an animal for sacrifice, generally a chicken or goat. Sacrificial animals would be killed and their blood offered to the asen, drinks poured on the metal altars, and food placed before them for the feasting of the dead. Prayers would be offered before the asen, the responses of the ancestors divined, and time allotted for the resolution of family problems (figure 80).

Of late, Ahanbiba, which means literally looking for strong drinks, calls for a smaller offering of food and drink on an annual basis, with less pres-

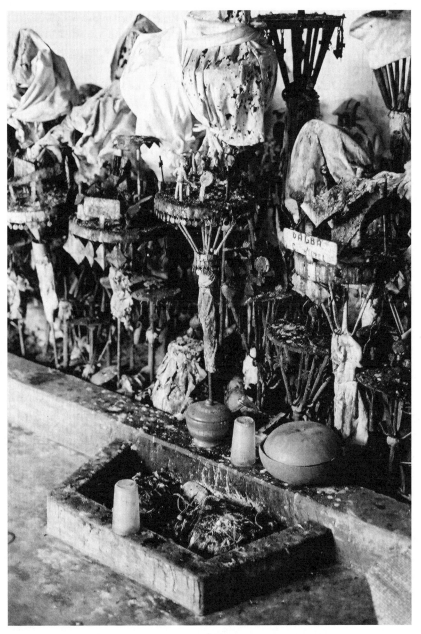

Figure 80. Deho interior showing remains of offerings for the ancestors. Ouidah, 2001.
Photo: E. Bay.

sure on individuals to attend in person and less emphasis on collective family decisions (Interview with Babatounde, 9 June 1999).[3] In brief, it would appear that the ceremonial cycles associated with the honoring of the dead have been altered towards a recognition that family members are less likely to be living in relatively close proximity and in daily contact with each other. A family member in a distant location can ensure that the ancestors receive his or her prayers and praises by sending money to kinspeople living at the home compound and rest assured that the ancestors have been approached on behalf of the collective family. Thus cynics assert that devout Christians who claim to have abandoned all vodun-associated beliefs may practice their faith in the full knowledge that their ancestors are being cared for on their behalf.

The ceremonial changes associated with the dead and the ancestors reflect and reinforce a trend over the course of the twentieth century, a slow weakening of family solidarity. Salaried individuals in the mid- to late twentieth century often spent their working lives in urban areas or outside the colony/nation-state, making physical contact rare and loosening individuals' sense of obligation. Wealth in cash is more difficult to estimate than that harvested in cotton or maize, which means that family elders these days have less ability to determine appropriate levels of assessment for kin projects. Family members living elsewhere send remittances home, but some kinsmen suspect that they send little of what they have, while others are sure that portions of payments remain in the pockets of those to whom the remittances have been entrusted. As money becomes a greater and greater measure of wealth, individuals have begun to focus more on training for occupations that promise cash income. The draw of urban dwelling, its relative freedom from family constraints and its promise of monied reward, has became increasingly attractive. In cities, one's occupation is a central marker of identity. Formal schooling and apprenticeships, both of which are costly, become investments with cash returns tied to individual occupational success. It is little wonder that pledges of kin solidarity began to disappear from asen in the late twentieth century, replaced by images of individuals at work, motifs that boast visually of what one can do on one's own.

Shifting Centers of Cultural Dynamism

Even as the use of decorative ancestral asen became widespread in Fon culture in the twentieth century, and even as people learned to use asen creatively to convey changing messages about the nature of family ties, the declining

centrality of Abomey began to have an impact, silently and subtly, on the future use of ancestral asen. The colonial authorities, by formally abolishing the kingdom, opened the way for Dahomey to be honored as a form of cultural heritage, a phenomenon that we observed in chapter 4. At the same time, colonialism introduced new avenues for achievement and stature that were unrelated to kin and earlier culture. The shift toward the new is literally evident in the changing geography of status.

The cities of Abomey and Ouidah were the two most important centers for politics, economics, and culture in the kingdom of Dahomey. Connected by a major north-south road that cut across an older coastal system of east-west economic and cultural flow described in chapter 1, the two cities stood at opposite ends of a north-south axis of power, prestige, and cultural dynamism. In the wake of the colonial conquest, however, each city became relatively isolated, while new cities gained predominant influence. Cotonou, on the coast some forty-four kilometers east of Ouidah, developed from a village to a staging place for French interests in the late nineteenth century and ultimately became the burgeoning commercial capital of the country. Cotonou's destiny as a port and urban center was sealed with the building of its first wharf in 1891 and enhanced with the coming of an airport in 1934. Porto-Novo, some twenty-one kilometers further east on the mainland side of the coastal lagoon, had been the capital of a kingdom that was a rival to Dahomey in the late nineteenth century. Allied with the French at the moment of conquest, Porto-Novo became the seat of government for the colony and prospered when the establishment of colonial borders left it an entrepôt with close links across the international boundary to British-controlled southern Nigeria and its capital, Lagos.

The infrastructure built by the French colonial authorities reinforced the political and commercial changes prompted by the shift from Abomey/Ouidah to Cotonou/Porto-Novo as axes of activity. Although the east-west coastal railroad built by the French reached Ouidah, the city ceased to serve as a port for oceanic trade after the colonial conquest and ultimately was bypassed, literally and figuratively, by a road along the coast. Concerned about the political importance of Abomey, the French routed their north-south railroad and motor road some ten kilometers east of the city, opening the way to the economic growth of the town of Bohicon. Nevertheless, Abomey remained a symbol of a polity whose potential as a political rallying point was feared in colonial times by the French and in the postcolony by non-Fon political rivals. Modernizing elites from both older cities, meanwhile, who lived their professional lives in Cotonou or Porto-Novo, or even outside the country,

looked to relatives in Abomey and Ouidah to maintain centers for family rituals, including the maintenance of deho. Abomey and Ouidah became sites for the building of weekend or retirement homes for these itinerant civil servants, dwellings that also served as guest quarters when large funeral celebrations drew dozens of kinsmen to their family centers from time to time. The two precolonial centers also became tourist destinations for outsiders. Abomey's museum, built in the restored former palace of the kings, opened in 1943, while that of Ouidah, created within the former Portuguese trading fort after independence, was launched in 1967.

In effect, the twentieth century saw a return to an emphasis on coastal east-west links, with people, goods, and ideas moving across international boundaries from Nigeria to what is now Ghana, supplemented by outside influences via sea and air links through Cotonou. As the century progressed, a form of hyperdevelopment became evident as rural-urban migration drew more and more people to the coast. With the recent development of Abomey-Calavi, west of Cotonou at the head of the lagoon, as a bedroom community for civil servants, and with improvements in infrastructure in Porto-Novo and the transfer of certain administrative functions there, coastal urban Benin has flourished. The eastern littoral of Benin now approaches a single urban conglomeration that contains what one scholar suggests is as much as one-fifth of the entire population of the nation (Elisée Soumonni, personal communication, 26 May 1999). While Abomey and Ouidah are looked upon as sites of nostalgia and heritage, excitement associated with the new and prestigious has increasingly devolved upon Cotonou. These long-term trends—the loosening of family solidarity and the decline of Abomey/Ouidah as centers of influence—serve as backdrops to active battles over religious systems, and asen, in the 1990s.

Politics and Religion in the 1990s

The secular French colonial state officially promoted no religion; however, during the colonial period Roman Catholic and Methodist missionaries became a central force in education, and the emerging elites were nearly always practicing Christians. Independent Christian churches founded by African prophets attracted increasing numbers, particularly in the south, by late in the colonial period. Islam, most common in the north and along the eastern borders of the colony, and Vodun, the predominant practice in the south, were tolerated. Colonial officials, never fully comfortable with Vodun, at times tried to survey numbers of adepts and occasionally prosecuted an

individual accused of chicanery or associated with sorcery. Freed from pre-colonial controls associated with the kingdom, priests (*hunon* or *vodunon*) of the so-called popular vodun gained a degree of political strength, particularly in rural areas. However, as early as the 1930s an observer opined that Vodun as a system was failing to come to grips with the changing sociopolitical setting, and the powers of the priesthood were becoming associated with secrecy and negative practices: poisoning, grave robbing, black magic, and the like (Maupoil 1943, 66–67). By midcentury, complaints by local communities that the two- to three-year initiation process prevented adepts from going to school had resulted in the reduction of the length of the initiation period. Meanwhile, the high costs of initiation and annual ceremonies, coupled with general objections that the vodunon were dictatorial, began to reduce the number of initiates (Elwert-Kretschmer 1995, 104–6).

In the early postcolonial period, religion was assumed to be irrelevant to a modernizing secularism among national leaders. From the mid-1970s to the end of 1989, the official national ideology was Marxist-Leninist. All religion was formally abolished, and the state promoted a developmentalist rationale that argued that funds spent on religious ceremonies, no matter what the faith, would be better employed in productive uses. The mid- to late 1970s were difficult for the Roman Catholic establishment, which had its massive educational efforts nationalized. Practitioners of Vodun, however, fared worse, being actively persecuted and sometimes imprisoned, as were members of at least one independent Christian group, the Celestial Christians. By the early 1980s, the state had relented, and the Catholics regained their position as the leading Christian denomination. The formal prohibition on religion remained in place until 1990, but the state for the most part turned a blind eye to the activities of Christians and Muslims, though controls on Vodun and other groups perceived by the state to be politically dangerous remained in place (Tall 1995a, 196–98). Meanwhile, popular discontent with the practices of Vodun priests in rural areas and pressures from the government combined to further reduce the numbers of new initiates (Elwert-Kretschmer 1995, 106). At the same time, Benin was feeling the effects of a rising interest in religion across Africa, and new denominations, particularly evangelical Christians, were attracting large numbers of followers.

Politically, by 1989 economic decline and a doubling of the number of civil servants, coupled with serious corruption and pressures from donors to institute financial reforms, had effectively bankrupted the country. President Mathieu Kérékou, who had come to power in a military coup in 1972, was forced to accede to popular demand and convene a Conférence des

Forces Vives (National Conference of Living Forces) that included political, trade-union, and religious associations. The nine-day national conference, which elected as its chair the archbishop of Cotonou, Monsignor Isidore de Souza, assumed sovereign powers and designed a timetable for a transition to democratic governance. Following the conference, de Souza chaired the interim legislative body, the Haut Conseil de la République (Supreme Council of the Republic), while Kérékou remained as nominal head of state, and effective power was placed in the hands of a prime minister, Nicéphore Soglo, a former World Bank official and descendant of a branch of the Dahomean royal family. By April 1991 the transition was complete: a constitution had been written and accepted by national referendum, elections had been held for all levels of government, and Soglo had assumed the presidency after defeating Kérékou and eleven other candidates.

Benin's national conference went on to serve as a model for democratizing movements across francophone Africa. The role of the churches, and particularly the Roman Catholic church, first in sustaining a suffering population as Benin declined economically and then in promoting the political process that led to change, suddenly made the links between religion and politics visible and legitimate. The religious affiliations of political figures became a factor in democratic governance throughout the 1990s. Archbishop de Souza was lauded as the voice of conscience and reason that alone had convinced Kérékou to relinquish power without a bloody struggle. Soglo, a lifelong Catholic, in the early 1990s convinced many that he was a follower of Vodun. Suffering from what was said to be sciatica and typhoid at the end of the presidential campaign, Soglo delayed his inauguration and spent nearly his entire first two months in office being treated in France. When he later sponsored an international festival that celebrated Vodun as national culture (Ouidah '92) and established a Vodun national holiday, rumors spread that he was repaying the vodun healers who had secretly saved his life after political rivals poisoned him. Political analysts argue that the favor he showed to vodun was calculated to earn him votes for reelection (Mayrargue 1995; Tall 1995a). Meanwhile, Kérékou himself, having expressed remorse at the mismanagement of Benin during his seventeen years in power, returned to politics as a born-again Christian five years after losing power. He defeated Soglo to regain the presidency in 1996 ("Soglo" 1991, 573; *Africa Research Bulletin* 1991, 10044, 10080).[4]

How were these religious-political changes at the national level related to ancestral asen? The new visibility of religion in the democratic political system and the lifting of the formal ban on the practice of religion enabled the

open expression of resurgent religious activity all over the country. Missionary Protestant evangelicals, Catholic charismatics, Celestial Christians and other independent churches, Wahhabi-supported Muslims, new congregations of vodun, and other religious activists made southern Benin burn with religious fervor in the 1990s. And the religions that impacted Fon families using ancestral asen—mainstream Roman Catholicism, Vodun, Protestantism, and particularly evangelical Christianity—all have perspectives on the use of asen.[5] Those perspectives differ, but all effectively discourage the continued use of ancestral asen.

ROMAN CATHOLICISM

Roman Catholicism, the predominant Christian denomination, uses the metaphor of family for religious relationships. Given the strict Catholic hierarchy, its version of kin structures probably resonates reasonably accurately with converts' experience of an ideology of patrilineal kinship. But it is not ersatz kinship that is the focus of church efforts to convert Beninese. Nor is it communion with spirits—in contrast to the evangelical Christians, the Roman Catholic church does not recognize the existence of African spirits. Rather, beginning in the 1970s, the church launched an impressive movement to appropriate aspects of Beninese ceremony and ritual as part of its conversion efforts.

In chapter 4 we followed the career of the French Catholic missionary Father Aupiais, who was extraordinarily influential in charting a direction for Catholic missionizing in the first three decades of the century. Working in the main with elite education, Aupiais articulated a vision of conversion made comfortable by the incorporation of aspects of African culture into liturgy. His students responded by collecting ethnographic data and writing, often eloquently, about the history and cultures of southern Benin. As if directly prompted by Aupiais and his work, the liberalizing Council of Vatican II (1962–65) issued a Declaration on the Relation of the Church to Non-Christian Religions that exhorted Catholics that "through dialogue and collaboration with the followers of other religions, carried out with prudence and love and in witness to the Christian faith and life, they recognize, preserve and promote the good things, spiritual and moral, as well as the socio-cultural values found among these men" ("Nostra Aetati").

Within five years after the end of Vatican II, activist priests and laymen in the area of Bohicon and Abomey had launched Mewi Hwendo (literally, black furrow), an ambitious movement to research Beninese local culture in order to promote conversion among the masses. Scholarly research on cul-

tural practices by priests and university-associated laity virtually exploded; regular meetings of researching intellectuals took place in the context of university scholarship in Benin and Paris. The church-inspired scholars in collaboration with local "intellectuels communautaires" (community intellectuals) have made major contributions to the literature on culture and religion in southern Benin in the last forty years.

The goals of the movement are significantly more far-reaching than the desires of Father Aupiais to make Catholicism less foreign to local peoples. It stresses instead the "Christianization of cultures or the inculturation of the faith" (Babatounde and Adoukonou 1991, 5). In contrast to the view of the Protestant evangelicals, Mewi Hwendo argues that, rather than being "une entreprise diabolique" (a diabolical or pagan undertaking), traditional religion represents a first response to God's grace (Adoukonou 1991, 68). The task of the church, therefore, is to research and understand "tradition" in order to encourage it to blossom into an expression of God's will—and a manifestation of Roman Catholic doctrine. In the context of southern Benin, Mewi Hwendo effectively proposes the insertion of Roman Catholic beliefs into the ritual and symbolic forms of Fon culture. For its central symbol, Mewi Hwendo has chosen the closed calabash that, as we saw in chapter 1, is a multivalent symbol associated with ideas of sacrifice and offering and ultimately linked to conceptions of the cosmos, reminding Fon peoples of the ties between the worlds of the living and the spirits. The symbolic motif for Mewi Hwendo is an image of two halves of a calabash tilted on the arms of a cruciform tree, pouring out a liquid (figure 81). Explained as "une image de cette Pâque africaine qu'est appelée à être la Théologie africaine" (an image of this African passover that is destined to be the African theology), the gourd is the essence of the philosophical base of the movement. "La calebasse fermée était pour le Danxomé des rois le symbole de la Divinité, du Vodun. Ce mystère 'tenu caché depuis les siècles en Dieu,' 'vient d'être révélé maintenant,' c'est le 'mystère du Christ . . . crucifié'" (the closed calabash was for the Dahomey of the kings the symbol of divinity, of vodun. This mystery, kept hidden for centuries in God, has now been revealed; it's the mystery of the Christ crucified) (Adoukonou 1979, vol. 1, frontispiece).

Some examples provide insight into inculturation as it was practiced in late twentieth-century Benin. Well before Vatican II, beginning in the 1940s, the church in the Abomey area had incorporated *hanye* (royal praise music) into services. Hanye songs continue to be performed, at court and as part of Catholic liturgy, accompanied by a gong and several calabashes covered with nettings of strung cowries or beads. Drums and bamboo lyres complete

Figure 81. The visual symbol of Mewi Hwendo painted on a metal compound gate. Bohicon, 1999. Photo: E. Bay.

the orchestral accompaniment for singing that has transformed praises for the royal dynasty dead to tributes for the God of Christianity (Segurola and Rassinoux 2000, 226). Under the influence of Mewi Hwendo, people are also encouraged to bring gifts comparable to those offered to vodun and ancestors into the church. Prepared foods, goats, and chickens have become offerings in services, sometimes brought before the altar by people wearing

dress comparable to that used in ritual by adepts of the vodun (Field notes, June 1999).

When I first did field research in Abomey in 1972, I learned that on the death of a familiar, one would purchase a meter or two of cotton cloth and present it with a small sum of money to the family as a "burial cloth" or shroud. People noted that a burial cloth should be made of locally woven cloth, and it was still possible at that time to buy lengths of locally woven fabric made of raffia and indigo-dyed hand-spun cotton thread, said to be the original fabric used for shrouds. The offering of cloth was symbolic, though Melville Herskovits reported that in 1930 longer lengths of cloth donated by the children, wives, and the institutionalized "best friend" of the deceased were used to wrap the corpse (1938, vol. 1, 357), and informants as late as the mid-1980s in Abomey confirmed the practice (Field notes, 25 July 1984). Caskets became customary at some point in midcentury, and the symbolic lengths of gift cloth were then simply piled with the body in the casket. For Mewi Hwendo, the giving of cloth is an act of charity. The deceased was charitable in life, yet those who remain at his death do not know if he will be accepted by God. The giving of cloth is a way of saying, "Lord, if something is lacking in the acts of charity that the deceased performed, here are gifts so that You will accept him" (Interview with Babatounde, 9 June 1999). The interpretation derived from the church's study of local cultural practice thus is compatible with Christian thinking.

But the giving of cloths presents practical problems. Often, the casket cannot be closed because of the number of cloths, and people acknowledge that in the past the gravediggers generally took many, sometimes sharing them with the head of the family, who distributed them as needed to less well-to-do members of the kin group. The church has intervened in this process to set a strict maximum of cloths that may be buried with the body. Those that are left, usually the great majority, are to be divided into three portions. One portion is to be given to the head of the family so that he may dispense charity to less well-off kinsmen. A second portion is to be conferred on the Dongan or Donkpegan, the head of the youth group whose charge it is to work as gravediggers. The third portion is to be given to the Catholic relief organization Caritas, which helps the poor. A similar division is to be made of the cash presented by friends of the family. Thus, from the church's perspective, what was good and useful in a Christian sense about "traditional" funerary services is preserved and made Catholic (Interview with Babatounde, 9 June 1999). Indeed, the church encourages Catholics to donate larger lengths of cloth, the two-meter minimum length for a wrapper at least, and ideally to

give a "pièce," a full six meters, at the time of a burial (Interview with Mitcho-zunu, 9 June 1999).

Ancestral asen present a less comfortable fit between local belief and Cath-olic theology, and it is in association with the cult of the dead that incultura-tion meets one of its limits. An asen's essential function is to attract and hold the spirit of the dead, to create a sacred site for interaction and communica-tion between living individuals and their ancestors. Underlying that func-tion is, of course, the understanding that the spirits of the dead are capable of assisting their kinsmen in the world of the living, a belief that cannot be squared with church teachings. A Mewi Hwendo lay member who earned his doctoral degree in France explained that in terms of the objectives of the movement, "It's fine to want to remember the dead, and to try to immortalize them with images. However, when it comes to worshipping them, making sacrifices to them, that is contrary to beliefs of Christians. Certainly you can honor a parent or relative with an asen, but a line is drawn at sacrifices. Thus it's easier to immortalize them with a photo or a cross" (Interview with Mitchozunu, 9 June 1999). Others in coastal Benin confirm that the church is encouraging people to discard asen and replace them with photos or crosses (Interview with Alomadè, 16 June 1999) (figure 82). By extension, the col-lective offering of prayer and sacrifice to the ancestors at lineage houses of prayer, either the Kakpleple or Ahanbiba cycles of ceremonies, is considered unnecessary and indeed is not in keeping with the practices of Christianity (Interview with Babatounde, 9 June 1999).[6]

VODUN

One of the characteristics of Vodun is its malleability, its responsive open-ness to the changing experiences and concerns of quotidian life. Historically, Vodun has welcomed and absorbed new spirits, under the assumption that the aché (or power) needed for success and prosperity in life may manifest itself in endless forms. Vodun that fail their followers, that prove inadequate to the challenges of life, over time lose their power and their servers. Con-versely, newer or older, temporarily forgotten, spirits may come to the fore, attracting the sacrifices and followers that strengthen them and allow them better to assist their human servants. In the waning days of the nineteenth century, the kings of Dahomey insisted that the deified royal ancestors were the predominant vodun powers in the spiritual realm and the inseparable partners of the powerful in the world of the living. Indeed, it is likely that the rival popular deities, and particularly Sakpata and its associations with the earth, gained some strength in the wake of the French conquest, for the

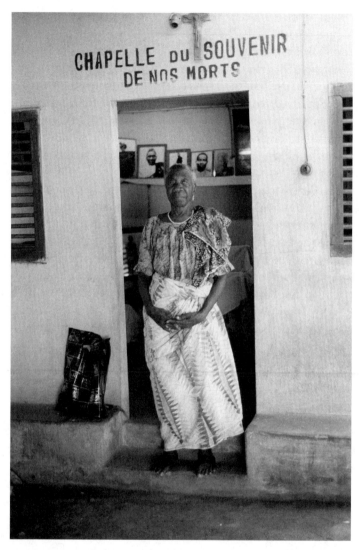

Figure 82. Deho transformed into photo memorial room for the family dead. Ouidah, 1999. Photo: E. Bay.

royal vodun were widely recognized as having failed to protect Dahomey from defeat. Nevertheless, the royal and popular vodun continued to be honored throughout the twentieth century; and their links to the political importance of individuals from the Abomey area made them forces to be considered, if not incorporated, in the political calculus of postcolonial rulers (Tall 1995a, 207).

Yet over the course of the twentieth century, shifts in the nature and ritual practices associated with Vodun point to changing conceptions of the individual, the meaning of kinship, and the relationship of humans to the spirits. The older vodun, royal and popular, were being challenged by the arrival of new "foreign" deities whose nature and ritual practices were associated with the protection of individuals as they grappled with urban Western culture and worked toward material success. And personal spirits that did not have possession rituals, like the divination deity or the spirits associated with twinning, began to become models for spiritual ties based on individual circumstances.

At the level of public cults, by the mid-twentieth century a new series of vodun and families of vodun had begun to bring different spiritual forces into southern Benin. Moving along the realigned east-west streams of cultural influence, and specifically from coastal Ghana and Togo, these new vodun and their families introduced spiritual forces drawn from as far away as the Islamic north. Tlon (Tron, Thron), Golo (Goro) vodun, Atingali, Kpe vodun, Mami Wata, and Alafia, among others, are associated with healing and protective forces. Golo, for example, literally means kola, which is chewed ritually to protect adepts from witches. Many of the new deities are dedicated in part or whole to protection from or the eradication of witchcraft, which in turn has been tied to modernity and processes of modernization in Africa.[7] Emmanuelle Kadja Tall points out that in southern Benin, as elsewhere, recent concerns about the threat of witchcraft focus on strong distinctions between good and bad, rather than concerns about the misuse of neutral power, and point to the need for individuals to arm themselves less against jealous kinsmen and more in defense against envious professional colleagues, disappointed lovers, and malcontent urban neighbors (Tall, 1995b).

The new vodun are strikingly eclectic. Tlon insists that followers adhere to the Judeo-Christian Ten Commandments, observe Muslim and Christian holidays, practice Fa divination, venerate older popular vodun like Legba and Sakpata, draw visual imagery from Hindu mythology, and desist from smoking (Rush 1997, 98–110)! Among the most prominent of the Tlon deities is Alafia, who came from the area of Ghana in the 1940s and is associated with the gaining of wealth by male merchants. In keeping with the eclectic nature of Alafia, Sossa Guédéhoungué, the wealthy businessman who was president of the association of vodunon in Benin in the 1990s, claimed at the same time to be a devout Roman Catholic (Rush 1997, 98–110). Alafia's counterpart for successful trading women is the well-known Mami Wata, a mermaid lookalike represented as a fish-tailed woman with long hair and snakes draped over her shoulders who is documented across a broad sweep

of coastal West Africa as well as areas of the Caribbean. In southern Benin she is said to have come from Ghana and is closely associated with the city of Ouidah (Rush 1997, 75, 123–26). Closely related to the new vodun are the overtly anti-witchcraft Celestial Christians, founded by the prophet Oschoffa in the late 1940s. Celestial practices are superficially similar to mainstream Protestantism, though members become possessed and utter revelations during church services (Field notes, 15 June 2003).

In her analysis of the new Vodun, Tall notes that from the beginning the new Vodun as well as the Celestial Christians appealed to people from segments of society most affected by social change in the colonial period: educated young men drawn into salaried labor and unschooled urban women left behind by the growing modern sector. They continue to draw heavily from two contrasting groups: marginal urban dwellers who are unemployed and often unqualified for salaried positions, and successful businesspeople, especially traders, who tend to see their accomplishments as evidence of their blessedness (Tall 1995a, 202–3). Both of these groups have reason to reject the ties of kinship. Poverty-stricken urban dwellers have little to gain from kinsmen and may well have moved to town to avoid kin obligations, while those who have built personal wealth and who credit their achievements to divine intervention may resent demands of less well-to-do relatives. Like the evangelical churches, the Tlon churches (the term "church" is used deliberately) provide social structures that help the poor and highlight the rich.

Most striking, though, are the departures of the new Vodun from the organizational structures of the older popular and royal cults. Membership links in the older Vodun are kin-based, with lineages expected to offer a family member to replace a deceased vodunsi. Family members in Abomey would occasionally mention to me the advanced age of a vodunsi in their lineage, wondering aloud if it would be possible some day to find a young person willing to replace her. In contrast, membership in the new cults is open and requires no initiation, or at most minimal training. In effect, the new cults are disconnected from kin links and place. Ceremonies are held on Sundays in urban areas and, at least among some groups, are called vodun mass. Associated with the new Vodun, too, is a cosmological shift that posits a Supreme Being, with individual vodun aligned in a subordinate position, a vision that is often compared to the hierarchy of saints of Roman Catholicism. With the celebration of Vodun as national culture that was prompted by the five-year Soglo presidency, participation and membership in the new Vodun became socially acceptable. At the same time, the older Vodun still retained a strong degree of prestige, to the extent that Sossa Guédéhoungué,

as president of the association of heads of vodun cults, felt compelled during the 1993 festival of Vodun to claim responsibility over the cult of Adantoshu, a "traditional" deity that provided a link with the older vodun (Tall 1995a, 205). Yet Tall reports that even the old cults are beginning to move toward the modernizing accommodationist models.

Shifts are discernible too among traditional vodun toward more individualistic, personal gods, or toward vodun whose malleable natures can appeal to personal and professional rather than social and community needs. Tall notes that "[l]a mode d'adhésion aux religions et cultes nouveaux, qui semble être laissé à la liberté de chacun, traduit les transformations de la société. A une logique dynastique ou lignagère se juxtapose une logique statutaire de classe, voire de genre. Les grands commerçants s'affilient à Alafia, les Nana Benz à Mami Wata, les chauffeurs et les mécaniciens à Gu" (the means of accession to the new religions and cults, which appear to be left to the free choice of everyone, reflects the transformations of the society. Next to a dynastic or lineage logic is juxtaposed a statutory logic of class, indeed of genre. The big merchants join Alafia, the Nana Benz join Mami Wata, the drivers and mechanics go for Gu) (1995b, 819–20).

The classic older personal gods, Fa of divination, Legba who opens the way to all the spirits, and the Hoho associated with twins, continue to flourish. Yet the natures of other spirits less associated with personal needs are changing. Dan Ayido Hwedo, who links earth with sky, and the most ancient with the present, is more and more associated with the bringing of wealth and the making of love charms for individuals. Gu now appears regularly next to Legba at entrances to homes, testimony to his importance to anyone who travels in vehicles made of metal. While none of these changes results in specific prohibitions against the honoring of ancestors with asen, the new vodun and their increasing popularity, linked with the changes that are being made in ritual modalities associated with them, correspond to patterns of weakening kin obligations. Urban dwellers, whose lives serve as models for most, are responding in their spiritual lives to patterns of affiliation that offer them security outside of blood relationships and mean that family solidarity exerts a less powerful pull on their loyalties.

EVANGELICAL CHRISTIANITY

Evangelical Christianity, which I use as an umbrella term for a large number of denominations, some of which were founded by Africans, while others were imported from abroad, is generally hostile to anything associated with Vodun, including the honoring of ancestral spirits with asen.[8] At the same

time, many evangelical churches regularly engage with spirits and accept forms of possession or spirit mediumship as legitimate religious phenomena. If spirit voices generally are welcome among evangelicals, the spirits associated with Vodun are considered evil and threatening, to be exorcized if they persist. Even so tenuous a connection as a personal name that incorporated the name of a vodun was an intolerable danger for a Pentecostalist I knew, for example, who blamed the "evil" spirit for causing a road accident that had harmed the vodun's namesake (Field notes, 21 August 2000). Asen by extension are equated with idolatry among evangelicals, and their use by definition is unacceptable. Jehovah's Witness missionaries in Abomey in the late 1990s, for example, were explicit in telling prospective converts that they should not use ancestral asen or serve vodun (Field notes, 8 June 1999).

But any interest in asen, and close adherence to extended family, on the part of Christian evangelicals is also threatened by the very structure of church social order. Evangelicals in Africa have creatively restructured ideas of kinship and family, effectively substituting the church congregation for kin links of mutual support—financial, physical, spiritual, and emotional—that were formerly the role of family. Church members learn to depend on other church members, their evangelical "brothers" and "sisters," to fulfill the material needs formerly at the center of kin relationships.

Evangelicals have particular appeal to women and young men, who historically fall uneasily under the authority and power of older men in African kin structures. Churches encourage individual initiative and autonomy even as they offer fictive kin relationships. In Europe, Protestantism was associated with individualism and the rise of capitalism. Yet, as Terence Ranger has observed, the gospel of prosperity in the African context instead has encouraged "penny capitalism," informal economic activity by women and young men, effectively by those most subject to family demands and those with least opportunity for advancement in a modernizing world. It also encourages training in various trades, and churches at times sponsor apprenticeships for members. The churches offer the kind of security that is most lacking for jobless or underemployed urban residents, whose relations with urban-based family members are increasingly fraught (Ranger 2003, 116).

Conclusions

In the course of this book, we have followed ancestral asen from their invention as an art form designed to celebrate the supernatural powers of the heads of a precolonial dynasty through the fall of their kingdom, through the social, economic, and political changes introduced by colonial rule, and

through the postcolonial swings from ostensibly democratic forms to Marx-ism-Leninism, and finally to a more fully functioning democracy. The impor-tance of kin links and the loyalty of southern Beninese to family have been central throughout and continue to be remarked by newcomers. The power of the ancestors to influence the lives of their descendants has comforted generations and has long been a foundational understanding in Fon cul-ture. Emmanuelle Kadja Tall, who has forcefully and eloquently described the new religions that today promote an individualist ethos and threaten the solidarity of kinship in Benin, stops short of suggesting that ancestral cults are about to disappear (1995a, 204; 1995b, 800–801). Yet we have just reviewed a series of religious movements, most of which are overtly opposed to the use of ancestral asen, that are closely associated with ideas of progress, enlightenment, and material success in contemporary southern Benin. Can ancestral asen survive?

Perhaps the best direction to look for an answer is to ancestral asen them-selves and the verbal-visual messages that continue to issue from them. One hundred fifty years ago, asen spoke parables of power, of men and women born in human form but able to access reservoirs of strength so profound they could defeat any enemy, surmount any hurdle. The asen of the monarchy celebrated kinship links so strong that they incorporated all Dahomeans and all those who might be incorporated into the polity, all standing in complex hierarchic arrangements under the king himself. Dynastic asen gloried in generational ties, marking the continued favor shown by royal father to son, commemorat-ing the way that the two synergistically enhanced each other's strengths.

Colonialism replaced a demanding and oppressive dynasty with the uncer-tainly of rulers who governed through seeming whim, with sometimes tyran-nical bureaucrats issuing directives that at times would have corresponded to local conceptions of proper power relationships, and at times must have been all but incomprehensible. Arbitrary power would have meant opportunity for some Beninese and a source of suffering for others, but for everyone it must have enhanced the importance of the security represented by ideolo-gies of family solidarity. Only extended family could guarantee the means for advancing in a changing world: bridewealth, protection in marriage, opportunities for schooling, advice in decision making, and assurances of good health. Through family, too, the supernatural protections that brought prosperity could be harnessed: allegiance to popular and dynastic vodun, offerings to enlist the collective power of the ancestors, membership in the religions of the colonial conquerors. Collective action through the family, the vehicle most prepared at the opening of the colonial period to provide protection, lasted through much of the century, or so the asen testify. By the

midcolonial period, they spoke nearly exclusively of family and kinship, of pledges of support, promises that would be kept, proverbs of mutual help.

But families grow and fracture. Nuclear units exist within extended kin networks: mothers who pay school fees for their children, fathers who work to help their sons with business ventures, children whose parents seek charms to help them pass exams. Economic diversification and opportunities for migration scatter kinsmen. Obligations are put off, and material success is gained without the apparent collective support of family, or even ancestors. Asen in the late twentieth century began to boast of individual achievement, of careers and jobs and apprenticeships. Proud children began to order asen that named dead parents, showed them in gainful employ, celebrated personal accomplishment, and said nothing of help outside their own abilities.

Families are still strong in southern Benin. They still have regular ceremonies, meetings, deliberations, and demands. Kinsmen pay assessments for funerals and return home for family deliberations and decisions. The ancestral cults remain; prayers and sacrifices are offered with regularity. But patterns are changing. The nuclear family is model and reality for many urban dwellers. Religious pressures to discontinue the use of asen combine with the loss of prestige of artisanal products made in cities now considered to be backwaters. Moreover, there are attractive new ways to honor the dead and win social standing: lavish funerals for parents and spouses and memorial masses for immediate family are considered to be forward-looking. Of what value is massive expenditure on objects seen only by family members?

The use of ancestral asen is clearly declining, and the end of an artistic tradition seems to be at hand (figure 83). Yet shouldn't the end of the life of an art form, like the end of a long human life, be met with admiration and celebration? We have witnessed the dynamism of artistic creativity in a precolonial African kingdom, with royal patrons and inspired artists collaborating to produce objects that reflected sacred forms associated with supernatural power and invoked complex oral arts. The visual praise "singing" of rebuses and other allusive imagery awed the assembled court and challenged smiths to further ingenuity. Colonial conquest brought hardship yet spurred innovation directly linked to foreigners' attempts to foster art as commodity. Mastering technologies of casting and adopting an elegant modeling style for human and animal figures, smiths transformed what was meant to be tourist art into sacred form. The vagaries of twentieth-century economics meant that adaptation to differing sources of materials became an unquestioned part of artisanry—long before westerners began to value concepts like recycling or assemblage. Over the years, the imagery of ancestral asen changed to reflect the changing life priorities and spiritual concerns of Beninese. The

Figure 83. Discarded asen on the site of an Aguda family's abandoned deho. Ouidah, 1999. Photo: E. Bay.

value of ancestral asen has now been diminished in the eyes of the people who embraced their use, and their continued production is unlikely in the future. But Beninese culture nevertheless continues to be vibrant, and we should look forward to future artistic production that reflects the changing values of contemporary life.

Notes

Introduction

1. Plurals in Fon or Fongbe, the most commonly spoken language in southern Benin, are formed by the addition of the word *lé* following the noun. In this text, I will treat words in Fongbe as if they were collective nouns: for example, an asen, many asen; a vodun, many vodun.

2. For the sake of simplicity, I will use "Dahomey" to refer to the territory controlled by the precolonial kingdom of the same name and "Benin" to refer to the French colony and postcolonial state. When the kingdom of Dahomey was conquered by the French, the name Dahomey was applied to the entire territory included in the colony, a land area that was much larger than the kingdom. Colonial Dahomey became independent in 1960 and changed its name to Benin in 1974, following a 1972 coup d'état.

3. An anonymous reader of the manuscript for this book suggested that asen are now being made for the tourist trade. Thanks to the convenience of email, I was able to contact Joseph Adande, a Beninese art historian who is well versed in contemporary arts developments, to ask if asen are indeed now being created for the tourist trade. Adande confirmed that, while larger numbers of ancestral asen are entering the trade of late, they continue to be exclusively objects made for use in local shrines. Asen in the trade thus have either been stolen from deho, purchased from family members who no longer wish to keep them, or acquired in an unconsecrated state in local markets or at the forges of smiths (personal communication 8 October 2005).

Chapter 1: Vodun, Sacrifice, and the Sinuka

1. Bakare Gbadamosi and Ulli Beier point to similar traditions of word manipulation in their analysis of Yoruba poetry: "Not only are the Yoruba highly conscious of the meaning behind the names, they also like to interpret every word they use.

They believe that every name is really a sentence that has been contracted through a series of elisions into a single word. Naturally, in the attempt to reconstruct the original sentence one may arrive at various meanings" (1972, 7). The dangers of a literal acceptance of these poetic etymologies came home to me when I was researching the history of the kingdom of Dahomey and was told the etymology of the place-name Atcherigbe, the site along the Zou River where the last king of the dynasty, Behanzin, had his central encampment following the taking of Abomey by a French force (figure 3). Atcherigbe, it was said, was derived from *non che di gbe* (the place my mother died) and referred to the death of the king's *kpojito* (queen mother) during the year between the court's flight from Abomey in late 1892 and Behanzin's surrender in January 1894. Later I discovered that Atcherigbe was commonly noted on French maps of Dahomey dating to 1890, three years before the woman's death, and I learned from reliable documentary sources that the queen mother of Behanzin in fact died along the banks of the River Kouffo. Yet the etymology was substantially if not literally correct, for she had died during the period in question.

2. Following common practice among Beninese people and many scholarly sources, I use the words "gourd" and "calabash" interchangeably in this work. However, "calabash" botanically refers solely to the fruit of a Western Hemisphere tree, *Crescentia cujete* (Chappel 1977; see also Berns and Hudson 1986, 173).

3. The religious system known as vodun in Gbe-speaking areas is comparable to that known as orisha in Yoruba-speaking areas of West Africa. Indeed, religious concepts and deities have historically passed from Gbe to Yoruba areas and vice versa. I will speak of the religious system as "Vodun," though as a system Vodun is inextricably tied to orisha, and the two might well be considered a single religious universe. Typically, names of vodun differ in the Fon ethnic context created by Dahomey: the Fon vodun Sakpata is known in Yoruba areas as the orisha Shoponno, the Fon Heviosso is the Yoruba Shango, Legba is Eshu Elegba, and Fa is Ifa.

4. In her work on vodun's descendant, Haitian vodou, Karen McCarthy Brown (1991) has extended the insight of how a god can be simultaneously the same yet different in her suggestion that a server in a sense creates her spirit through interactions with it and understandings of the nature of the family from which it springs.

5. Because half-brothers and sisters could marry within the royal family, some have speculated that the Tohosu are signs of an increased incidence of birth defects in the line. So far as I know, no one has tried to do a systematic study of the incidence of malformed children in the royal family, either in the twentieth century or before.

6. Hérissé hints at this secular meaning of Nesuhwe when he comments, "Bien que les *Lënsouhouè* soient des fétiches particuliers à la famille royale, nous ne pensons pas qu'ils fussent déjà honorés par elle quand ses fondateurs arrivèrent à Abomey. Nous croyons plutôt qu'ils sont un composé du fétichisme et de la croyance à l'âme humaine, inspiré aux princes par le désir de conserver leur supériorité même dans l'au-delà" (Although the *Lënsouhouè* were spirits unique to the royal family, we do not think that they were in use by them when the founders [of the family] arrived in Abomey. Rather, we believe that they represent a combination of beliefs in the spirits

and in the human soul, prompted by the princes' desire to maintain their superior rank even in the afterworld) (Hérissé 1911, 119).

7. Richard Burton describes similar asen in a scene at the royal court of Abomey in 1864, when he sees vodunsi of Lisa "waving peculiar iron rods, serpent-shaped, like the classical Jove's thunderbolts" ([1864] 1893, vol. 4, 31).

8. Interviews with Akati, 30 July 1984, 29 August 1984. Akati's testimony was confirmed independently by Basharu Nondichao (Interview, 3 August 1984). Suzanne Preston Blier has argued that the Gu figure is a *bocio*, a figural version of a *bo*, an object charged with power (1995, 337–40). I recorded a conversation in my 1984 field notes about bo associated with Gu on the occasion of a visit to a *boho*, a small war shrine in the palace of Gezo. My guide on that occasion defined a bo as "a charm. People say to bo, give me strength and on my return I'll feed you." When I asked about the Gu statue in Paris, which was known to him, he responded that it could be a bo, but as such it would be a charm of such power and force that the word *bo* would be inadequate to describe it (Interview with Chaba, 24 July 1984).

9. Skertchly's use of the term "calabash" rather than "asen" in descriptions of court ceremonies has led to confusion in the scholarly sources. Melville Herskovits, for example, reproduces a long passage from Skertchly describing an asen under the assumption that it is a description of a carved calabash (1938, vol. 2, 344–45).

10. A prominent smith and asen artist in the 1980s confirmed Mercier's description of the aladasen form as historically older. He added that a small aladasen is placed on a grave at burial, to be followed later by a "more modern" one (Interview with Agbakodji, 17 August 1984).

11. The exception are industrially manufactured beverages, generally alcoholic, which are poured on the ground and on the asen directly from the maker's bottle.

12. The metaphor of eating is also used to describe the amassing of resources by political elites in a manner comparable to that discussed by Jean-François Bayart (1993). For example, people in Benin remarked cynically at the time of Matthieu Kerekou's coup in 1972 that another set of characters would now eat. But the bitterness in these instances comes from a sense of illegitimate nourishment rather than the reciprocal relations of humans and spirits. It is a condemnation of people who take food from those who have not offered it and who offer nothing in return.

13. Each vodun has favorite foods and can be angered or disempowered, in effect poisoned, by being fed foods forbidden to him or her. Similarly, each Fon clan has a prohibited food, usually the meat of a particular animal, and family members would never eat such a food or offer it to the dead (Herskovits 1938, vol. 1, 160–62).

Chapter 2: The Invention of Ancestral Asen

1. *Cyon* are wooden rods that are placed on fresh graves and are meant to channel and control the spirits of the dead. Bachalu Nondichao asserts that they are the same as the wooden rods used to control masquerade figures during performances of Kutito, the Fon adaptation of the society known as Egungun among the Yoruba (Interview, 11 September 1984).

2. I am grateful to Robin Law, who found this evidence and provided a copy to me.

3. See also Burton [1864] 1893, vol. 3, 200 n.1 and 201.

4. Twentieth-century descriptions of burial practices similarly note that a simple small asen was sometimes placed as a grave marker until the "second burial" or final funeral ceremonies, which took place months and sometimes years after the initial rites. Indeed, a prominent smith remarked in the 1980s that the small asen were removed from the grave at the time of the second burial and placed in the family prayer house, or deho. Several years later, a large asen would be ordered to be consecrated and placed there (Interviews with Nondichao, 6 June 1999; Agbakodji, 28 August 1984).

5. The land turtle is a symbol associated with Fa divination.

6. See Skertchly 1874, 381 and 419, for additional explanations of asen motifs.

7. Hérissé explains that "une tente abrite les 'asen' de peur que, frappés par les rayons du soleil, ils ne perdent leur pouvoir de retenir l'âme des ancêtres" (a tent covers the asen out of fear that, hit by the rays of the sun, they might lose their power to hold the soul of the ancestors) (1911, 191).

8. No term resembling *Bassajeh* was familiar to informants in late twentieth-century Abomey. Rather, these women are commonly referred to as Daasi, a term that combines the honorific for the king (*Daa*) with the suffix for a dependent (*-si*) and is equivalent to the terminology used for initiates of all vodun (e.g. vodunsi, Sakpatasi, Legbasi, Dansi, etc.).

9. Twentieth-century analyses of Nesuhwe report additional springs as sources of water, including Gudu and Amodin; all are said to be the watery homes of Tohosu, the abnormal children fathered by men of the royal lineage who return from the world of the living to the waters from which they were born.

10. King Adandozan, who ruled after Agonglo from 1797 to circa 1818, was overthrown in a coup d'état mounted by Gezo. His name was deleted from the king list, and ceremonies in his honor were never celebrated publicly.

11. A final bit of corroborating evidence comes from across the Atlantic in Haiti, which became home to thousands of individuals forcibly deported from Dahomey in the eighteenth century, and which spawned a religious system that incorporated the gods of the Fon along with elements from other African cultures. Because the importation of African slaves into Haiti ceased abruptly in 1791 at the opening of the Haitian revolution, the religious elements that survived in Haitian vodou must have existed there prior to the end of the eighteenth century and presumably reflected some of the cultural practices of the areas of the continent of their origin. Interestingly, asen for deities are known in Haiti, but not asen made in honor of ancestors.

Chapter 3: The Hountondji Family of Smiths and Dahomean Royal Patronage

1. *Daa* is an honorific indicating the head of a family.

2. The term "Portuguese" is commonly used to describe the coastal culture of

enclaves like Ouidah that were settled by Portuguese-speaking peoples, many of them freed Africans who returned from Brazil. The Dahomeans in the late nineteenth century were in contact with the governments of Brazil and Portugal, and it is difficult to know which is meant in this and similar traditions.

3. Dalzel provides an identical description of an eighteenth-century forge ([1793] 1967, xxv).

4. In her excellent study of copper working in Africa, Eugenia W. Herbert follows Herskovits but expreses the reservation that "[a]lthough tradition claimed that the kings of Dahomey had storehouses full of such figures [brass castings], there does not seem to be much firm evidence for dating this art form" (1984, 220).

Chapter 4: From Tourist to Sacred

1. Importation of motor vehicles into Benin increased greatly in the second decade of the twentieth century, as attested by a dossier of documents, "Automobiles Ford," in the archives of French West Africa in Dakar (Dossier, ANS). With World War I consuming virtually all motor-vehicle production in France, Fords became the controversial vehicle of choice in Benin, controversial first because importing Fords violated policies requiring the importation of French products, and second because of the French perception of pro-German sentiments on the part of Henry Ford. An indication of the level of wartime prosperity was the report that several chiefs in the southern region, including Abomey, had purchased Ford cars with revenues gained through recruitment bonuses. The development of transport services in the northern part of the country in the 1915–17 period further prompted a huge demand for motorized vehicles.

2. A master caster in the 1980s claimed that hands and feet had to be cast abnormally large; otherwise, they would be broken in casting (Interview with Agbakodji, 21 August 1984).

3. Cordwell suggests that Gnassounou was inspired to such genre figures by seeing dioramas at the colonial expositions in France (1979, 488–90).

Chapter 5: Messages of Power

1. Herskovits claimed that carved gourds functioned "principally . . . to convey love messages from men to women" (1938, vol. 2, 345–46), although the overall message of love is elusive at best on several that he illustrates (see, for example, vol. 2, figs. 20–23). We have no firm evidence that the gourd art form was practiced in the precolonial period, and it appears to have died out in Abomey by the final third of the twentieth century. A *makpo,* or recade (from the Portuguese *recados* [messenger]), a prominent symbol of rank in the precolonial period, was an ax- or hoe-shaped scepter that was sent with official messengers as a mark of the identity of the sender. It was also a part of the regalia of prominent persons, carried over the left shoulder and used for gesturing in dance. To be personalized, the top of the makpo was typically decorated with an image that referred to its owner. The definitive work on Dahomean makpo

was done by Alexandre Adandé, who worked with a large collection in the Musée de l'Homme in Paris (1962).

2. Behanzin died in exile in 1906 and was reburied in Dahomey in 1928, and Ago-liagbo, exiled to Gabon and later permitted to return to Benin, died in the 1940s.

Chapter 6: Mixed Messages and Migrating Meanings

1. See, for example, Herskovits's discussion of nineteenth-century sources' descriptions of court appliqués (1938, vol. 2, 329–32).

2. Herskovits's assumption that significantly lower prices were charged for "society banners" is difficult to accept, for the costs to the artists would have remained the same. Certainly tourists would have paid more, but the assumption that local well-to-do people would have agreed to substantially higher prices seems counterintuitive at best. The contrary was true, according to Norbert Agheci (Abbécy, MH).

3. Hérissé published a photo of a banner with scenes of war that he identified as a "copie du drap mortuaire qu'on étend sur l'autel du roi Gelele au jour des ceremonies commemoratives" (copy of a mortuary cloth that is hung on the altar of King Glele the day of commemorative ceremonies) (1911, planche IX). In its motifs and use, such a cloth was far different from the funerary-cloth tradition documented in 1930.

4. A good portion of the *Anthropos* article, including the full explication of one of the appliqué cloths not discussed here, is included in the catalog of an exhibition held at the Musée Albert-Kahn in Paris, November 1996 to September 1997 (*Pour une reconnaissance* 1996, 48–50). The catalog also reproduces one of the appliqués deposited in the Musée d'Ethnographie du Trocadéro with an abbreviated version of its message (60). A second of the Musée d'Ethnographie appliqués is pictured in Iroko and Rivallain (1998, 27). The two funerary cloths acquired by Herskovits are pictured in Herskovits (1938, vol. 1, plate 39, facing p. 241) and in Herskovits and Herskovits (1934, 73, 74). While this book was in production, I discovered that Pierre Verger, on unknown dates between 12 December 1948 and 1 April 1979, photographed two, possibly three, appliqué banners that appear to be funerary cloths. Images of those appliqués are among the images preserved at the Fondation Pierre Verger in Salvador da Bahia, Brazil.

5. In some areas of coastal Benin, particularly among groups popularly known by the ethnonyms Ewe, Peda, and Gun, the second burial might include the exhumation of the skull and its public display prior to reburial.

6. Agheci called them "initiates," but it is unclear what he meant by that term. Herskovits speaks of funerary cloths in association with mutual-aid society members (1938, vol. 1, 250–53).

7. The meaning of the configuration of motifs is unclear. The curators of the National Museum of African Art suggest that the rider is Oudji himself, shown in conjunction with the animal that represents the power of his kingdom of Porto-Novo. If the rider is meant to be Noufflard, the whole suggests an interesting interpretation

of the accommodationist thinking of the midcolonial period, when French ideology likened subject peoples to horses being directed to a common destination by a wise colonial rider. Riding a lion is a far different task than handling a horse, however, and perhaps this was the point!

8. I do not know the scientific name for the gbejihen bird, though a colleague has remarked that its behavior closely resembles the galah, the Australian cockatoo. The proverb asserts that in a field of millet devastated by the voracious eating of a flock of these tiny birds, if there is so much as a single untouched stalk, a bird will be there to eat it.

Chapter 7: Death and the Culture Wars

1. Anthropologists describe three levels of kin organization among the Fon. The smallest is the *hwe,* or household, consisting generally of a man, his wives and children, unmarried sisters and brothers, and other dependants. At an intermediate level is the lineage, or *hennu,* which comprises a series of households that traces its origins to a single historical individual. The clan, or *ako,* links lineages that consider themselves to have been descended from a founding ancestor, who is often described as having supernatural characteristics. Deho, shrines with asen, are located at the levels of households (hwe) and in the compounds of lineage heads (*hennugan*).

2. Funeral practices varied dramatically across southern Benin in the early to mid-twentieth century. Generally, however, there were two major gatherings, as described here. In addition, smaller ceremonies and gatherings of family and friends took place before and after the two major events, depending upon the relative importance of the deceased, the locale, and the resources of the family. See Souza 1968 for a brief description of such ceremonial cycles at mid-twentieth century.

3. In Ouidah, a family indicated that Ahanbiba might also be called Hwedudu, which literally means the household eats.

4. Camilla Strandsbjerg analyzes how Kérékou discursively associated Christianity with democracy in contrast to a negative pairing of vodun and military government during his mid-1990s political reinvention (2000).

5. According to Bachirou Nondichao, Muslims do not use ancestral asen (personal communication, 14 June 1999).

6. Paul Falcon, writing just before the founding of Mewi Hwendo, explores some of the earlier debates about the spiritual significance of honors for the ancestors (1970, 158–63).

7. A burgeoning literature links processes of modernization with the expansion of beliefs in witchcraft. Among the fine works analyzing this phenomenon in Africa are Peter Geshiere's *The Modernity of Witchcraft* (1997) and Jean Comaroff and John Comaroff's edited *Modernity and Its Malcontents* (1993).

8. Among the most prominent of the evangelical Christians are the Assemblies of God (Pentecostal from the United States) and the Jehovah's Witnesses.

Bibliography

Adams, Captain John. 1823. *Remarks on the Country Extending from Cape Palmas to the River Congo.* London: G. and W. B. Whittaker.

Adandé, Alexandre. 1962. *Les Récades des Rois du Dahomey.* Dakar: Institut Fondamental d'Afrique Noire.

Adandé, Joseph. 1997. "Traite nègrière et art dans le royaume du Danhome (XVIIIe-XIXe siècle)." Paper prepared for the United Nations Educational, Scientific, and Cultural Organization/Social Sciences and Humanities Research Council Summer Institute on the Slave Trade from the Nigerian Hinterland, York University. 25 July.

Adoukonou, Barthélémy. 1979. *Jalons pour une théologie africaine.* 2 vols. Paris: Editions Lethielleux.

———. 1991. "Dialogue avec les Religions non-Chrétiennes." In *Une Expérience africaine d'inculturation.* Vol. 1. 63–84. Cotonou: Centre de recherche et d'inculturation.

Africa Research Bulletin. 1991. (1–31 March; 1–30 April), 10044, 10080.

Agheci, Norbert. 1932. "Emblèmes et chants." *Anthropos* 27: 417–22.

Anignikin, Sylvain C. 1986. *Etude sur l'Evolution Historique social et spatiale de la ville d'Abomey.* Cotonou: Projet plans d'urbanisme en republique populaire du Benin.

L'Art Dahoméen: Collection du Gouverneur Merwart. 1922. Marseille: Imprimerie Moullot.

Babatounde, Joseph, and Barthélémy Adoukonou. 1991. "Historique du Sillon Noir." In *Une Expérience africaine d'inculturation.* Vol. 1. 3–18. Cotonou: Centre de recherche et d'inculturation.

Balard, Martine. 1998. *Dahomey 1930: Mission Catholique et Culte Vodoun.* Perpignan: Presses Universitaires de Perpignan.

Barber, Karin. 1981. "How Man Makes God in West Africa: Yoruba Attitudes towards the *Orisa.*" *Africa* 51.3: 724–44.

Barnes, Sandra T. 1997. "Introduction: The Many Faces of Ogun." In *Africa's Ogun*. 2d ed. Ed. Sandra T. Barnes. 1–26. Bloomington: Indiana University Press.

Bay, Edna G. 1975. "Cyprien Tokudagba of Abomey." *African Arts* 8.4 (Summer): 24–29.

———. 1979. "On the Trail of the Bush King: A Dahomean Lesson in the Use of Evidence." *History in Africa* 6: 1–15.

———. 1985. *Asen: Iron Altars of the Fon People of Benin*. Atlanta: Emory University Museum of Art and Archaeology.

———. 1987. "Metal Arts and Society in Nineteenth- and Twentieth-Century Abomey." In *Discovering the African Past: Essays in Honor of Daniel F. McCall*. Ed. Norman R. Bennett. 7–31. Boston. Boston University African Studies Center.

———. 1998. *Wives of the Leopard: Gender, Politics, and Culture in the Kingdom of Dahomey*. Charlottesville: University Press of Virginia.

Bayart, Jean-François. 1993. *The State in Africa: The Politics of the Belly*. Trans. Mary Harper, Christopher Harrison, and Elizabeth Harrison. London: Longman.

Berns, Marla C., and Barbara Rubin Hudson. 1986. *The Essential Gourd: Art and History in Northeastern Nigeria*. Los Angeles: UCLA Museum of Cultural History.

Blier, Suzanne Preston. 1995. *African Vodun: Art, Psychology, and Power*. Chicago: University of Chicago Press.

———. 1998. *The Royal Arts of Africa: The Majesty of Form*. New York: H. N. Abrams.

Bouche, Abbé Pierre. 1885. *Sept Ans en Afrique Occidentale: La Côte des Esclaves et le Dahomey*. Paris: Librarie Plon.

Brand, Roger. 1991. "La Société Wemenu, son dynamisme, son contrôle: Approche ethno-sociologique d'une société du sud Bénin." Ph.D. dissertation, Université de Paris V.

Brown, Karen McCarthy. 1991. *Mama Lola: A Vodou Priestess in Brooklyn*. Berkeley: University of California Press.

Burton, Richard. [1864] 1893. *A Mission to Gelele, King of Dahome*. Vols. 3 and 4 of *Works of Captain Sir Richard F. Burton*. Ed. Isabel Burton. London: Tylston and Edwards.

Capo, Hounkpati B. C. 1991. *A Comparative Phonology of Gbe*. Berlin: Foris Publications.

Chappel, T. J. H. 1977. *Decorated Gourds in Northeastern Nigeria*. London: Ethnographica.

Chaudoin, E. 1891. *Trois Mois de Captivité au Dahomey*. Paris: Librarie Hachette.

Chautard, R. P. 1894. Letter. *Annales de la propagation de la foi* 66: 267–75.

Cole, Herbert M. 1989. *Ideals and Power in the Art of Africa*. Washington, D.C.: Smithsonian Institution Press.

Comaroff, Jean, and John Comaroff. 1993. *Modernity and Its Malcontents*. Chicago: University of Chicago Press.

Cordwell, Justine M. 1979. "Human Imponderables in the Study of African Art." In *The Visual Arts, Plastic and Graphic*. Ed. Justine M. Cordwell. 469–512. The Hague: Mouton.

Dalzel, Archibald. [1793] 1967. *The History of Dahomy.* London: Frank Cass.

Delange, Jacqueline. 1974. *The Art and Peoples of Black Africa.* New York: E. P. Dutton.

Drewal, H. J. 1990. "African Art Studies Today." In *African Art Studies: The State of the Discipline; Papers Presented at a Symposium Organized by the National Museum of African Art, Smithsonian Institution, September 16, 1987.* Ed. R. Abiodun. 29–62. Washington, D.C.: National Museum of African Art.

"Early Enquiry into Slavery and Captivity in Dahomey, An. 1960." *Zaire* 14.1: 53–67.

Ellis, A. B. 1890. *The Ewe-Speaking Peoples of the Slave Coast of West Africa.* London: Chapman and Hall.

Elwert-Kretschmer, Karola. 1995. "Vodun et contrôle social au village." *Politique Africaine* 59 (October): 102–19.

Etienne-Nugue, Jocelyne. 1984. *Artisanats traditionnels en Afrique Noire: Bénin.* Dakar: Institut Culturel Africain.

Fagg, William. 1959. "Cire-perdue casting." In *Seven Metals of Africa.* Ed. M. Plass. Plates J-6 and J-7. Philadelphia: University of Pennsylvania, University Museum.

Falcon, Paul. 1970. "Religion du vodun." *Etudes dahoméennes* 18–19: 1–211.

Foa, Edouard. 1895. *Le Dahomey.* Paris: A. Hennuyer.

Forbes, Frederick E. [1851] 1966. *Dahomey and the Dahomans.* 2 vols. London: Frank Cass.

Gavoy, l'Administrateur. 1955. "Note historique sur Ouidah." *Etudes Dahoméennes* 8: 47–74.

Gbadamosi, Bakare, and Ulli Beier. 1972. *Yoruba Poetry.* Nendeln, Liechtenstein: Kraus-Thomson.

Geshiere, Peter. 1997. *The Modernity of Witchcraft.* Charlottesville: University Press of Virginia.

Gillon, Werner. 1984. *A Short History of African Art.* New York: Viking Penguin.

Glélé, Maurice Ahanhanzo. 1974. *Le Danxome.* Paris: Nubia.

Hazoume, Paul. 1937. *Le Pacte de Sang au Dahomey.* Paris: Institut d'Ethnologie.

———. 1938. *Doguicimi.* Paris: Larose.

Herbert, Eugenia W. 1984. *Red Gold of Africa.* Madison: University of Wisconsin Press.

Hérissé, Auguste le. 1911. *L'Ancien royaume de Dahomey.* Paris: Larose.

Herskovits, Melville J. 1938. *Dahomey: An Ancient West African Kingdom.* 2 vols. New York: J. J. Augustin.

Herskovits, Melville J., and Frances S. Herskovits. 1934. "The Art of Dahomey." *American Magazine of Art* 27 (January): 67–76.

[Hountondji, Daah Djidji Sinlon.] N.d. *Historique Hountondji.* Abomey: Hountondji family.

Howe, Ellen. 2000. "Fon Silver Jewelry of the Twentieth Century." *Met Objectives* 1.2 (Spring): 4–5, 8.

Iroko, A. Félix, and Josette Rivallain. 1998. *Les Appliqués sur tissus du Bénin.* Saint-Maur des Fosses, France: Editions Sépia.

Journal de Francesco Borghero, premier missionnaire du Dahomey, 1861–1865. Ed. Renzo Mandirola and Yves Morel. 1997. Paris: Kartala.

Law, Robin. 1990. "The Gold Trade of Whydah in the Seventeenth and Eighteenth Centuries." In *West African Economic and Social History: Studies in Memory of Marion Johnson.* Ed. David Henige and T. C. McCaskie. 105–18. Madison: African Studies Program, University of Wisconsin.

Le Dahomey au début du XXe siècle: Cinq ans de progès, 1900–1905. 1906. Exposition Coloniale de Marseille.

M'Leod, John. [1820] 1971. *A Voyage to Africa.* London: Frank Cass.

Manning, Patrick. 1982. *Slavery, Colonialism, and Economic Growth in Dahomey, 1640–1960.* Cambridge: Cambridge University Press.

Maupoil, Bernard. 1943. "La Géomancie à l'ancienne côte des esclaves." Ph.D. dissertation, Université de Paris (reissued by the Institut d'Ethnologie, Musée de l'Homme, Paris, 1961).

Mayrargue, Cédric. 1995. "Le religieux et les élections législatives de mars 1995 au Bénin." *Politique Africaine* 58 (June): 158–62.

Mercier, Paul. [1951] 1966. "Evolution de l'art dahoméen." In *L'Art negre.* Paris: Présence Africaine.

———. 1952. *Les Asẽ du Musée d'Abomey.* Dakar: IFAN.

"Nostra Aetati: Declaration on the Relation of the Church to Non-Christian Religions." Proclaimed by His Holiness Pope Paul VI. 28 October 1965. 22 May 2007. www.vatican.va/archive/hist_councils/ii_vatican_council/documents/vat-ii_decl_19651020_nostra aetate_en.html.

Pour une reconnaissance africaine: Dahomey 1930. 1996. Boulogne-Billancourt: Musée Albert-Kahn.

Ranger, Terence. 2003. "Conference Report: Evangelical Christianity and Democracy in Africa: A Continental Comparison." *Journal of Religion in Africa* 33.1: 112–17.

Reste, J. F. 1934. *Le Dahomey.* Paris: Comité de l'Afrique Française.

Rosenthal, Judy. 1998. *Possession, Ecstasy, and Law in Ewe Voodoo.* Charlottesville: University Press of Virginia.

Rush, Dana Lynn. 1997. "Vodun Vortex: Accumulative Arts, Histories, and Religious Consciousnesses along Coastal Benin." Ph.D. dissertation, University of Iowa.

Sagbo, Bernard Fidèle. 1997. "Pouvoir politque et cultes vodun dans le Dahomey pré- et post-colonial." *Hemispheres* 11: 33–41.

Sastre, Robert. [1970] 1993. "Les Vodu dans la vie culturelle, sociale et politique du Sud-Dahomey." In *Vodun.* Paris: Présence Africaine.

Savary, Claude. 1967. "Notes à propos du symbolisme de l'art Dahoméen." *Bulletin Annuel du Musée et Institut d'Ethnographie de la ville de Genève* 10: 69–98.

———. 1970. "Poteries rituelles et autres objets cultuels en usage au Dahomey." *Bulletin annuel du Musée d'ethnographie de la Ville de Genève* 13: 33–57.

Segurola, R. P. B. 1963. *Dictionnaire Fon-Français.* Cotonou: Centre Catéchétique de Porto-Novo.

Segurola, B., and J. Rassinoux. 2000. *Dictionnaire Fon-Français*. Madrid: Ediciones Selva y Sabana, Sociedad de Misiones Africanas.

Silverman, Raymond A. 1986. "Bono Brass Casting." *African Arts* 19.4 (August): 60–64.

Skertchly, J. A. 1874. *Dahomey as It Is*. London: Chapman and Hall.

Smith, William. [1744] 1967. *A New Voyage to Guinea*. London: Frank Cass.

Snelgrave, William. [1734] 1971. *A New Account of Some Parts of Guinea and the Slave Trade*. London: Frank Cass.

"Soglo Sworn In." 1991. *West Africa*, 15–21 April, 573.

Souza, Isidore de. 1968. "Le Sud-Dahoméen face au problème de l'au-delà." In *Regards sur la Vie Dahoméenne*. Cotonou: Service Culturel de l'Ambassade de France.

Strandsbjerg, Camilla. 2000. "Kérékou, God, and the Ancestors: Religion and the Conception of Political Power in Benin." *African Affairs* 99: 395–414.

Tall, Emmanuelle Kadya. 1995a. "De la démocratie et des cultes voduns au Bénin." *Cahiers d'Etudes Africaines* 35.1: 195–208.

———. 1995b. "Dynamique des cultes voduns et du Christianisme céleste au Sud-Bénin." *Cahiers des sciences humaines* 31.4: 797–823.

Verger, Pierre. 1954. *Dieux d'Afrique*. Paris: Paul Hartmann.

———. 1957. *Notes sur le culte des orisa et vodun*. Mémoires d'IFAN, no. 51. Dakar: IFAN.

———. 1968. *Flux et Réflux de la Traite des Nègres entre le Golfe de Bénin et Bahia de Todos os Santos du XVIIe au XIXe siècle*. Paris: Mouton.

———. 1995. *Ewé: The Use of Plants in Yoruba Society*. São Paulo: Companhia das Letras.

Waterlot, Em. G. 1926. *Les Bas-Reliefs des Bàtiments royaux d'Abomey*. Paris: Institut d'Ethnologie.

Archives du Musée de l'Homme, Paris (MH)

Abbécy, Norbert, to Directeur du Musée d'Ethnographie, Palace du Trocadéro, 30 August 1933.

Archives d'Outre-Mer, France (AOM)

Archives d'Outre-Mer, Aix-en-Provence. "Relation de Royaume de Judas en Guinée, De son Gouvernement, des moeurs de ses habitans, de leur Religion, Et du Negoce qui sy fait." N.d. [ca. 1714]. Manuscript. In Dépôt des Fortifications des Colonies, Côtes d'Afrique, ms. 104.

Archives Nationales du Bénin (ANB)

Administrator at Abomey to Governor of Dahomey et Dépendances. 15 August 1901. 1E2$_4$.

Memo on the Exposition Coloniale et Internationale de Paris, no. 629, addressed to the Lt. Gov. of Dahomey, 26 May 1930. 1Q2.

Archives Nationales du Sénégal (ANS)

Dossier Automobiles Ford, 1917, 8G9.
Gouverneur Général de l'AOF à M. le Ministre des Colonies, 25 September 1917. 8G9.

Interviews

Abiala, Jean. Abomey, 7 August 1984.
Adamon, Wanjile. Porto-Novo, 29 September 1984.
Agbakodji, Aloha. Abomey, 17 August 1984, 18 August 1984, 28 August 1984, 2 September 1984, 27 September 1984.
Agessi Voyon, T. P. Abomey, 9 August 1984, 29 August 1984.
Ahossi, Merry Louis. Cove, 5 September 1984.
Akati, Simon Gounon. Abomey, 30 July 1984, 9 August 1984, 29 August 1984.
Alomadè, Robert. Ouidah, 16 June 1999.
Babatounde, Abbé Joseph. Bohicon, 9 June 1999.
Badiji, Christophe. Hoja, 3 October 1984.
Chaba, Protais. Abomey, 24 July 1984.
Domonhedo, Jean. Abomey, 14 September 1984.
Hunkpatin, Maturin, and Gerome Alitonu. Bohicon, 26 September 1984.
Mitchozunu, Romuald. Abomey, 9 June 1999.
Nondichao, Bacharu. Abomey, 3 August 1984, 11 September 1984, 6 June 1999.
Nyawhi, Daa Kannoumavo. Ouidah, 22 September 1984.
Smiths of the Adjovi, Sodoganji, and Atelele families. Ouidah, 17 June 1999.
Souza, Leah de. Ouidah, 16 June 1999.

Index

EDNA G. BAY is Professor of Interdisciplinary and African Studies in the Graduate Institute of the Liberal Arts at Emory University. She is author of *Wives of the Leopard: Gender, Politics, and Culture in the Kingdom of Dahomey* and numerous articles on southern Benin/Dahomey. She has edited works that include *Women in Africa: Studies in Social and Economic Change* (with N. J. Hafkin), *States of Violence: Politics, Youth, and Memory in Contemporary Africa* (with D. L. Donham), and *Rethinking the African Diaspora: The Making of a Black Atlantic World in the Bight of Benin and Brazil* (with K. Mann).

The University of Illinois Press
is a founding member of the
Association of American University Presses.

Composed in 10.5/13 Adobe Minion Pro
with Meta display
by Barbara Evans
at the University of Illinois Press
Manufactured by Thomson-Shore, Inc.

University of Illinois Press
1325 South Oak Street
Champaign, IL 61820-6903
www.press.uillinois.edu